The Man who Drew the Drunkard's Daughter
The Life and Art of George Cruikshank 1792–1878

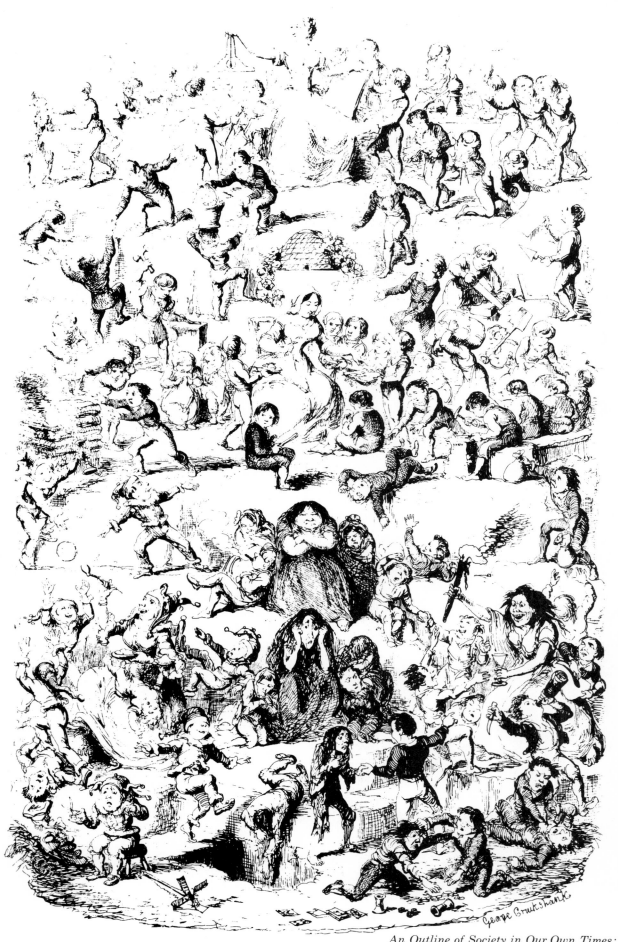

An Outline of Society in Our Own Times:
etching from Our Own Times 1846

The Man who Drew the Drunkard's Daughter

The Life and Art of
George Cruikshank 1792–1878

Hilary and Mary Evans

Frederick Muller Limited · London

First published in Great Britain 1978 by
Frederick Muller Limited, London, NW2 6LE

ISBN 0 584 10259 3

British Library Cataloguing in Publication Data

Evans, Hilary
 The man who drew the drunkard's daughter.
 1. Cruickshank, George
 2. Cartoonists–England–Biography
 I. Title II. Evans, Mary, b.1936
 741'.092'4 NC242.C7

ISBN 0–584–10259–3

Designed by Robert and Jean Wheeler
Phototypeset by Computer Photoset Ltd, Birmingham
Printed and Bound by W & J Mackay Ltd, Chatham, Kent.

Contents

PICTURE ACKNOWLEDGEMENTS

Thanks are due to Her Majesty the Queen, the
Victoria & Albert Museum, the National Portrait
Gallery and the Greater London Council for
permission to reproduce pictures in their
possession. Apart from the seven plates attributed
to these sources in the captions, all the
illustrations are from the Mary Evans Picture
Library.

The Three Worlds
of George Cruikshank

He was a good man. And like all good men, he wanted to leave the world a better place than he found it. Luckier than most, he found himself endowed with a talent which could help him achieve this purpose, and so, for the seventy five years of his working life, he dedicated himself and his art to setting the world to rights. Even when he wasn't deliberately preaching, his pictures are loud with his unspoken comments, his approval or reproach, his anger or sympathy or hope.

Fortunately, both for himself and for the world he wanted to change, he was not only a good man but a good artist. If George Cruikshank the reformer had a message to get across, George Cruikshank the artist saw to it that the message was delivered with style and taste, discretion and wit. Even in his most blatant pieces of propaganda the moral is sugar-coated with art and, in return, his art is strengthened by this inner core of purpose. Without a sense of direction, his art could have been hesitant, diffuse, lacking conviction; assigned a definite job to do, it is confident, simple, self-assured. Without it, he would have been just one among the many competent professional illustrators of the day, ranked with Seymour or Onwhyn or Phiz. It is his sense of purpose which raises him above the rest.

This continuing sense of mission meant, too, that George Cruikshank the artist and George Cruikshank the man lived comfortably together in the same body. His work sprang out of his life, and in turn directed its course; his art was integrated with the other elements of his existence, never causing conflict. What the reformer wanted to say, the artist was happy to express. Self-doubt, trauma, hesitation of will—none of these seem ever for a moment to have disturbed either the steady progress of his career as an artist or his development as a man.

It was, up to a point, what the totalitarian ideologists prescribe—the artist putting his talents to work for Humanity, Art the Handmaid of Progress: from each according to his ability. The difference is that George the artist took his orders from George the man, not from some Humanity-in-the-abstract. If he believed profoundly in the social responsibility of the artist, it was because he believed in the social responsibility of *everybody,* whether artist or politician or greengrocer. But it was a responsibility which demanded personal initiative, not passive obedience to what others dictated. We know how angrily he opposed the police-state policies of the British government in the troubled post-Waterloo years; he would never have subscribed to any ideology which allowed Society to dictate either what a man should believe as a man or what he should express as an artist.

So the views he expressed were always his own. Insofar as he gave any thought to religious or political doctrines, he distrusted them. He had a lifelong suspicion of the Catholic Church in particular, but on patriotic rather than doctrinal grounds, and there is no evidence that he favoured any other sect except as a provider of a measure of social and moral stability. Nor, for all his activity in political controversy, was he ever a party man. Each issue was evaluated on its individual merits, not as a plank in some

politician's platform. He was as turncoat in his allegiances as he was constant in the human sympathies which underlay them. Now radical to the point of revolution, now conservative to the point of reaction, he gave his support to whatever seemed best—not for a party, not for principle . . . but for people.

So, resolute to help the world, but treading no party line and obedient to internal impulses rather than external pressures, he was free to tackle in his own way the central theme that runs through all his art: the discrepancy between the world as it is and the world as it might be.

George knew both worlds and made them his own. He drew things as they too often tragically are: the waste of life in the gin shop; the violence of the mob, whether in rebellious Ireland or communist Paris; the tyranny of authority, whether vested in a Minister of State or a Parish Beadle. He drew lesser faults with a gentler tolerance: a housewife over-concerned for her polished fire-irons; servant girls gossiping on area steps; young men enjoying a midnight spree at the watchman's expense. But he also drew the world as it might be, and occasionally is: children playing peacefully on a suburban green; a theatre crowded from pit to gallery with cheerful playgoers; a Christmas party with the cake arriving in splendour. Whichever world he was drawing, the other was implicit in it. Look on this picture and on that, he invites us, and see how life is and how it could be. All we have to do is to choose between them.

But, all too often, we do not choose. We continue to waste our shillings in the gin-shop, our greed and cruelty continue to drive girls onto the streets

The world as it is.
The Last Half Hour: wood engraving, source unknown, circa 1860

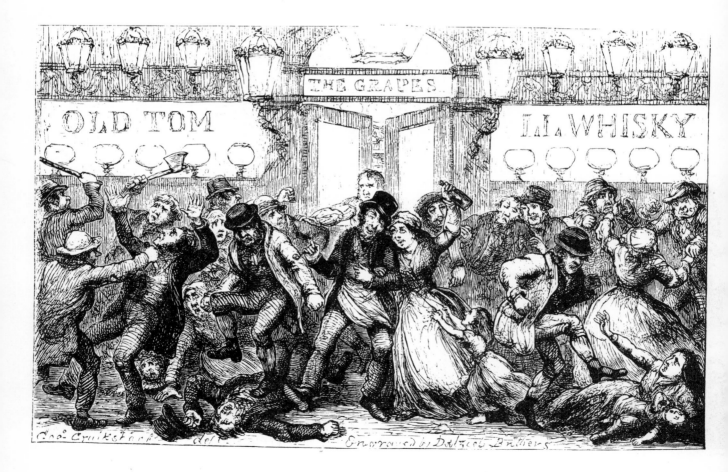

and boys into thieving. Such obstinacy in choosing evil might make even the strongest-willed despair: if against stupidity even the gods strive in vain, what can a fellow-human hope to accomplish, however strenuously he deploys his talents? Luckily for George–and again, luckily for us–he found a third world to escape into, where he could forget both the world of reality and the world of the unrealised ideal. In this never-never world of fantasy, jolly Sir John Falstaff can drink his fill without dragging his family to ruin; Cinderella and her Prince can live happily ever after; and even the Fairies' revenge is not half as cruel as that of the Irish rebels.

In each of these three worlds George made himself at home, and makes each of them familiar to us in turn. But because, whichever world he was depicting, his theme remained the same–humanity–his three worlds are not distinct, they touch and overlap. Even in his most horrific scenes he reminds us what we have in common with the unfortunates who have been caught up in them: but for circumstance, the debauched drop-outs from the Gin-Shop could be sitting beside us laughing in the theatre gallery, the bloodthirsty mob could be sharing with us the delights of Greenwich Fair. George the artist prevented George the reformer from separating men into white sheep and black goats, for artists know all the shades of grey which lie between. So the father in the history of 'The Bottle' is destroyed by his own weak nature: his downward career starts with a kindly human gesture. 'The Worshippers of Bacchus' sin through ignorance; it is their decent, praiseworthy wish to mark a happy domestic occasion to toast a bride, celebrate a christening, rejoice in a birthday which sets their feet on the fatal path. And in that

The world as it might be. Children on a Suburban Green: etching, source unknown, circa 1860

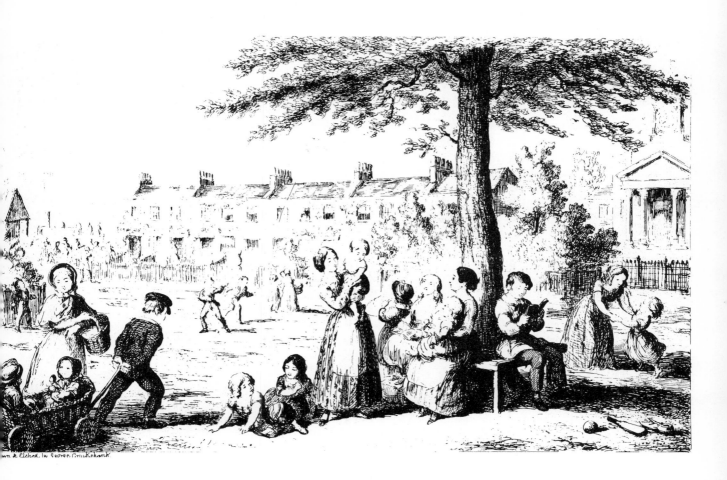

Jack climbing the Bean Stalk.

"Ruffians are abroad——
· · · ·
Leviathan is *not so* tamed."

THESE ARE

THE *REASONS* OF LAWLESS POWER,

That back the Public Informer,

who

Would put down the *Thing*,

that, in spite of new Acts,

And **attempts to** restrain it,

by Soldiers or Tax,

Will *poison* the Vermin,

That plunder the Wealth,

That lay in the House,

That Jack built.

left: The world of fantasy: Jack and the Beanstalk: etching from the Fairy Books *1854*

picture which focuses his whole attitude to life within a single frame, The Outline of Society, good and evil touch and mingle; we are free to choose, no border guards prevent the good defecting to join the wicked, the sinner can always have second thoughts and return to grace.

Nor is his third world, his fantasy world, so remote that we must first pull up our stakes in the world of reality. We can escape for a little while as if spending an hour or two at the theatre, and return to the real world rested and refreshed. And in any case it turns out that its inhabitants aren't so unreal as they at first appear. Jack's Ogre is more easily outwitted than a tyrannical mill-owner or a corrupt politician; the witches are fearsome creatures, but no more so than the master of a workhouse. As for the fairies, you have only to open your library door quietly enough to catch them appraising your picture collection with their customary exquisite taste.

For, though the real world contains much to horrify and dismay, George loved it too strongly to leave it for long, nor would he encourage the rest of us to do so. His love of his fellow creatures and his affection for the strange ways in which we behave is vivid in every picture he drew—we are his single and lifelong preoccupation. Among all the thousands of his pictures, there is not one in praise of nature or God: no landscapes or studies of plants or natural beauty, hardly a picture of animals which does not also contain humans. We do not know why he gave up the Royal Academy classes he started attending at the age of sixty, but perhaps he realised that they were concerned with

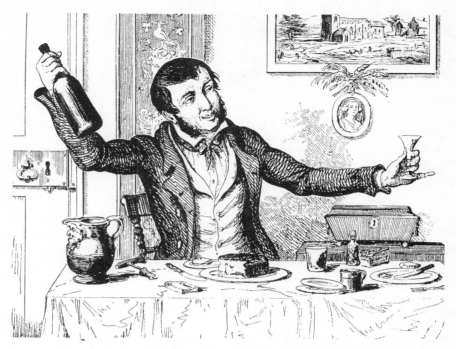

left: These are the Reasons
of Lawless Power: wood
engraving from The
Political House that Jack
built 1821

above: The tyranny of
authority, The Parish
Beadle: detail from etching
for Dickens, Oliver Twist
1838

right: The kindly gesture
that ruins a career. The
Father: detail from
glyphograph, The Bottle
1847

every aspect of art except the one which concerned him: people, always people, were his only subject and only object. Art–art in the abstract–could only come between him and people, just as religious creeds and political dogmas would prevent him from seeing people as they really are.

And so, picking his way by the light of his own instincts, George avoided the rocks on which so many reformers wreck their good intentions. He isn't tempted to settle for textbook solutions and he isn't up in a pulpit, preaching. He's sitting beside us, clapping his hand on our shoulder, understanding our weaknesses but encouraging us to try and overcome them. He had a robust faith–no twentieth century words could replace that fine Victorian phrase–he had a robust faith in humanity; he never doubts that there is hope for you and me, despite our fondness for a drop of gin, our weakness for a pretty figure, our little prides and superstitions, even our bigotries and cruelties. He never lets us forget that it is not strength but weakness which makes man choose evil rather than good; his art encourages us to hate, not the cruel and bigoted people, but the circumstances which have made them so.

George didn't hate anybody. Even in his fairy tales, the giants and monsters are drawn more with pity than with fear and hate; in his moral drawings there are no downright villains, only victims of circumstance. The landlord who makes his living by selling the Demon Drink is to be pitied because he knows no better; Bill Sikes and Fagin are no less the playthings of fate than Nancy and Oliver.

Such attitudes could easily have made him a sentimentalist, but this danger too he managed to avoid. He was a tough-minded man, not evading the issues, always knowing the score. He didn't avoid the fact that drink can send a man's son to the thieves' kitchen and his daughter to the brothel, and he didn't fool himself, or us, into thinking things could be set right with a sanctimoniously pointed finger and a pious text. People are as they are, because the world is as it is: if we want to change them, we must first change the world. And so, all his life, George put his talents to work to change the world.

Early Days of a Londoner

Almost every day of George's life was spent in London. There would be brief excursions to the seaside–to Hythe or Margate, for a whiff of the sea air of which he was so fond–and once he visited a friend at Bath. A theatrical tour took him to Birmingham, Manchester and even Glasgow–the farthest he ever got from London. Once, indeed, there was a day trip to Boulogne, the only occasion when he ever set foot on foreign soil. The remainder of his days, from the day on which he was born to the day he died, were passed in the city whose life provided him with an unending supply of the raw material of his art, a gift he repaid by recording it with a sympathy and vividness which probably no other artist has ever matched.

But George's world was circumscribed even more narrowly than by the geographical boundaries of London. Even in the city streets there was much that would always remain remote and unfamiliar to him. Though he met the Lord Mayor, and the Prime Minister, and even the Queen, these were formal encounters; he never mixed intimately with the wealthy or the powerful. The aristocrats of Mayfair and the potentates of Whitehall were as remote from him as the giants of Fairyland or the characters of a historical romance. At first glance, you would hardly guess; so powerful was his imagination, that he could depict the world of the rich and the powerful with astonishing vividness. But it was a tour de force of his artistic skill; it lacks the unreflecting, spontaneous detailed observation he displays when he shows us the London he knew at first hand. He knew gin palaces better than the royal variety, was more comfortable in pubs than in clubs, more at home in the wings of Sadlers Wells Theatre than in the corridors of power. His genius brought him into professional contact with men of the calibre of Dickens and Thackeray, and many became his personal friends–but their world never became his. He lived in a suburban house in Pentonville; he travelled by bus, not in a private carriage; he worked hard for every penny he earned and he needed it all to live on. The man who was one of the greatest artists of his age was never poor, but he was also never wealthy. He was never roofless, but he never knew luxury, universally loved, but never the intimate of the rich and powerful. Till the day he died, he remained a member of the honest, hopeful, hard-working lower middle class into which he was born.

George's origins are vague, to say the least. The general impression gathered by his friends was that his grandfather had been a Customs Officer at Leith, near Edinburgh. Apparently, his prospects had been blighted by the 1745 rebellion, in the course of which he had actually fought for Charles Stuart at Culloden. Subsequently he had married a sailor's daughter, who sometime around 1756 produced a son, Isaac–George's father. Isaac appears to have been their only child and if George had any uncles and aunts, we don't know of them. Here, in 1788, he married a Highland girl named Mary MacNaughton, who had some vague and distant aristocratic connections. In 1784 or so, when Isaac, a commercial artist by profession, was in his early twenties, he came down to London where there was said to be more work. In

Also

'George Cruickshank',

 by W. H. Chesson.

 Pub. (London) Duckworth & Co.
 (New York) E. P. Dutton & Co.

 "Popular Library of Art" Series
 date 1921 or earlier
written possibly 1903 (on internal evidence)

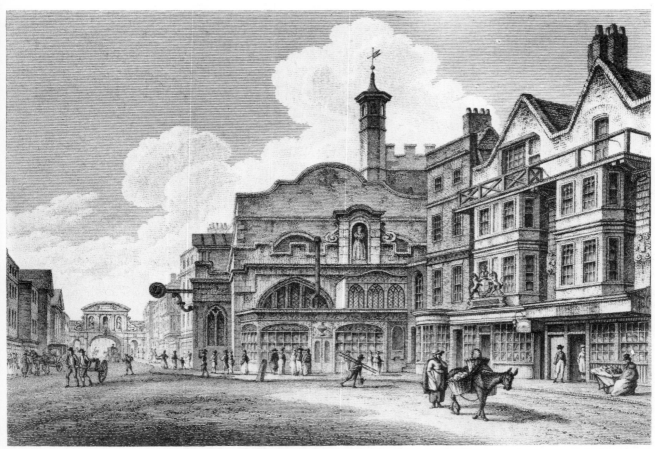

Fleet Street in 1800: copper engraving by Colnaghi.

George was eight and living just round the corner when this view was taken: it was a scene he must have seen daily. Many of the book and printsellers his family worked for were located in the streets to the left.

the following year their first son was born, George's elder brother Isaac Robert. George himself came three years later, on 27 September 1792. There was also a sister, Margaret Eliza, born considerably later than her brothers in 1807, who was to die at the age of 18 in 1825.

'My dear father was of Lowland or Saxon family, and my mother of a celtic Highland family.' It is temptingly easy to trace in George's life what he inherited from each of his parents. That tolerant, easy-going attitude to the world, which kept him balanced and steady throughout his life, surely he got that from his father? From him, too, must have come the professionalism and the industry: the pride in his craft and his skill, which ballasted him through all the ups and downs of his career, through the wildness of his youth; the fluctuations of his professional success, the triumphs and the disappointments.

But these safe, solid qualities would never have enabled him to rise to the heights–they would have kept him a competent, conscientious journeyman like his father. To achieve more, he needed his mother's legacy–the individual will, the strength of purpose to follow a thing through when his mind was made up to it–and of course the strength of character to make his mind up to it in the first place. Thanks to these qualities, he was able to rise above Grub Street and harness his talents to that declared aim of his–'to prevent evil and try to do good'–which was to direct the course of his entire career. For his professional ambition, he was doubtless indebted to his father Isaac; for the direction in which that ambition was turned, to his mother Mary. As though by some calculated combination of fairy gifts, they gave him both the aspiration to better the world and the skill with which to do it.

14

On the day-to-day level we know next to nothing about George's parents, just a few scraps and anecdotes. We hear of Isaac sneaking out of the house to the tavern when Mary brought home the minister from the Scots Church for a dish of tea; there are stories that Isaac was a little too fond of a drink, but we know too that he was a hard-working and respected professional man. We gather that, in their early days at least, there were some financial struggles. For a while Mary had to take in lodgers: a fellow-Scotsman, Mungo Park, the African traveller, is mentioned as one of them. But it was not long before Isaac's skill and industry had won the Cruikshank family a reasonably secure and steady income.

George was born while the family were living in Duke Street, Bloomsbury, but not long after the birth of their children they moved to 117 Dorset Street, Salisbury Square, just off Fleet Street; here all George's childhood was spent. It was a convenient address for a commercial artist. Then, as now, Fleet Street was the centre for ephemeral publishers of all kinds–the kind of people who employed Isaac and would later employ his sons. Isaac could occasionally rise above hackwork–in 1792 he had a painting in the Royal Academy exhibition, a moral representation of the distresses of virtue–but for his daily bread he was dependent on the daily commissions of the printsellers and publishers, and for those he needed to live on the spot. His work ranged from lottery tickets to political cartoons, from miniature portraits to book illustrations, whatever was required. It wasn't a bad living, it kept the family fed and housed–and in the course of time, Robert, George and Eliza were recruited into the family trade.

The Moment of Reflection: hand-coloured etching 1796.
The despotic Empress Catherine the Great of Russia assailed by her victims' ghosts–a characteristic cartoon by Isaac Cruikshank.

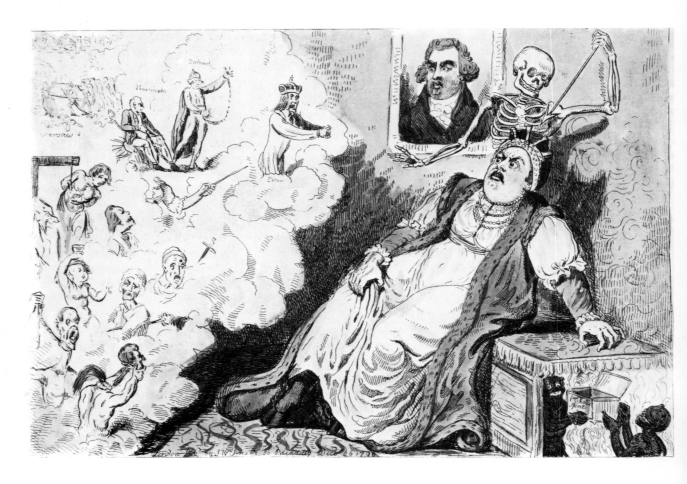

'No Leisure for Lectures'

The world into which Robert and George and Eliza were born was a world of hard but regular work. If they never knew wealth, nor did they ever know poverty at first hand, though they must have seen plenty of it around them. Their father's ability and industry brought him a steady flow of commissions on which all the family, as soon as they were old enough, were called upon to help.

It was an age when a great deal of the world's work was still done inside people's homes. Factories and ateliers were the exception. Dressmakers and food preparers, shopkeepers and manufacturers, did their living and working under the same roof. A craftsman would go out to obtain commissions, then return to his home to execute them. So it certainly was in the Cruikshank home, just as it was to be in George's homes throughout his life. Work was going on more or less steadily all day, and almost every day, in the Criukshank home. Little Robert and George and Eliza were accustomed, from their earliest years, to see Isaac etching and Mary colouring the prints which paid for their daily bread.

To obtain his commissions Isaac, and later his sons, would set out into the streets of Holborn, Fleet Street or Ludgate Hill, where the booksellers and printsellers clustered. In the small, professional world of the commercial artist a man's individual proficiency and limitations would soon get known. Soon, contacts–sometimes regular, sometimes intermittent–would be established. A job might come about as the result of the artist calling at a printseller's shop just when there was a job going; or the printseller would send his lad round to summon a particular artist for a specific job; or he might even call in at the artist's home to discuss an urgent commission. It was an easy-going, informal trade.

In those early 1800s, there did not exist the hard-and-fast division between publishers and booksellers which exists today. Printsellers and booksellers were generally their own publishers, embarking on ventures which their experience or their intuition suggested might be profitable. Normally they would capitalise the venture themselves, perhaps inviting the printer to share in the risks and the profits. If the publication was a sizeable one involving considerable expense–a portfolio of plates, for example–the publisher might start by soliciting subscriptions. He would go about, carrying a prospectus of the proposed work, persuading a sufficient number of wealthy patrons to promise to purchase copies of the book, and so underwrite the venture.

So the people who commissioned work from the Cruikshanks were printsellers and booksellers who were also publishers, who would commission the author as well as the illustrator, who would see the work through the press and finally sell it directly to the public. They took all the risks but also, in the absence of middlemen, they reaped most of the profits. It was rare for the author or illustrator to share in the profits; they were normally paid an outright sum for their contribution, and, if the book was a runaway success, it was their publisher, not they, who enjoyed the benefit. Since it had been he

who had taken all the financial risk, this was probably fair. After all, the book could equally well have been a disaster. It does, however, enable commentators of a later age to accuse publishers of meanness and greed, battening on the talents of others. It is significant that George, not a man to suffer injustice lightly, never uttered a word of complaint in this respect.

One result of this business pattern was that books and prints were published by a great number of publishers each issuing a relatively small output. This is why we find artists like the Cruikshanks working for so many different employers–steady, long-term relationships such as that which existed between Gillray and Mrs Humphreys were the exception. Later, we shall see some of the variations on the basic pattern which occurred in the course of George's career–a career which, we must remember, spanned so many decades that it inevitably witnessed many developments in business practice. But the picture just drawn depicts more or less the professional world in which Robert and George started their careers.

We know virtually nothing about George's childhood and upbringing. We know that he went to school in Edgware for a short while. Edgware is a fair distance from Fleet Street, further than a boy could walk twice daily even in an age when most people walked if they had anywhere to go. This suggests that George was sent there as a boarder, and this may be reflected in some of the pictures of school life which he did in the 1820s, several of which relate to boarding schools, with titles like 'Home for the Holidays' and 'Black Monday–Back to School' (see plates on page 63). These scenes suggest a somewhat higher social level than we would expect for the Cruikshank household, but where so much is conjectural, they may provide a clue to his background.

From a very early age the three children shared in the family occupation. There is no reason to suppose that they were reluctant–I doubt if they ever felt they had any choice, but I also doubt if they resented this fact. George recalled later that he started to help his father as soon as his hands could hold the tools, and he was certainly producing work of a kind as early as 1799, when he was seven years old. To begin with, he would simply have assisted Isaac, preparing plates, helping with colouring and so on:

> When I was a mere boy, my dear father kindly allowed me to play at etching on some of his copper plates–little bits of shadow or little figures in the background: and to assist him a little as I grew older.

Gradually he would have been permitted to do a little more on the less important jobs–those unending designs for lottery tickets, valentine cards, twelfth night characters and so on which were the bread-and-butter of the commercial artist's life.

Scholars and biographers of Cruikshank have produced various accounts of his earliest work, seeking to identify the first true production of his skill, pointing to this picture or that as 'the earliest genuine Cruikshank'. When so much was being produced in what amounted to a workers' co-operative, the assignment of an individual item to one member of the family or another seems pointless; for even though a piece might indeed have been created entirely by George's unaided hand, it would have been produced so completely under the inspiration and guidance of his father or brother that any attempt to discern the authentic 'hand' of the artist is meaningless. He himself recalled at a later date:

George Gruikshank, aged 19: detail from etching, Interior View of the House of God *in The Scourge, by P. D'aigaille from G. C.'s original 1811.*

George's fondness for putting himself into his own pictures had begun even at this early age.

George Cruikshank, aged 20: pencil sketch, 1812.

A supposed self-portrait.

Many of my first productions, such as halfpenny lottery pictures and books for little children, can never be known or seen, having, of course, been destroyed long ago by the dear little ones who had them to play with.

(Letter to George W Reid, 1870)

It is generally accepted that by 1804 or so he was producing work in his own right–in that year he is on record as having been paid for a lottery ticket. One of his earliest authentic productions was a picture of Nelson's funeral carriage, produced shortly after the tragic victory at Trafalgar in 1805; George was then thirteen years old. Such skill as he had acquired was derived entirely from his experience in working with his father:

He told me that it was not because he despised academical instruction that he never availed himself of its salutary discipline, but simply because the pressure put upon him in his early years was so great that he had no leisure for the lectures or work of an art student.

(Cuthbert Bede, Personal recollections of George Cruikshank)

As with so many of George's statements about himself, this should not be taken too literally. We know that in 1804, the twelve year old George showed a portfolio of his drawings to Fuseli, then Keeper at the Royal Academy, and applied for a place in the Schools there, only to be told that if he wished to attend Fuseli's lectures he would have to fight for a place.

It is improbable that George ever seriously contemplated taking up any other career. But two other forms of activity appealed to him then, and maintained their appeal throughout his life. One was the stage. The great actor Edmund Kean was a friend of the family, and the Cruikshank family must frequently have been to see him on the stage, as well as other great

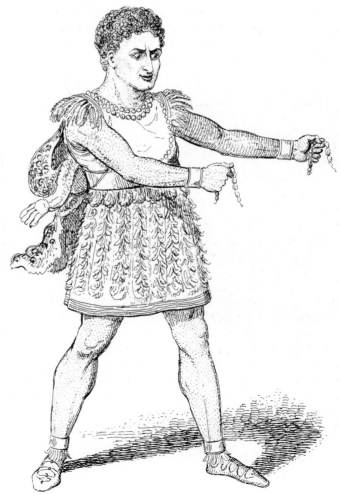

Edmund Kean as Omreah in 'The Carib Chief': etching by Robert Cruikshank.

The great actor was a family friend, whose visits to the Dorset Street household helped to foster George's lifelong love of the theatre.

actors of the day. George was a talented juvenile actor and continued as an enthusiastic amateur all his life. He also did some scene painting at Drury Lane and put up a plan for a theatre. Scenes of theatrical life crop up time and again in his work. The thought of taking up acting professionally must certainly have crossed his mind, even if he never entertained the possibility seriously.

At the same time he had a taste for matters military. We must remember that throughout the whole of his childhood Britain was actively at war with France. Until he was twenty three years old, George did not know what it was like to live in a country not at war. It is not surprising, therefore, that the soldier's life always seemed to him an admirable and desirable one. He had cause to disapprove of many of the things soldiers were called upon to do by the politicians, but in his old age he was heard to regret that he had never joined the army. Perhaps he was envious of his brother Robert who in 1805 went off at the age of sixteen as a midshipman in the East India Company's ship *Perseverance*. (A series of circumstances led to his being left behind on the island of St Helena, whereupon his family gave him up for lost–when he arrived home he found his relatives in mourning for him.) According to H S Ashbee, George too was destined for the sea, and only escaped the press-gang by hiding. When asked in later life what he would have done if he had been caught, '"Well,' answered Cruikshank, with a simplicity that was one of the great charms of his conversation, 'well, I should have done my duty, and become an admiral!"'

The closest George came to adopting the military life was when he joined the Loyal North Britons, a volunteer regiment made up of Scots in London. He took part in the Grand Review in Hyde Park in 1814 at which Czar Alexander was present, and thoroughly enjoyed himself in the uniform 'of which a tall feather and tight green trousers were the conspicuous features'. Looking back on the occasion, he reminisced:

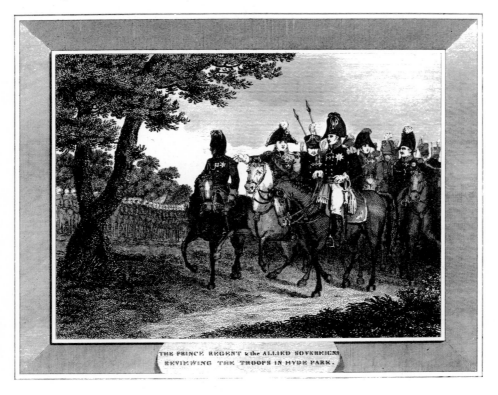

THE PRINCE REGENT & the ALLIED SOVEREIGNS REVIEWING THE TROOPS IN HYDE PARK.

The Prince Regent and the Allied Sovereigns Reviewing the Troops in Hyde Park, 1814: copper engraving by Romney.

George, as a Volunteer with the Loyal North Britons, was among the troops reviewed.

As I had the honour of being present upon that occasion, I can assure my friends that we made a very respectable military appearance, and that the pop-pop-pop of our 'feu de joie' was as regular as the pop-pop-pop of the regulars. But when we marched in review past the Prince Regent, his Imperial Visitor and the crowd of general officers, I remember feeling a considerable degree of chagrin at the paltry appearance we made in point of numbers, and wished most heartily that these foreigners could have seen the 'mobs' of volunteers as they had marched in that park in 1803–4.

The Volunteers were disbanded after Waterloo, and it was not until George was sixty seven that he once again had the opportunity to don a soldier's uniform.

Just what, apart from the tight trousers and green feather, attracted George to the soldier's life, we can only conjecture. For any young Britisher of 1814, a degree of military ardour was almost inevitable–that family tradition about grandfather at Culloden may have added its weight. But it is not unreasonable to speculate that George's military inclinations had a more personal origin, and reflected one side, at least, of his social views. Even at this time, he wanted to play an active part in public affairs, and at this stage in his career, to do so through art seemed insufficient: he was looking for something more directly active. How this impulse was gradually modified and how he came to see art as his most effective mode of action is an important aspect of his artistic development from the earliest days.

The Mulberry Tree: woodcut, 1808.

This broadside ballad, intended to be sold in the streets by itinerant ballad-mongers, is typical of the sort of catchpenny work George was producing in his early years: he was 16 when this was done.

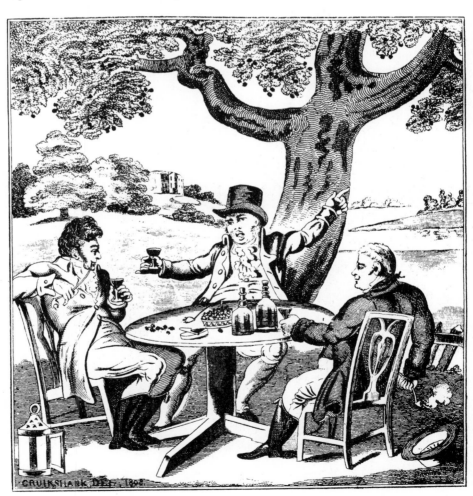

Gillray's Heir?

The period of the Revolutionary and Napoleonic Wars–the last decade of the eighteenth century and the first of the nineteenth–was the greatest age of British political caricature. Two supreme artists in this genre, Gillray and Rowlandson, maintained a steady flow of savagely brilliant prints, some directed against the French, others hitting at affairs nearer home, so inventive in their virulence that even today they retain much of their point as well as their artistic impact. Beside these two giants there were any number of lesser caricaturists whose work, though it might never rival that of the two supreme artists at the top of their form, was often equal to their more average productions. One of them was Isaac Cruikshank.

These caricature prints were generally etchings of about 40×25cm, printed in outline and then coloured by hand. They were sold for a shilling plain, two shillings and sixpence coloured, by the printsellers who commissioned them from the artists, and were displayed in the windows of their shops where they provided a constant attraction to passers-by. Crowds would gather to inspect the newest productions, which had a relatively greater impact than anything comparable today because of the rarity of any other visual material. What an excitement it must have been, to emerge from Mrs Humphreys' shop with the brand-new Gillray in one's hand, crisp and bright from the printer!

Mrs Humphrey's Print Shop, Saint James' Street: from an etching by Gillray.
 Gillray's, and later George's newest caricatures kept a huddle of passers-by at this window.

But by 1810 or so James Gillray, a strange and unstable person at best, had virtually incapacitated himself by his addiction to alcohol, though he was to live until 1815. His patron and employer, Mrs Humphreys, needed someone to finish his plates–and, eventually, to take his place altogether. Perhaps Isaac Cruikshank would have been the obvious choice, but in 1811 he too died–some said, from the same complaint as Gillray. So his son George was invited to don Gillray's mantle.

It is likely that at first George was employed only to finish up Gillray's sketches, but, as time went on, he showed himself capable of originating work on his own. The journalist, George Augustus Sala, who knew George towards the end of his life, said of his early political work: 'His manner of handling was, at the first, mainly founded on that of the renowned Gillray, to whose position as a caricaturist, political and social, he ultimately succeeded.'

This is something of an overstatement. George, fine artist as he already was at the age of nineteen, could never take Gillray's place, and he knew it, 'I was not fit to hold a candle to Gillray,' he admitted in later life. It is doubtful whether anyone could have done. The sustained inventiveness which enabled Gillray to produce his hundreds of devastatingly pointed comments on complex political circumstances, week in and week out, over a period of years, and in the course of such daily work to create so great a number of masterpieces of caricature, was a unique performance which will probably never be matched. Even Rowlandson, fine though his best work is, could not compete in sheer productivity, and his fame rests at least equally on his book illustrations and topographical prints. As for George, it is unlikely that he was temperamentally suited to stick to the caricature line of business for long.

But that he had a real ability for caricature was soon apparent. His work was eminently worthy of his model and of Mrs Humphreys' judgment. The series of caricatures on Bonaparte's Russian campaign are magnificent pieces of work, fully meriting to be placed alongside anything that his father ever did, and by no means unworthy of Gillray himself.

By the time his father died George had produced some 150 etchings. From now on his output was to increase. He grew daily more skilful and, as his name became more familiar to publishers and to the general public, the demand for his work increased. Probably to begin with it was his industry and

Caricature of William Pitt: etching 1812.

A crude little piece which nevertheless already hints at George's vivid imagination, if not yet his ability to translate it in memorable visual terms.

conscientiousness which encouraged the printsellers to employ him, but, if so, it was not long before he began to display those unfailing powers of imagination which were to distinguish him from so many other illustrators hawking their talents from St Paul's to Temple Bar.

We must not look for much distinction in this early work of his. He was drawing what he was told to draw, on subjects selected by others, and his techniques and styles were those of prevailing fashions or past masters. There is little to interest anyone but the scholar in his work of this period when it is set beside what he was to produce later. From 1811 to 1816 he was employed on a monthly satirical publication entitled *The Scourge* for which he produced 38 plates in all, and in 1815 on a more short-lived journal called *The Meteor*. At the same time he was knocking off occasional illustrations as required–the trade cards, lottery tickets, Valentine cards and other hackwork on which his family had always been employed. The few examples of his work of this period which have survived could have been produced by any artist of average skill.

As for George's political convictions, they, like his talent, were at the bidding of anyone who chose to employ him. The commercial artists of the day were neither encouraged nor inclined to assume grand airs about their role in society; they were there to draw what they were told to draw. So long as the war raged, this meant that George's satirical efforts were directed against the common enemy, and at his own countrymen when they seemed to be impeding the struggle against the French. But after Waterloo, things changed.

Boney Hatching a Bulletin

Boney's Grand Leap à la Grimaldi

Murat Reviewing The Grand Army: hand-coloured etchings, 1812–1813.
These three satirical comments on Napoleon's Russian campaign show why George must have seemed Gillray's natural heir.

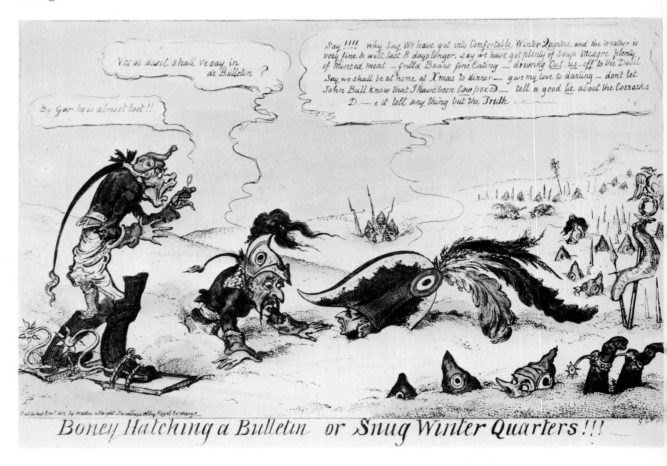

Boney Hatching a Bulletin or Snug Winter Quarters!!!

THE NARROW ESCAPE, or, BONEY'S GRAND LEAP, "a la GRIMALDI" !! — "No sooner had Napoleon aligted, & entered a miserable house for refreshment; then a party of Cossacks rushed in after him. Never was Miss Platoff so near Matrimony !! Had not the Emperor been very alert at Vaulting, and leapt through the Window, with the nimbleness of an Harlequin, while his faithfull

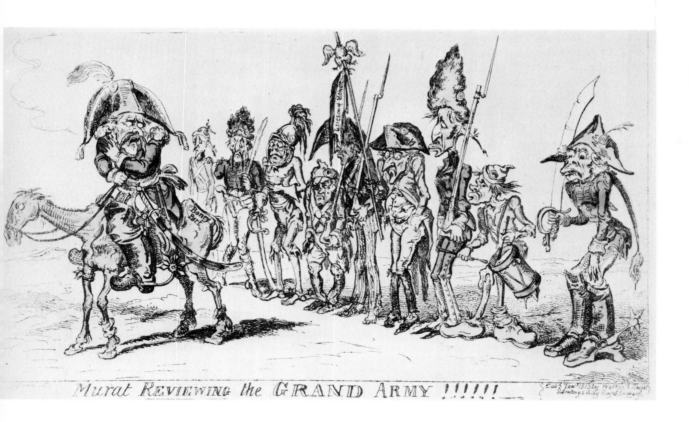

Murat REVIEWING *the* GRAND ARMY !!!!!!

Artist and Craftsman

Every piece of work which George produced, except for a handful of oil paintings towards the end of his life, was intended for reproduction; that is to say, it had to be compatible with one or other of the various printing processes then available. To ensure that his work was suitable the artist had also to be something of a craftsman. Even if he did not himself do the laborious donkeywork necessary to adapt his original drawing for printing, he had to have the technicalities of reproduction in mind while he made his drawing, and design accordingly.

The majority of George's work consisted of etchings; this is true both of his earliest work and of the work which he was to produce at the height of his career. Etching was a laborious process, and George was one of the very few great artists for reproduction to employ it consistently. The reasons will become apparent as we follow his career but, for the moment, let us just see what making an etching actually involved.

He would start by making a rough sketch, perhaps scribbling alternative effects alongside until he felt he had got it all right. When he was satisfied with his design he would trace it carefully with a pencil on to thin or tracing paper. Next, he–or an assistant, meanwhile–would prepare the etching plate which, during his early career, would be of copper. The plate was heated, and on to it was rubbed a lump of wax-like resinous compound; there were various formulae, the one vital property being that it should be resistant to acid. The heat of the plate melted the compound sufficiently to spread a thin layer over the plate–this was called the ground. When the plate was covered all over, it was blackened by holding it over a candle flame or some equivalent.

George or an assistant would then take the plate and the drawing round to the printer (one of the reasons why it was professionally useful to live in the publishing quarter!). Plate and drawing would be placed together between dampened paper, and run through a roller press. The pressure would leave a faint silvery-grey impression of the drawing on the black ground of the plate.

That was the easy part. Now George would set to work to do the actual etching. For this he used a series of sharp steel needles of varying thicknesses, with which he cut through the ground to the copper beneath. As the ground was relatively soft, this wasn't physically difficult. The skill came in controlling the needle so that lines flowed smoothly, and in massing the numerous scratches which formed the shaded areas and created the subtle variations of tone called for by the original design.

When the image had been fully cut, the plate was dipped into a solution, usually of dilute nitric acid. Where the needle had exposed the copper, the acid would start to bite into the metal: elsewhere the plate was protected by the ground. So gradually the acid bit the artist's drawing into the plate.

The biting process could be halted at any time by removing the plate from the acid and rinsing it in water. If George wanted certain parts to be only lightly etched, he would varnish them over; then the plate would go back into the acid–perhaps after some further etching–so that other parts could be more deeply cut. This 'stopping out' process could be repeated as often as he

wished. According to the strength of the acid, he might keep the plate in the bath for anything from one to one hundred minutes.

Then the plate went to the printer again. All that was necessary now was for the printer to coat the plate with ink, then wipe it off; this would leave ink in the cuts which the acid had bitten. When the paper was pressed onto the plate, the ink was taken up, to produce a perfect replica of the original. In transferring the drawing to the plate in the first place, the image would have been reversed; now that it was transferred from the plate to the printing paper, it was reversed back to the right way round again.

Later in his career, George took to using steel instead of copper plates.

Etching on steel example: detail from Windsor Castle

Steel is of course harder than copper, and the acid used previously wasn't strong enough. But in 1824 a man named Turrell concocted a mixture of nitric and other acids, which enabled steel to be successfully used. The result was a deeper and finer line, because the acid didn't spread sideways in the cuts to anything like the same extent as in copper. This is what gives George's maturer etchings their delicate lines and subtle shading. The printer, too, appreciated the development, for the steel plates enabled him to achieve a much longer print run before the plates began to wear out.

Some of George's etchings were coloured–notably the big political prints of his Napoleonic series. The colouring was entirely hand done–colour printing didn't come in until nearly the end of George's career, and as far as is known none of his work was printed in colour during his lifetime. Hand colouring was a tedious business, often done by teams of girls on an assembly line basis, one doing the green, another the red, and so on: you can often see where they went over the edges of the artist's drawing. Under the circumstances, it is surprising how good the colouring often was.

For some of his book and magazine illustrations, particularly during the 1820s, George used wood engraving rather than etching. The great advantage of this, from the publisher's viewpoint, was that the picture could be reproduced on the same page as the text, because a wood block prints in relief like the typematter itself–the ink goes onto the sticking-up bits, not into the cut-in bits. It isn't possible to print the two kinds of print at the same time: a publisher using etched illustrations has to choose whether to cut the words as well as the picture, or print the sheet twice over, or print words and illustration on separate sheets. All these were done, but all were relatively expensive. To etch the words as well as the picture is a lot of hard work, and was done only when the picture was the dominant element and the words not too many–as, for example, on George's Napoleonic caricatures. Printing the sheet twice over was rarely done in Britain. The normal practice was to print the etched illustrations on separate pages, which then had to be stuck by hand into the book before it was trimmed and bound. This was how all George's maturer book illustration work was produced, but of course it added considerably to the cost of production. The publisher, therefore, had to weigh up whether the appeal of providing etched plates was sufficient to tempt the potential purchaser into the additional expense. In the 1820s the name of George Cruikshank wasn't perhaps well enough known, nor had the market for quality illustrated books been properly established and so, during this period, most of George's book illustrations consisted of wood engravings and it was not until 1840 that the etched plates were used to any great extent.

The wood engravings were made by drawing directly onto a piece of hard wood–usually pear or alder–which had been previously whitened with chalk. The rest of the work was done by the engraver, or 'cutter' as he was often termed. Cutting may not have called for the same creative imagination as did the initial drawing, but it was a longer job and required a high degree of skill, so it is not surprising that artist and cutter were generally paid about the same for their respective contribution. What the engraver had to do was cut away all the areas which George had left white, leaving his black portions projecting and, since the black portions were often small and delicate lines, the carving too had to be delicate. The thoughtful artist created his original drawing in the knowledge of what would subsequently happen to it, so that it was essentially a question of teamwork. A good engraver could make all the difference to the job, and in some cases–though we may suppose this happened rarely in George's case–he could positively improve on the original.

Cutting wood block

right: Wood block example: title page to Out and About

Aquatint example: detail from Life in London

Example of Lithograph: In this detail from Gin and Water, *the ability of lithography to simulate the texture of a chalk drawing is clearly shown, but George rarely used this technique.*

When the time came for printing, the wood block was locked into the printing frame together with the typematter, and words and pictures inked together to transfer the image to the paper.

Etching and wood engraving account for the bulk of George's work, but he did occasionally use other techniques. The celebrated plates which he and his brother Robert did for *Life in London* (see pages 44–45) are hand coloured aquatints, a process originally intended to simulate water colour painting. It is essentially a variant of etching, which uses the ground itself, broken by heat to give a mottled surface, to print shaded areas which give the characteristic aquatint look. Outlines and any necessary detail are effected by etching in the usual way.

A few of George's drawings were reproduced by lithography, notably the contrasting prints 'Gin' and 'Water' reproduced on pages 166–167. This is a flat surface process which gives almost perfect reproduction of pencil and chalk drawings, and was generally used for large-format illustrated books. A very few of George's drawings were steel engraved–for example, pages 75 and 78. This was in fact the most commonly used illustrative process for quality books at this period, familiar to all of us through the topographical local views to be seen in every country bookshop. The engraver played a very important part in this process–in the plates we have reproduced, George's characteristic style has vanished almost completely–so it is a blessing that George's publishers seldom used it.

One other process used by George was a rare variant known as Glyphography, which was occasionally used during the 1840s but never became popular. George was probably the only major artist to employ it. However, the use he made of it for his series 'The Bottle' and 'The Drunkard's Children' (pages 128–137) is very impressive, and it is surprising that the process was not more extensively used. Some of the details of the technique are still obscure, but basically it seems that the artist drew onto a metal plate which had first been stained black, then overlaid with a white composition. As George cut through the white with his etching needles, the black showed through just like a drawing. When his drawing was completed, the white areas were built up with additional material, and a relief block made in the form of an electrotype–more or less a mould created by depositing metal into George's etched plate; when removed, it formed a metal relief block to be printed from in the usual way.

Comparing his performance in these various processes, there is not the slightest doubt that George was right to choose etching whenever he could. His work in all media is of interest, but those where it has to be interpreted by some other hand, no matter how skilful, lose a proportion of his individuality, whereas his etchings remain utterly distinctive. His wood engravings for, say, Hone's *Every Day Book* (pages 56–57) are very good, but not easily distinguished from the work of Hone's other contributors: whereas his best etchings are uniquely characteristic.

'Young Artist with a Light Purse'

Once Napoleon had been safely packed off to Saint Helena, England could turn her attention to domestic matters and, at once, issues which had been kept under the lid during the war began to bubble up more vigorously. The England of 1815 was a very different place from the England of 1790; the Industrial Revolution had already started to wreak its changes on the structure of English society in the eighteenth century, and the effect of the war had been to accelerate them. From the end of the war until the passing of the first Reform Bill in 1832, Britain was a battlefield for continual political conflict, and naturally the conflict was reflected in the work of a political caricaturist.

George's political views have been stigmatised as turncoat, his record interpreted as that of a man who was willing to hire his talents to the highest bidder–an out-and-out mercenary. If this were so, it would be in no way extraordinary; a commercial artist was not supposed to be presenting his own views, but giving expression to the views of others. But in fact there is no reason to suppose that George was merely the acquiescent exponent of others' opinions. Beneath the superficial switches of loyalty which appear in his work there is an underlying consistency which explains why he was at one time attacking the Establishment, the Crown and its ministers, and the next taking a swipe at the radicals with whom he had just been allied.

In the light of all that we know of George's character in other respects, such shifts of standpoint can be seen as conforming to a fundamental logic. At no time in his career did George ever feel himself beholden to any man, tied to

The popular comic actor, Liston, as Paul Pry

no party leader's apron strings, a signatory to no set of rigid principles. On every issue he followed his own instinct, sometimes impetuously and even foolishly, but always sincerely and candidly. At heart he was essentially a conservative, not caring for revolutionary change, loving things settled and customary and traditional. But his heart also told him that certain changes were necessary; that settled things were not always settled justly; that a thing was not necessarily right because it was customary, and that traditional authority could easily turn into tyranny. While the war against France was in progress, he cheerfully used his etching needle in the service of patriotism, but now that the war was over, he used it to oppose anyone who threatened the public good, whether the threat came from entrenched authority or maverick dissidents.

William Norris in Bedlam: wood engraving after an etching by Cruikshank 1815.

 Much of George's early work consisted of 'working up' the drawings or ideas of others: this print was based on a drawing by G. Arnald. Professional skill was what Hone was buying, not artistic creativity.

One of his earliest 'reformatory' prints was an engraving based on a sketch by G.Arnald. It showed William Norris, an American patient at the insane asylum of Bedlam, who had been chained to his straw bed for fourteen years. George's etching was made in 1815 for a commission by William Hone, the publisher with whom he was to be most closely associated for the twelve eventful years which followed.

Hone, who was twelve years older than George, was a notable–even a notorious–figure in the political press immediately after the end of hostilities with France. He was, as all London publishers had to be, an opportunist, always on the lookout for what would catch the public's fancy, but he was also a fervent if somewhat erratic idealist, and this led him, in 1817, to be actually tried on a blasphemy charge for publishing attacks on the Establishment. His trials–with which George was not directly involved–were a triumphant vindication of the rights of the individual, and made Hone, rather to his surprise, a champion of popular liberties. Thus encouraged, he went on to publish further and more elaborate attacks on the government which were, as we shall see, to bring the name of George Cruikshank prominently and permanently to the public notice.

Hone's daughter later recalled:

> I think our father's first acquaintance with the artist was his wanting a plate re-touched (either Napoleon or Byron) and Cruikshank was recommended as a young artist with a light purse by (I think) Mr Neely of Sherwood's house. He had been finishing etchings for them of some plates his father had left incomplete . . . Our father took great interest in the young and almost self-taught artist, and encouraged him to the exercise of a talent in which he was unrivalled.

There was a tradition in the Hone family that their connection with George dated from 1811, and the reference to Isaac's unfinished plates would seem to confirm this. However, most scholars prefer to date the association from 1815, the date of the Norris print. In any case, the association was at first only an intermittent one, and George continued to pick up work as and when he could. Various odd items crop up from the 1815-1820 period which show that he was working for half the book and print sellers of London. A representative choice of his work at this time illustrates the variety of commissions he was ready to undertake.

For Caulfield's *Remarkable Characters* of 1819, George was responsible for a number of the pictures of highwaymen, thieves and eccentrics which fill the four volumes. His portrait of the religious enthusiast Thomas Baskerville has a strength derived from a conscious imitation of the old woodcut technique; that of Mrs Sarah Mapp, the noted eighteenth century bonesetter, has a touch of caricature which is more characteristic of the artist. While both are competent, neither is distinguished.

The little figure of Dominie Sampson, from a chapbook published by Hone entitled *Guy Mannering: or, the Astrologer*–apparently some kind of pirated version of Sir Walter Scott's novel–is more evidently in the true Cruikshank style. But he wasn't getting much opportunity to show his real paces; much of his work consisted of things like the etching from Croker's *Cruelties of the Algerine Pirates,* which we would hardly know to be George's work except that his name appears underneath. How many such illustrations, we may speculate, appeared without any such identification and so will never be certainly attributed to him? However, except to scholars, the point is hardly important. Such pictures are interesting as showing the sort of work George was doing at this period, but they have little intrinsic worth. But if there are few premonitions at this time of the supreme book illustrator that George was

Dominie Sampson: etching from Hone chapbook, Guy Mannering *1816*

above: Sarah Mapp, Bone-setter

right: Thomas Baskerville,
Religious Enthusiast:
etchings from Caulfield's
Remarkable Characters
1819

Captain Croker Horror
Stricken at Algiers: etching
from Walter Croker's The
Cruelties of the Algerine
Pirates 1816

CAPT CROKER HORROR STRICKEN AT ALGIERS,
on witnessing the Miseries of the Christian Slaves chain'd & in Irons
driven home after labour by Infidels with large Whips. Page ibid

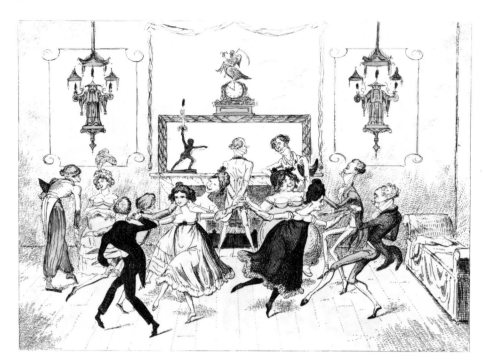

An Elegant Quadrille: hand-coloured etching 1817

to become, some of his one-off prints are more indicative. 'An Elegant Quadrille' and 'The Cholic' are typical of the sort of prints that were filling the print-shop windows which had previously exhibited attacks on Bonaparte, and though it was to be some years before publishers realised that it was in this direction that George's best talents lay, they must have contributed to the consolidation of his reputation as one of the most promising young artists of the day.

The Cholic: hand-coloured etching 1819

'What are you going to do with this, George?'

On the 26th of January, 1819, an event occured to which George was always to attach great importance. For us, too, the incident is interesting, though for not quite the same reason. Let us start with George's own account of the matter, in a letter to a friend named Whitaker:

> About the year 1817 or 1818 there were one-pound Bank of England notes in circulation, and, unfortunately, there were forged one-pound notes in circulation also; and the punishment for passing these forged notes was in some cases transportation for life, and in others DEATH.

> At that time I resided in Dorset Street, Salisbury Square, Fleet Street, and had occasion to go early one morning to a house near the Bank of England; and in returning home between 8 and 9 oclock, down Ludgate Hill, and seeing a number of persons looking up at the Old Bailey, I looked that way myself, and saw several human beings hanging on the gibbet opposite Newgate prison, and, to my horror, two of these were women; and, upon inquiring what these women had been hung for, was informed that it was for passing forged one-pound notes. The fact that a poor woman could be put to death for such a minor offence had a great effect upon me—and I at that moment determined, if possible, to put a stop to this shocking destruction of life for merely obtaining a few shillings by fraud.

> I went home, and in ten minutes designed and made a sketch of this 'Bank-note not to be imitated'. About half an hour after this was done, William Hone came into my room, and saw the sketch lying upon my table; he was much struck with it, and said, 'What are you going to do with this, George?'

> 'To publish it,' I replied. Then he said, 'Will you let me have it?' To his request I consented, made an etching of it, and it was published. Mr Hone then resided on Ludgate Hill, not many yards from the spot where I had seen the people hanging on the gibbet: and when it appeared in his shop windows, it created a great sensation, and the people gathered round his house in such numbers that the Lord Mayor had to send the City police (of that day) to disperse the crowd. The Bank directors held a meeting immediately upon the subject, and after that they issued no more one-pound notes, and so there was no more hanging for passing forged one-pound notes; not only that, but ultimately no hanging, even for forgery. After this Sir Robert Peel got a Bill passed in Parliament for the 'Resumption of Cash Payments'. After this he revised the Penal Code, and after that there was not any more hanging or punishment of death for minor offences. . .

> I consider it the most important design and etching that I ever made in my life; for it has saved the lives of thousands of my fellow-creatures; and for having been able to do this Christian act I am indeed most sincerely thankful.

George wrote that account in 1875, when he was in his eighty third year: so it is not surprising that one or two factual details are incorrect, and it could be a simple slip of memory which made him omit to mention that a Royal Commission had issued a report recommending the printing of less easily counterfeited notes just four days before the event he describes.

What is more significant is the question of responsibility. Hone himself claimed that the bank-note parody was *his* idea, and that he dashed off a rough sketch which George subsequently worked up. Certainly a rough

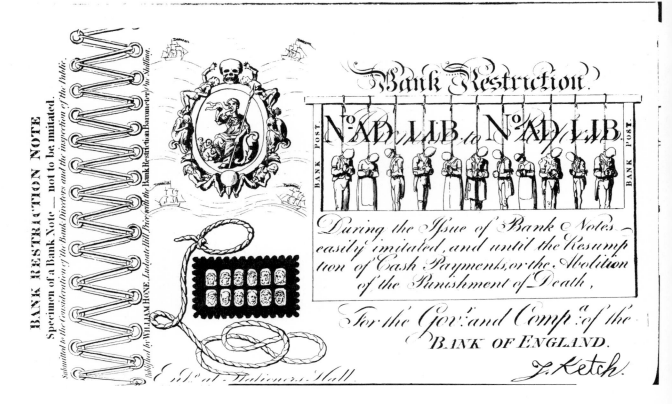

Bank Restriction Note: etching 1819

sketch by Hone existed, though of course there is no evidence that this was the first intimation of the project.

The question of who was really responsible for the idea is not in itself very important; a good many of the ideas on which George worked must have sprung out of casual conversation, an exchange of ideas with publisher or author after which it was hardly possible to say who had contributed most. But the bank-note matter was only the first instance we shall encounter of George making rather wider claims to authorship than he truly merited, and we may as well face up here and now to this quaint defect in the artist's character. As we shall see, on later occasions his claims led to more serious disputes with others who were less sympathetic than the tolerant, easy-going Hone who, we may be sure, didn't give a damn who got the credit for the idea.

These inflated claims constitute one of the few blemishes on George's otherwise honest and generous nature. What motives, what impulses inspired them? I think we can start by at once ruling out any question of deliberate dishonesty. From all that we know of George's character, it would have been totally against his nature to lay claim to something when he knew the facts to be otherwise. So if deceit there was, the first to be deceived was George himself.

I suggest that the unconscious motivation sprang from two causes. First, we should remember that the world of the commercial artist, even the artist who had proved his ability, was always a highly competitive one. The rewards were not high, the artist needed a continual supply of commissions, a good name was essential to sustain the flow of work. Even at the height of his career, George could never have entirely lost the feeling of insecurity: for were there not younger artists coming up all the time to threaten his livelihood? So at every stage of his career, he was anxious to obtain all the

credit he could muster–from which it is but a short step to claiming credit to which he was not fully entitled.

The second cause is a deeper and more personal one. The ambition which he once expressed in the words 'drawing and painting to prevent evil and try to do good' was the supreme driving-force of his existence. Naturally and inevitably, he craved tangible results as proof of the worth of his work. Again, it was but a short step to claiming that because a certain reform took place *after* his protest, it took place *as a result of* his protest.

Whatever his motives, it was not a serious fault and not hard to forgive. I dare say his friends winked at one another behind his back, as much as to say, 'There goes old George again, claiming other men's flowers as his own. . .'

Whoever had the inspiration, the Political Banknote was a tremendous success. Hone is said to have made more than £700 by it, though this figure is supplied by George himself and may be an exaggeration! In the absence of any definite figures, it is hard to know what to believe, but one thing is certain, this and other political squibs produced by the Hone-Cruikshank partnership sold in prodigious quantities. Mackenzie comments:

> There was a rush and a crush to get them. Edition after edition went off like wildfire. Of some, as many as a quarter of a million copies were sold.
>
> (Quoted in Jerrold's Life)

and Thackeray wrote:

> There used to be a crowd round the window in those days, of grinning, good-natured mechanics, who spelt the songs, and spoke them out for the benefit of the company, and who received the points of humour with a general sympathising roar.

If we believe the facts as they are sometimes stated, Hone must have made about £12,000 from his more successful ventures, of which he had to pay George, who is said to have been paid at the rate of half a guinea a plate, some £10, leaving the publisher with a net gain about a thousand times as great as his artist's. How are we to make any kind of sense of this, especially when there is no record that George, never backward in claiming his rights, ever suggested that Hone treated him unfairly? I think we must assume, at the very least, that George considered he was getting fair payment for his work, for both his personal friendship and his working relationship with Hone were happily maintained over several years.

Much of the point of the political pamphlets they produced together has been blunted by time, but we can still admire the vigour of George's drawings–George, Prince of Wales and subsequently King, in a devastating variety of ignominious situations; poor Queen Caroline, whom George, in common with most ordinary folk, saw as a much-abused lady; Count Bergami, a reluctant witness at Caroline's trial; the forces of Law and Order deployed against the man in the street at Peterloo.

In 1820, when George succeeded to the Throne, both Robert and George Cruikshank accepted money from the Crown in return for a promise not to depict the new King in any immoral situation. The circumstances of this curious transaction are obscure; while it seems that the payment to Robert was in respect of a specific picture, there is no indication that the same applied to George. £100 was a great deal of money in those days, and the size of the bribe constitutes something of a tribute to the effect of his caricature work.

Was it in return for this payment that George produced his fine caricature of George IV as Coriolanus, boldly facing the radical opposition (among whom can be seen Hone and George himself)? Or does the print represent a

left: George IV:
Give Not Thy Strength Unto
Women, Nor Thy Ways to
that which Destroyeth Kings

right: Non Mi
Ricordi–Count Bergami in
the Witness Box

far right: Caroline Suffers
while her Husband Enjoys
Himself: wood engravings
from The Queen's
Matrimonial Ladder,
published by Hone 1820

Give not thy strength unto women, nor thy ways to that which destroyeth kings.
Solomon.

Coriolanus Addressing The
Plebeians: hand-coloured
etching 1820.
 George IV confronts the
radicals outside Carlton
House. George has depicted
himself on the far right,
holding a portfolio of
caricatures, and next to him
is Hone with a cudgel on
which are inscribed the titles
of two of his anti-
establishment squibs. The
'Black Dwarf' and other
radicals are also included.

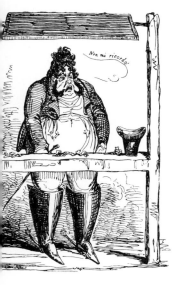

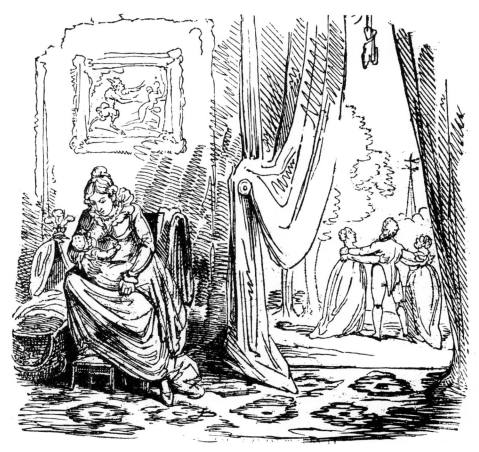

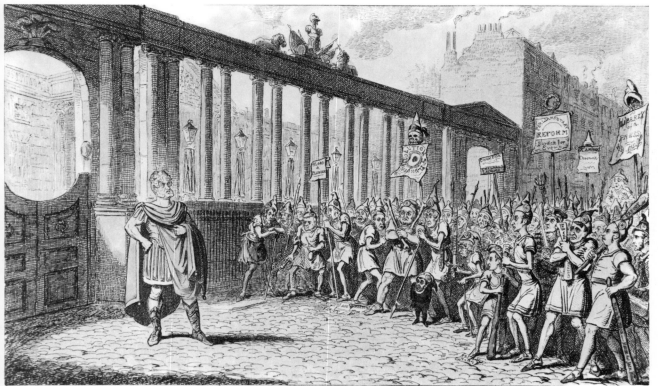

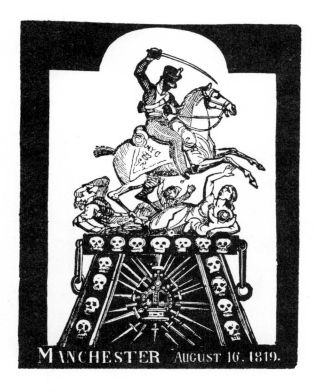

VICTORY OF PETERLOO.

A MONUMENT is proposed to be erected in commemoration of the achievements of the MANCHESTER YEOMANRY CAVALRY, on the 16th *August*, 1819, against THE MANCHESTER MEETING of Petitioners for Redress of Wrongs and Grievances, and Reform in Parliament. It has been called a *battle*, but erroneously; for, the multitude was *unarmed*, and made no resistance to the heroes *armed*; there was no contest—it was a *victory*; and has accordingly been celebrated in triumph. This event, more important in its consequences than the Battle of Waterloo, will be recorded on the monument, by simply stating the names of the officers and privates successfully engaged, on the one side; and on the other, the names of the persons killed, and of the six hundred maimed and wounded in the attack and pursuit; also the names of the captured, who are still prisoners in His Majesty's goals; with the letter of thanks, addressed to the victors, by His Majesty's Command.

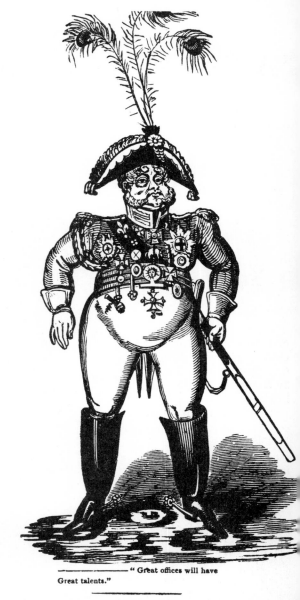

"Great offices will have Great talents."

This is THE MAN—all shaven and shorn
All cover'd with Orders—and all forlorn;

This is the Man all Shaven and Shorn: wood engraving from The Political House that Jack Built *published by Hone 1821*

left: The Victory of Peterloo: wood engraving from A Slap at Slop *1822*

swing of the pendulum, a feeling by the essentially patriotic George that opposition must be checked before it turns into extremism; that, for all his faults, the King deserved some respect for his position if not for his person? Certainly, neither this drawing nor his acceptance of the royal payment meant that George had deserted his reformist friends. It was in the following year that he depicted the Monarch as 'the man all shaven and shorn' in *The Political House that Jack Built* and a year after, in *A slap at Slop,* that he ferociously published his design for a monument to the 'Victory' of Peterloo.

George might legitimately take some of the credit for the gradual improvement in political conditions which came about in the 1820s and which were to culminate in the Reform Bill of 1832. But as the crisis passed, so did the urgent need for his involvement. Henceforward his reforming zeal was directed against social rather than political targets, and was a fuller expression of his pervading sympathies.

'A Couple of Boobies'

Sparring Match at the Fives Court: etching by George Cruishank, from a drawing by Robert, for Egan's Boxiana *1813.*

An interesting example of collaboration between the brothers, on a scene which represented the tastes and interests of both of them at this period.

'Take the pencils out of my sons' hands,' their mother declared, 'and they are a couple of boobies!' She cannot have been anything but proud of the way in which both of them had followed so successfully in their father's footsteps, but she may well have shaken her presbyterian head at the wild and carefree life they led during their teens and early twenties. No doubt their success encouraged them to make the most of life in London, and we may presume they were not short of cash. But we do not hear of them indulging in the more disreputable excesses of the day; they didn't go in for gaming to any notable extent; they were involved in no sexual scandals; there is no record of their ever having run foul of the law. None the less, they had a wide first-hand acquaintance with the seamy side of London life; they were on familiar terms with the bare-knuckle boxing champions of the day and with actors like Edmund Kean—and neither the boxing ring nor the stage were considered respectable haunts during this period of history.

Heavy drinking, on the other hand, was so habitual as almost to pass unnoticed. It is significant that when in 1823 John Wilson wrote an article in *Blackwood's Magazine* about George's work, he took the opportunity to offer a little moral advice from a fellow-countryman—he recommended George, in his own interests, to moderate his drinking to a bottle a night!

Hone's daughter was to recall:

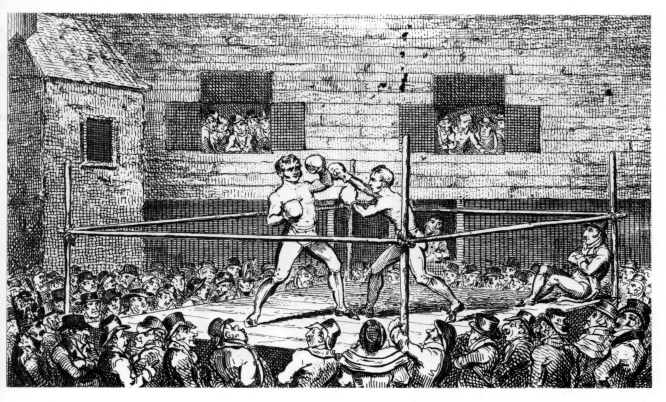

Both our mother and father sought to draw him from the loose companionship he indulged in, by keeping him at home in the evenings, and often to sleep–he was the only one our mother had a bed made up for.

Sometime around 1820, Robert married. The whole Cruikshank family seem to have moved to King Street, Holborn, but soon Robert and his wife went to St James Place, a very fashionable address compared with any the family had known hitherto. Here it was his intention to set up in business as a portrait painter; we know even less about Robert's life than we know of George's, so how successful his venture was we do not know. But a trickle of illustrated work continued to appear over his signature, so even though he was overtaken by the growing fame of his younger brother, he seems to have maintained himself in reasonable comfort.

During this period when Robert was married and George was not, George seems to have continued his carefree course of life. It is reported that when he visited his brother's house, his sister-in-law felt obliged to seize him, wash him and comb him! George, Eliza and their mother seem to have moved at about this time to Claremont Square, Pentonville, near Sadlers Wells and The Angel, Islington. This suburb, still picturesque if somewhat decrepit today, was then on the outskirts of London, within easy reach of the

Robert Cruikshank: etching.
Possibly a self-portrait, possibly by his brother. Either way, the family likeness is very noticeable.

Eliza Cruikshank: drawing by George Cruikshank.
We know so little about Robert and George's sister that it is good to have this slight memorial.

country. In this district George was to live for the rest of his life.

Scattered hints continue to be all we have of George's way of life, but a portion of a letter written by Hone to George's mother raises interesting speculations:

> Ludgate Hill, 8 July 1822
>
> Whatever of kindness I entertain, and I entertain much, for your son George, has been from admiration of his talents and respect for his honourable disposition. For everything that could diminish either of those qualities, I have expressed to him not only deep regret, but remonstrated with him more severely than anyone but a sincere friend, feeling deeply for his best interests and real welfare, would venture to do. If he has, as you say, left your house for three years, you must be better acquainted with the reason for his seeking a home elsewhere, than I am.

The implications are tantalising, and encourage all kinds of conjecture. The very fact of such a letter having been written at all suggests that Mrs Cruikshank, out of touch with her son, was writing in reproach if not appeal to the man she knew played an important role in George's life. To judge by the formal language Hone uses, he was not on close terms with Mrs Cruikshank, and we get the impression that he is answering charges, whether open or implied, of being accessory to George's desertion of his home, if not of positively alienating his affections. Knowing Hone's public reputation, it would not be at all surprising if she disapproved of him and his association with her son, and she probably did not know—as no doubt many people did not know—that when Hone wasn't publishing his savage attacks on the Establishment, he lived a blamelessly respectable family life with his wife and daughters, professed temperance, and loved above everything to lose himself in antiquarian research!

We may also deduce, despite what some of his biographers have asserted, that George was not yet married in 1822. Had he been so, his mother would hardly have continued to regard him as being under her nominal authority—after all, he was now thirty years old! I would also suggest—though this can be no more than conjecture—that Hone knew more about his protegé's conduct than he is willing to admit to Mrs Cruikshank: that last sentence of his is more an evasion than a denial of knowledge. It is evident that some circumstances had driven a wedge between George and his mother. If it had been a marriage of which for some reason his mother disapproved, then there would have been no occasion for Hone to refer so vaguely to a 'reason for seeking a home elsewhere'.

I suggest, therefore, that George was at this time living in circumstances of which his mother, and perhaps even his publisher, were unlikely to approve—and that Hone knew about it and his mother did not. It seems most likely that this took the form of living with some woman to whom he was not married, and it seems unlikely that she was his future wife Mary, for we know that when he did marry, he and his wife came to live just round the corner from the family home.

Such speculations are amusing, but hardly important. In the almost complete absence of solid fact, however, we are driven to seize upon any clue and wring from it any nourishment we can get. All these scattered, insubstantial hints are nothing in themselves, but what is significant is that they all point in the same direction. It is abundantly clear that George was living a life, not of debauchery and excess, but certainly of wild and careless abandon, and, in so doing, was acquiring, at first hand and in intimate detail, the experience that was to make him the undisputed visual delineator of low life in London.

'Life in London'

Robert and George were able to put their knowledge of 'life in London' to brilliant use in their illustrations to a book with precisely that title. Eight years previously, the two brothers had provided some of the illustrations for Pierce Egan's *Boxiana, or Studies of Ancient and Modern Pugilism:* now they were invited to provide the pictures for a broader work by the same writer, *Life in London, or the Day and Night Scenes of Jerry Hawthorn Esq and his Elegant Friend Corinthian Tom, in their Rambles and Sprees through the Metropolis,* published in twelve monthly parts commencing October 1820.

Nothing could have been more suited to the brothers' tastes, and the thirty six coloured aquatints are an astonishing record of life in the London of the day. It is hardly a comprehensive picture. The scenes are chiefly of low life, or dissipated life, or vulgar life–and always of leisured life, unspoilt by anything so tedious as work. Egan takes his protagonists to gaming houses and taverns, theatres and low coffee houses, police courts and cockfights. His illustrators follow in his steps, depicting each scene with a vividness of detail that could come only from first-hand observation. It all adds up to an unmatched panorama of the fleshpots of Regency London.

Jerry in Training for a Swell

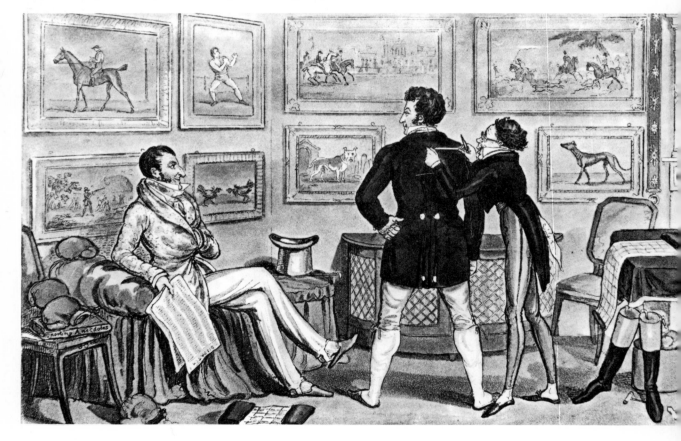

*Making the Most of an
Evening at Vauxhall*

Getting the best of a Charley

*Coffee Shop near the
Olympic Theatre: hand-
coloured aquatints by Robert
and George Cruikshank
from Egan's* Life in London
1820–1821

The accounts of how the book came to be written vary and so do the attributions of credit. Moncrieff, one of the many who adapted the book for the stage, insisted that the three main characters were intended to represent Egan and the two Cruikshanks. Even if this were the origin of the book, the author must have used his poetic licence to the full, if only in that the heroes of the book are made to find out about life in London the hard way, whereas their creators had grown up in the midst of such scenes and had no need to suffer so violent an initiation. Nor, just because they depicted such scenes, need we assume that they took an interest in ratting or cockfighting, that George ever overturned a watchman's hut or bailed out a prostitute at the Bow Street Magistrate's Court.

The book was published by Sherwood, Neely and Jones of Paternoster Row, and was published–as was the custom for expensively illustrated books–in parts which came out about once a month; each part included three of the aquatint plates. The new King gave permission for the book to be dedicated to him–a most appropriate gesture, given its subject matter–and this is reflected in the fact that one of the final plates shows the *ne plus ultra* of life in London, a visit to Carlton House where George IV lived. There is no indication which plates are by Robert, which by George. The general consensus of opinion is that the greater number are Robert's work, but the grounds for this opinion are unknown to me. There is no detectable difference in style which would enable us to award the plates to one or other brother. It is even possible that the two of them collaborated on each plate, as they had done, for instance, on the sparring match in *Boxiana* (page 41)–each doing whatever he was best at.

The book was an immediate and tremendous success. Egan's lively and racy text, so full of current slang and colloquialisms as to be almost unreadable to us, must have made the same esoteric appeal as hippy or pop language today, giving the reader the sense that he too had been admitted to the select fraternity of 'fast' men. Edition succeeded edition, and the book was transferred to the stage in several competing versions, some of which played simultaneously. The copyright situation was very much looser then than now, and those who adapted the book for the stage freely drew their inspiration from the Cruikshank illustrations without acknowledgement and without payment. It is however alleged that George did some scene painting for one of the dramatic versions, and also that he painted a pub sign for the actor Walbourn, who played the character of Dusty Bob in one of the stage versions–he was the proprietor of the 'Maidenhead' pub at Battle Bridge, and George depicted him in his role.

To what extent the brothers profited financially by the success of the book is unrecorded: it was usual for the publisher to agree a set payment for the illustrations, irrespective of the number of copies sold, but as the success of the work became apparent as month succeeded month, the brothers may well have requested and probably received additional payment. But their triumph had a more important consequence than any short-term profits; it established them as among the leading illustrators of the day. From this time on, George Cruikshank and his work were known to every publisher in England.

Naturally, the publisher's first thought was for a sequel. This was, inevitably, *Life in Paris,* in which, for reasons unknown, all the illustrations are George's work. Inevitably, it lacks the intimate observation that the London book offers but, considering that George had never visited Paris and was dependent wholly on his own imagination combined with visual references supplied by others, this book too is an astonishingly effective sequel.

The progress of the TRIO was interrupted for a short period, in their way to *Corinthian-House* through the streets, with the following dialogue between a *costard-monger* and " his *voman*," whose *donkey* had accidently slipped one of his feet into a plug-hole.

Donkey Caught in a Pug Hole: wood engraving from the same book

Gaming in the Palais Royal: hand-coloured aquatint by George Cruikshank from David Carey's Life in Paris *1822*

'Our gay friend must pull up'

Life in London made George sufficient of a public figure to inspire an article in the prestigious *Blackwood's Magazine* in July 1823. The articles in this journal were unsigned, but this piece is generally ascribed to Professor John Wilson, though others have attributed it to Sir Walter Scott's biographer, Lockhart. Whoever wrote it, it must have been extremely gratifying to the thirty one year old artist to have his work treated at such length and in such terms, despite the admixture of moral censure which the author took it upon himself to throw in for good measure:

> It is high time that the public should think more than they have hitherto done of George Cruikshank; and it is also high time that George Cruikshank should begin to think more than he seems to have done hitherto of himself. Generally speaking, people consider him as a clever, sharp caricaturist and nothing more–a free-handed, comical young fellow, who will do anything he is paid for, and who is quite contented to dine off the proceeds of a 'George IV' today, and those of a 'Hone' or a 'Cobbett' tomorrow. He himself, indeed, appears to be the most careless creature alive, as touching his reputation. He seems to have no plan–almost no ambition–and, I apprehend, not much industry. He does just what is suggested or thrown in his way, pockets the cash, orders his beef-steak and bowl, and chaunts, like one of his own heroes–
>> Life is all a variorum,
>> We regard not how it goes.
> Now, for a year or two, to begin with, this is just as it should be. Cruikshank was resolved to see *life*;and his sketches show that he has seen it, in some of its walks, to purpose. But life is short, and art is long, and our gay friend must pull up.

Whether this article appeared at a critical juncture in George's life, or whether he was shocked by it into a re-examination of his life, we can but speculate. From now on, in any case, we start to feel that George has taken a more direct control over his affairs; though ready to do all kinds of work for all kinds of publishers, some kind of selectivity seems to be at work. For one thing, the political squibs become a thing of the past, comment on public affairs is replaced by more general social criticism. And we feel that he is beginning to know what he's best at–perhaps he allowed himself to be guided by another article which appeared in *Blackwood's* the following year:

> George Cruikshank is an exquisite humourist. In low London life, above all, he is admirable. He seems to have given his days and his nights to the study of that portion of human nature which is to be contemplated in the glorious atmosphere of round-houses. . . Who, like him, for a Charlie–a lady of the saloon–a gentleman of the press–or a pick-pocket? Take him off the streets of the east end, however–bar him from night-cellars, boxiani, and flash–and George sinks to the ordinary level of humanity. There is only one other sort of thing he does like himself–and this is the pure imaginative outré. . . This artist's poverty is visible whenever he attempts 'the Gentlemen of England'–there he is out of his own sphere. He cannot hit the quiet arrogance of the only true aristocracy in the world–he cannot draw their easy, handsome faces, knowing, but not blackguard, proud, kind, scornful, voluptuous, redolent in every lineament of high feeling, fifteen claret, and the principles of Mr Pitt. He can do a dandy, but he cannot do the thing!

Maybe it piqued George to be told he should keep away from the upper classes–but he seems to have followed the advice, if only because it echoed his own inclination. At the same time, he may have been encouraged by the suggestion that his other forté was 'the pure imaginative outré'. From now on he starts to explore the world of fantasy in which he had scarcely set foot hitherto, and soon emerges as its finest delineator.

As for Blackwood's other charge, of lack of industry, if it was ever valid, it was never to be so again. From now on, and for the rest of his life, sketches and drawings and etchings and engravings were to flow from his work table as though from an assembly line. A rough calculation based on his attributed work shows that he must have produced on average an illustration of some kind every three days of his life, week in and week out, working days and holidays, and if some of these were hastily dashed-off sketches, the count also includes his paintings and such elaborate set pieces as 'The Triumph of Cupid' and 'The Worship of Bacchus'–the latter of which occupied him for more than a year. Never again could he be accused of having 'not much industry'!

Sometime about 1823, George must have married. Beyond the fact that his wife's name was Mary; that at least one visitor to their home refers to her as possessing 'charm'; and that, to judge by one of George's self-portraits (see page 119) she seems to have owned a pet spaniel, we know nothing whatever about this first marriage. We may at least surmise that it contributed to the new stability of George's life, even though, as we shall see, it did not entirely cure him of his wayward inclinations.

Mary Ann Cruikshank: Pit, Boxes & Gallery from The Sketch Book *1836* (see page 39). *The Desecration of the Bright Poker from* The Comic Almanack *1847* (see page 108).

Is it venturing too much to suggest that the female companion with whom George has depicted himself is his first wife Mary?

Changes in street naming and numbering have brought a certain confusion to the question of where exactly the Cruikshanks lived, but their address seems to have been 22 Myddelton Terrace, Amwell Street, Pentonville until about 1835 when it changed to No 23. The two houses (now 69 and 71 Amwell Street) appear to be identical, so I cannot imagine why he should want to move next door. Their new home was just round the corner from the old family home in Claremont Square, so George evidently fancied the neighbourhood. When he married, however, his mother seems to have moved out to Finchley, where she lived for the rest of her long life. Robert was still living in St James' Place; there is no further mention of their sister Eliza, who died in 1825 aged only 18.

And so, married and settled, and with his professional ability firmly established by *Life of London,* he was all set to give the public good cause 'to think more than they have hitherto done of George Cruikshank'.

Angels and Fairies

By the time the last number of *Life of London* appeared in 1822, George, now thirty years old, had found his feet as an artist. He was to spend the next ten years discovering in which direction he should let them carry him.

One might have expected *Life in London* to be followed by a spate of successors–other social surveys thinly disguised as picaresque novels would not have been difficult to devise. But, apart from *Life in Paris,* there were no sequels. Instead his talents were called upon for a wide variety of subjects. In a sense it seems a waste of those talents, but in another, eventually more important sense, it was the best thing that could have happened. For by being compelled to try his hand at a wide range of subjects George was able to learn where his talents would find their greatest scope.

There was a danger, of course, which was that George did almost everything well. Throughout his long career we can hardly point to a single out-and-out failure. Even in ventures the least suitable to his abilities, he is able to add some touch of originality, play some individual variation on a familiar theme, which gives it a unique interest. So it was with much of his work of the 1820s. Nevertheless, there were some solid indications as to where his best hopes might or might not lie.

Sometime before 1825 he was invited to submit specimen illustrations for an edition of *Paradise Lost*. He produced two specimen plates, of which one, showing Satan calling up the rebel angels, he was later to refer to as the best drawing that he ever did in his life. Unfortunately the scheme fell through, and even those two drawings are as lost as paradise itself–we shall never know how accurate his self-assessment was. On the face of it, we might say that he was not the right artist for the work nor perhaps was it the right subject for him. But that is reasoning in the light of what we know he went on to do. Had the project come off, it might have turned his art–at this point in his career when his talents were still malleable–in a wholly different direction. We might have had our own English Doré, an illustrator of a wholly different cast than the future collaborator with Ainsworth and Dickens.

Instead, he was asked to produce a series of aquatints for a life of Napoleon, based on paintings by Vernet–paintings very much in the French grand manner. The results are extraordinary, and reveal a total misconception of George's abilities. But even so, they show a new facet of his genius, one which was to emerge triumphantly twenty years later when he depicted the Irish Rebellion of 1798 (pages 119–121).

More immediately successful were his illustrations for popular tales translated from the German of Grimm, Chamisso and De la Motte Fouqué. Years later, Ruskin was to write of these etchings:

> If ever you happen to meet with two volumes of Grimm's German Stories, which were illustrated by Cruikshank long ago, pounce upon them instantly: the etchings in them are the finest things, next to Rembrandt's, that, as far as I know, have been done since etching was invented.

Praise indeed, and praise that was echoed by many other discerning critics. Writing in 1840 in the *Westminster Review,* Thackeray was to say, 'We

Napoleon and Augereau in the heat of the tremendous Battle of St. George: aquatint after Vernet 1823.

A curious piece of hackwork of the kind George would soon be able to leave behind him. The pompous paintings of Vernet could not of course be reproduced without being engraved; but reducing them to aquatints–a technique evolved to simulate water-colour painting–seems calculated to destroy most of their original impact.

below left: The French Repulsing a Mameluke Charge: wood engraving 1823.

George also illustrated a less pretentious life of Napoleon, for which his drawing style was more appropriate.

below: The Elves and the Cobbler: wood engraving from an etching from Grimm's Household Tales *1824.*

One of George's first essays in a genre which he was to make especially his own, and which was to be so admired by Ruskin. These illustrations did more than any other to establish George as an illustrator.

preferred his manner of 1825 to any which he has adopted since.' This observation was made before George produced his finest book illustration, and it is not unlikely that Thackeray might have found reason to revise his judgement, yet it is one that is shared by many. William Bates, for instance, writing in 1878, says, 'Looking at these excellent etchings I am disposed to regard George Cruikshank as then at his best, and question whether he made any absolute advance after this early epoch'. Certainly, here in these fairy illustrations one can, perhaps for the first time, confidently recognise what might be termed 'the Cruikshank style'–for though he had many styles, the combination of fantastic detail within a satisfying harmonious framework which we discern in these etchings was to be the dominant characteristic of his work all his life.

If today we are more prone to admire his social commentary than his flights of fancy, this is perhaps simply the swing of fashion. Ours is a socially hypersensitive age, and it is his eye for the nuances and niceties of human behaviour which impresses us most. Personally, I have no hesitation in preferring his more mature work, and even among his work in the 1820s I would rather have such slight things as the series of street characters he did for the *Gentleman's Pocket Magazine* in 1827–modest, unobtrusive sketches but brilliantly observed. It was, after all, Thackeray again who said of George that he was 'a man of the people if ever there was one'. But it would be a mistake to overlook the importance of the Grimm illustrations in George's artistic development, for here is the 'pure imaginative outré' which Professor Wilson had called for. Fairy themes were to crop up intermittently throughout his life and inspire some of his most brilliant compositions–his very last etching was to be an illustration for a fairy story.

below right: The Jolly Beggars: wood engraving for Burns' poem in Points of Humour *1823*

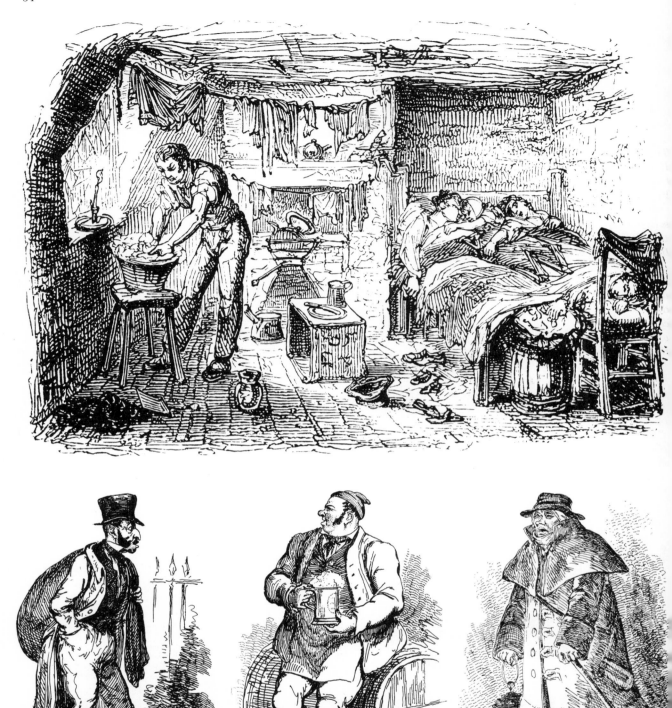

OLD CLOTHES MAN. BREWER'S DRAYMAN. WATCHMAN.

'Cruiky's Droll Designs'

The Widower and his Family: wood engraving from Wight's Mornings at Bow Street *1825.*
One of George's earliest scenes from everyday life, this beautifully observed little vignette marks a great step forward from Life in London *and foreshadows the wonderful observations of daily life which were to come. It is on record that he was paid 2 gns each for these drawings.*

For a while George continued to be closely associated with William Hone, though the unequalness of their partnership had been shrewdly perceived by an anonymous lampoon of as long ago as 1820 addressed to Hone:

> I grant exceptions sometimes may occur;
> for instance, such dull boggling slang as *you* sell,
> however coarse, attention would not stir
> nor barrow-women of their pence bamboozle,
> without a wood-cut to explain the sense,
> and help along its lame incompetence.
>
> Therefore the wisest job that ever you did
> (next to your well-known 'Trial' and 'Subscription')
> was your flash bargain with a wag concluded,
> to aid your threadbare talent for description.
> For who, in fits at Cruiky's droll designs,
> can stay to criticize lop-sided rhymes?
>
> Make much of that droll dog, and feed him fat:
> your gains would fall off sadly in amount
> should he once think your letter-press too flat,
> and take to writing on his own account.
> Your libels then would sell about as thick, sir,
> as bare quack labels would without th'elixir.
>
> *Slop's Shave at a broken Hone*

left: Old Clothes Man, Brewer's Drayman, Watchman: etchings from The Gentleman's Pocket Magazine *1827*

Cruikshank and Hone: woodcut from Facetiae & Miscellanies *1828.*
The idea for the drawing came from Hone. George depicts himself drawing on a wood block.

Perhaps the partnership would have dissolved in any case, whether due to the cooling-down of the political crisis which had inspired their most noteworthy joint efforts, or because Hone's interests were now swinging more towards antiquarianism. In 1825 he planned an *Every Day Book,* which was to come out as a kind of almanack at 3d a week or 1/- a month, with brief printed items relating to all manner of subjects associated with the date–it was no more than an excuse for an omnium gatherum of miscellaneous scraps, like the 'bedside books' of more recent times. The text is illustrated with wood engravings, and eleven of these are George's work.

It seems to have been an extremely friendly working relationship. There is an account of Hone, Cruikshank and William Hazlitt meeting at the Southampton Coffee House in Chancery Lane (George here at least drank something stronger than coffee) where the artist would dip his finger in his ale and sketch his suggestions on the table top. For the topical subjects, they would set off together on expeditions, as when they went to Mr Cross's Menagerie in Exeter Change so that George could make his sketch of the dead elephant. In May they went to the Pied Bull at Islington, associated with Sir Walter Raleigh, and under the influence of a vast quantity of drink drew up a memorandum which is worth quoting in full as a personal sidelight on George's private life at this period:

> Pied Bull, Islington
> 21 May 1825
> Memorandum made on the spot, by us the undersigned, now assembled for the purpose of looking at this house, previous to its being pulled down. That we have done so, and each of us smoked a pipe, that is to say, each of us one or more pipes, or less than one pipe, and the undersigned George Cruikshank having smoked pipes

Dead Elephant at Cross's Menagerie, Exeter Change

innumerable or more or less–and that each of us did cause to be brought, or did bring, to wit, by and through the undersigned David Sage, whose father, David Sage the elder, is about to pull down the house, many to wit, several pots of porter, in aid of the said smoking, and that the same being so drunk, he, the said David Sage, at the suggestion, and by desire of the not so undersigned, brought wine, to wit, port wine at 3/6 per bottle (duty knocked off lately) wherewith, and with other ingredients, bowls of negus were made by the undersigned William Hone and partaken of by each of us–the first toast being given 'To the Immortal Memory of Sir Walter Raleigh'. Intervening sentiments and toasts being expressed and drunk, the next of importance was the Country of Sir Walter and ourselves–'Old England'. We, the first three undersigned, came here for the high veneration we feel for the memory and character of Sir Walter, and that we might have the gratification of saying hereafter that we had smoked a pipe in the same room that the man who first introduced tobacco smoked in himself. The room in which we do this, is that described in the Every-Day Book of this day by W.H. In short, we have done what we have said, and there is nothing more we can say, than this, that as Englishmen we glory in the memory and renown of our revered countryman.

William Hone, Chairman

George Cruikshank

Joseph Goodyear

David Sage

(Goodyear was a wood engraver employed by Hone to cut the drawings for the book.)

Apart from such convivial expeditions, Hone expressed his affection for George by praising, in almost fulsome terms, any engraving of George's that appeared in the book. Thus of The Barrow Woman who appeared in July 1825, he writes:

The London Barrow Woman

The London Barrow-woman

See! cherries here, ere cherries yet abound,
With thread so white in tempting posies ty'd,
Scatt'ring like blooming maid their glances round
With pamper'd look draw little eyes aside,
And must be bought. *Shenstone.*

Mr George Cruikshank, whose pencil is distinguished by power of decision in every character he sketches, and whose close observation of passing manners is unrivalled by any artist of the day, has sketched the barrow-woman for the Every-Day Book, from his own recollection of her, aided somewhat by my own.

That last modest phrase may well conceal a more sizeable contribution. According to Hone's daughter:

In all the work he executed for William Hone, our father himself was a ruling spirit, conveying the motif of the design, by description in words, to George Cruikshank to carry out with his pencil.

But Hone continued to be generous with credit; in November he wrote:

There cannot be a better representation of 'Guy Fawkes', as he is borne about the metropolis, 'in effigy', on the fifth of November every year, than the drawing to this article by Mr Cruikshank.

In the following January George was sent out into the cold:

A hard frost is a season of holidays in London. The scenes exhibited are too agreeable and ludicrous for the pen to describe. They are for the pencil–and Mr Cruikshank's is the only one equal to the series. He has hastily essayed the preceding sketch in a short hour. It is proper to say, that however gratifying the representation may be to the reader, the friendship that extorted it is not ignorant that scarcely a tithe of either the time or space requisite has been afforded Mr Cruikshank for the subject.

When, in August 1826, George for the first time produced a book himself, Hone gave *Phrenological Illustrations* a rave review of three and a half pages. He commences with an apology:

'In the name of wonder,' a reader may inquire, 'is the Every-Day Book to be a review?' By no means–but George Cruikshank is 'a remarkable person': his first appearance in the character of an author is a 'remarkable event' in the August of 1826; and, as such, deserves a 'remarkable notice'.

The concluding paragraph urges the public to render George financial assistance by cutting out the bookseller-middleman:

Guy Fawkes: wood engraving from Hone's Every Day Book *1826*

Though the work is to be obtained of all the booksellers in London, and every town in the United Kingdom, yet it would be a well-timed compliment to Mr Cruikshank if town purchasers of his *Phrenological Illustrations* were to direct their steps to his house, No 25, Myddelton Terrace, Pentonville.

From Hone's accounts we know what George was paid for his contributions:

February 8	*Twelfth Night*			
	Drawing, G Cruikshank	2	2	0
	Cutting, H White	2	0	0
September 3	*Candler's Fantoccini*			
	Drawing, George Cruikshank	2	2	0
	Cutting, White	2	15	0
January 21	*Skating on Serpentine*			
	Drawing, George Cruikshank	3	3	0
	Cutting, White	3	3	0

This was quite reasonable payment for the day. Though Hone had made good profits from his earlier political publications, he was never a rich man–in fact he was in the debtors' prison during much of the time his *Every Day Book* was being published–and it is doubtful if he got more than very modest returns for his miscellanies. But if he was careless with his finances, George was even more so; Hone accepted accommodation bills totalling at least £47 at various times on behalf of his protegé, that is to say, he acted as a kind of banker, guaranteeing George's borrowings.

Unfortunately, sometime in 1827, the friendship between publisher and artist came to an unhappy end due to a third party; a man named Percy, who had been employed by Hone as a business manager, managed to make a complete mess of Hone's finances, either through complete incompetence or through deliberate deceit. In the course of this mismanagement, he succeeded in alienating many of those who had business dealings with Hone, among them George with whom some question of an accommodation affair was still outstanding. What it was all about exactly, we don't know. Whatever it was, Hone deeply regretted it, but the bitterness remained, on George's side at least, until nearly the end of Hone's life, when they were reconciled. But George never worked for Hone again.

Billingsgate Fishwives–'Language': etching from Phrenological Illustrations *1826.*

This book was the first to be published by George himself.

Punch and Judy

George would have been interested in anything which entertained the public, but working with Hone must have helped to direct his attention to popular traditions and customs. Not long after doing a sketch of Fantoccini for Hone, he provided the illustrations for a little book intended to record in detail the puppet drama of Mr Punch, his unfortunate wife Judy, and his brave dog Toby. Here is his own account of how it came about:

Having been engaged by Mr Prowett, the publisher, to give the various scenes represented in the street performances of 'Punch and Judy', I obtained the address of the proprietor and performer of that popular exhibition. He was an elderly Italian, of the name of Piccini, whom I remembered from boyhood, and he lived at a low public house, the sign of the Kings Arms, in the Coal Yard, Drury Lane. Having made arrangements for a 'morning performance', one of the window frames on the first floor of the public house was taken out, and the stand, or Punch's theatre, was hauled into the 'club-room'. Mr Payne Collier (who was to write the description), the publisher, and myself, formed the audience; and as the performance went on, I stopped it at the most interesting parts, to sketch the figures, whilst Mr Collier

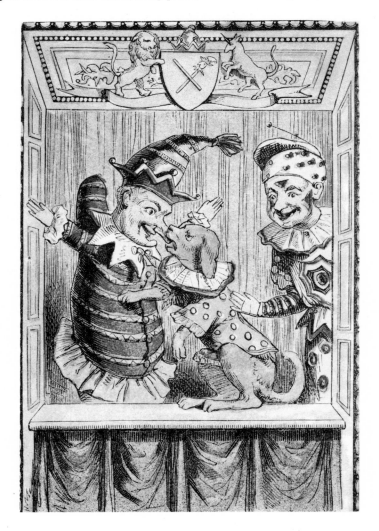

Punch and Judy: wood engravings to accompany P. Colliers text 1828

61

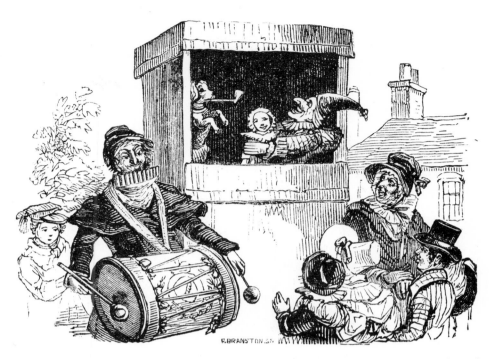

noted down the dialogue, and thus the whole is a faithful copy and description of
the various scenes represented by this Italian, whose performance of 'Punch' was
far superior in every respect to anything of the sort to be seen at the present day.

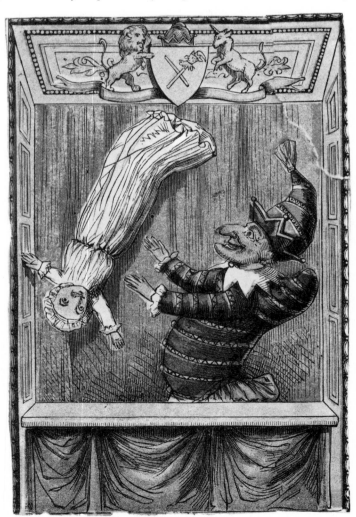

Scraps and Sketches

One of the questions which plagued George throughout his life was how to publish the one-off items which his fancy was continually throwing out–sometimes a scene he wanted to record, sometimes an abuse he wanted to expose, sometimes a whimsical thought which flashed through that ever-active mind of his and which he wished to share with others. Alongside his formal sets of illustrations to books by others, there ran a succession of anthological publications, sometimes presented as almanacks, sometimes as monthly magazines, sometimes simply as albums.

His *Scraps and Sketches,* first published in 1827 and followed up in the three succeeding years, was the first such collection of random pieces. Together with odd things he did for such scrappy books as Wight's *Mornings at Bow Street* and *Points of Humour,* they reveal the remarkable fertility of his imagination. The text is often a mere excuse for his illustration–we are left with the impression that whatever subject was proposed, it would spark off some kind of visual response. George produced no major work during the latter half of the 1820s, but his scraps and sketches include a dazzling assortment of squibs and jeux d'esprit as well as many quieter, more thoughtful items which show that he was not concerned merely with the surface appearance of life. A little sketch like *The Age of Intellect* is a penetrating comment on education which hasn't lost any of its force a century and a half later.

"The Age of Intellect"

The Age of Intellect: etching from Scraps and Sketches *1828*

Christmas Party from 'Holiday Scenes'

Witches and Fairies

Because of the reputation of his illustrations for Grimm's tales, George was asked to illustrate Sir Walter Scott's *Letters on Demonology and Witchcraft* in 1830. Later, George was to develop a 'fairy tale' style which might have been appropriate for this serious study of the paranormal, but in 1830 his illustrations are too whimsical for the text and wholly out of key with Scott's measured consideration of his subject. Considered on their own, however, the etchings are fine examples of George's ability to give solid, tangible form to verbal accounts. If there are fairies, if there are witches, then this, we feel, is how they must be. They are credible creatures, and yet for all that, sufficiently not of our world to retain their fascination and mystery.

Another series of illustrations in the same genre are those George did for Sir John Bowring's *Minor Morals for Young People,* which appeared in three volumes from 1834 to 1839. Here again, his Wandering Jew is not to be compared with that created by Gustave Doré, nor his vampire with the legend which Bram Stoker's text was to evoke so shudderingly, but here is a Jew we might meet any day in the street, a vampire as the police might find themselves called upon to cope with. Like the fairies and the witches, they are creatures of substance–the Wandering Jew throws a shadow, the witches need barrels to support them in the water. George's fairies can no more flout the laws of nature than the rest of us.

right: The Wandering Jew and far right: The Vampire of Emboré: etchings from Sir John Bowring's Minor Morals for Young People *1839*

Witches' Frolic, and right: Fairy Revenge: etchings from Sir Walter Scott's Letters on Demonology & Witchcraft *1830*

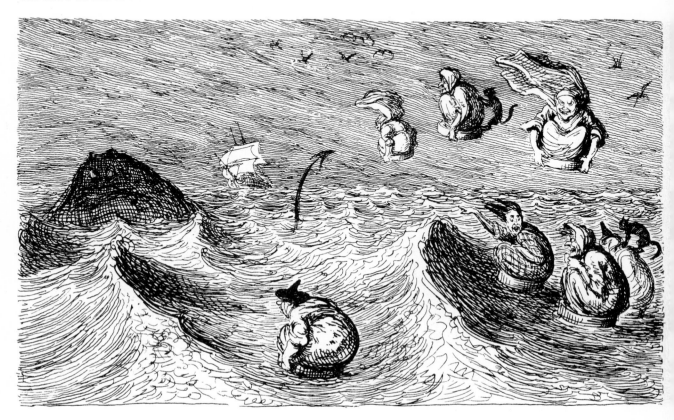

The Comic Almanack

In 1835 George got something he had long needed: a periodical publication in which he could appear before the public regularly, not illustrating the works of others but in his own right. The publisher Charles Tilt, of 86 Fleet Street, conceived and suggested to George *The Comic Almanack*. It was to be a monthly publication, dealing with matters topical or timeless, and it would also, of course, be a constant challenge to George to come up with something fresh and regular for each month's deadline. But George had already proved that he could respond to such challenges with professional punctilio.

In the event, *The Comic Almanack* was the most successful of all his periodical ventures. Twenty thousand purchasers bought the early issues, and though the sales were to fluctuate later, there was a sufficient market to keep the thing going for the next nineteen years. During that time George produced one hundred and ninety five full-page plates for the Almanack, together with more little wood engravings than I care to count.

The text was anonymous, but that anonymity concealed a number of the best-known popular authors of the day–Thackeray, Albert Smith, Henry and

March Winds

'All a-Growing!'

Horace Mayhew, Robert Brough. Today, most of the text is unreadable–either because it is too topical to mean much to us, or because the tortured punning of the funny-at-any-price articles becomes unbearably tedious when read in the lump. Spread over nineteen years, we might feel differently. But about the plates there can be no dispute; except for a few where he was required to illustrate a serial story in the text, they comprise a series of witty inventive comments on all manner of subjects, and include some of his happiest flights of fancy. There can be no better way of getting to understand the way George Cruikshank's mind and feelings worked, than by leafing through these pages. They reflect a personality always ready to see the humorous side of things, yet always aware of the underlying reality, ready to make the best of anything, but concious that the worst exists also. We don't find George the reformer in these pages–the Almanack was never used as a pulpit–but neither is its apparent levity quite so shallow as at first might appear. A print such as *Born a Genius* (page 109) strikes a bitter note all the more telling for being cast in the comic mould. On the final page of the first volume, these words appear:

MORAL
While we venerate
what is deserving of veneration
let us not forget that
quackery, knavery, bigotry and superstition
always merit
exposure and castigation.

Sic Omnes

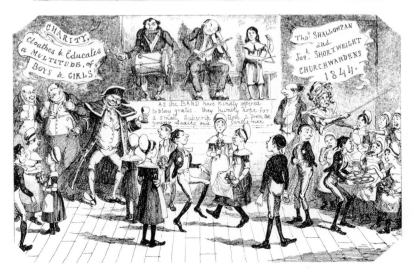

A Charity Ball: etchings from The Comic Almanack *1835–1838.*
 The plant sellers seem to be in a neighbourhood very like the one in which George and Mary lived. He has depicted himself standing in the doorway of Tilt's shop–Tilt was the publisher who had first suggested The Comic Almanack*–and also as the musician on the left in the Charity Ball scene. I hesitate to identify him in the steamboat scene but I feel safe in suggesting that this, too, is based on personal experience. This sort of intimacy, which the* Almanack *made possible, was perfectly suited to George's art.*

Cruikshank on his Feet

With his *Comic Almanack* successfully launched, we may regard the first phase of the artist's life as complete. He was now forty three years old, an admired and respected artist who had done things which all the world knew of and praised. But he had been, what most professional artists expected to be, a hack–a cab plying for other men's hire rather than a carriage choosing its own course. In his spare time he might indulge his private whims, but his public career was to serve the public by doing what the public paid him to do. Now, with the Almanack, he had taken the first step towards declaring his independence.

AUTHOR OF "ILLUSTRATIONS OF TIME".

George Cruikshank in 1833: lithograph by Daniel Maclise from Fraser's Magazine.

 Maclise and George would have met at Ainsworth's, where they were both frequent guests. Of this picture, George commented: 'Maclise and I were friends, and I held him in esteem as a worthy man and a great artist; but you will please to observe that this sketch was made by him before we became acquainted, and is therefore not only not like me, but represents me doing what I never did in the whole course of my life–that is, making a sketch of anyone. All the characters which I have placed before the public are from the brain–after studying and observing Nature–and not from any sketches made on the spot'.

 I think we may reasonably discount some of this as springing from George's vanity. He certainly did make sketches from life, as when he accompanied Collier to record the Punch & Judy performance, and Mrs Keeley the actress reported that George went behind the scenes to sketch her in character for 'Jack Sheppard'.

 Nor do I think it likely that Maclise, with his genius for catching his subjects in characteristic attitudes, would have drawn George in a pose he never adopted in real life. The older George might more reasonably have taken exception to having been shown sitting on a barrel, with a tankard and pipe at his side.

His personal life, on the other hand, was becoming more settled and more disciplined. As we shall see, he never sank utterly into respectable decorum, but at least he was now married, and had his own home. Though he had no children so far as we know, his wife Mary–to whom he constantly refers in letters as 'my better half'–must have acted as some kind of anchor. We know nothing of their private life though we may judge by internal evidence, such as the bathing scene he did for *The Comic Almanack* in August 1836, that he and his wife went on seaside trips like other husbands and wives, and another contribution to the Almanack is signed from Hythe. Apart from these occasional trips, he remained in London, at his home at Myddelton Terrace–it is interesting to note that the young Charles Dickens, with whom he was soon to be associated, took the occasion while visiting George to inquire about house rents in the district. When he found that a house like George's rented for at least £55 a year, he decided the neighbourhood was too expensive for him!

But though married life, and advancing years, may have restrained some of George's former wildness, it was first and foremost his work which regulated his life. He was a busy man all his life, but these were some of his busiest years. The amount of work he was turning out was, as we shall see, nothing less than astonishing. To maintain such productivity, even with his remarkable facility, must have pinned him down to his work table for most of the hours of most of his days.

His biographer Jerrold has sketched for us the outline of a typical working day in George's life. He breakfasted at 8, then smoked a leisurely pipe. At about 9 he started work, and kept at it until lunch at mid-day. This was only a light meal, and he was soon back at the work table until 3, when he had a more solid dinner. After this came his time for relaxing–with another pipe, a mug of porter, and some friends to chat with until a further meal, tea, at 5 (I think this may have been only a pot of tea, with no solid food). From 6 till 9 he was back at work again, till the day's work ended in time for supper at 9. After that came a last pipe, grog, and friendly company until bedtime. That works out at about eight hours of actual work. The number of meals seems surprising–but then three working sessions, not ending until 9 in the evening, is also something out of the common. How unusual this schedule was, and whether he arranged the day to suit his working pattern or vice versa, we can only conjecture–it would seem that he preferred the 'little and often' approach to the long sustained slog.

His evenings at home were frequently diversified with entertainment. He

Suppose I do show my leg they are no disgrace to me

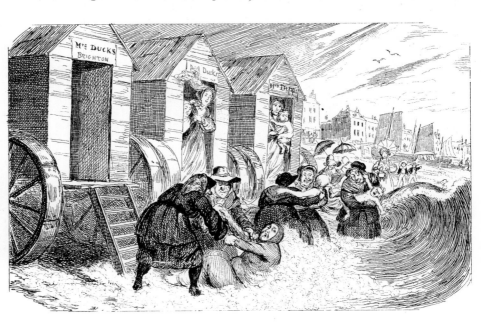

was evidently a welcome guest at other men's dinner tables, and entertained considerably himself—we find quite a few references to tea-parties at his home, which suggests that he was always ready to receive visitors so long as they didn't interfere overmuch with his work. With Sadlers Wells Theatre just round the corner, and with his great love of the theatre, many an evening visit must have been spent watching the great clown Grimaldi, whose memoirs he was one day to illustrate, and other favourites of the stage which he so often depicted. Grimaldi was also the President of a club called the Crib, which met at the Sir Hugh Myddelton pub, just across the New River from the theatre. George was a member of this club and no doubt contributed to its convivial gatherings with his spirited renderings of popular ballads.

Few details survive of George's working methods and arrangements. Presumably one room in his home was set aside as a studio. One of his assistants was a certain Joe Sleap, son of the Finchley carrier, whom George had perhaps got to know as a result of travelling to visit his mother who now lived at Finchley. Joe started with the Cruikshank household as a servant, but soon became a working assistant and a personal friend—he helped with the job of biting the etching plates, and other workday tasks. Unfortunately, he was to die as the result of an overdose of opium—drug-taking was by no means rare a century and a half ago. The only other assistant known to us by name was one named Sands—and his name is all we know of him.

As for his personal character and temperament, these would seem by now to have been set in the mould in which, thanks to so many testimonies by friends and acquaintances, he is so well known to us despite the scarcity of facts and figures. He was universally loved, his quirks and eccentricities accepted as part of his nature and easily forgiven. There must have been some who found his never-serious-on-the-surface attitude too frivolous for their

Sadlers Wells in 1827: steel engraving by Shepherd.

George was living within a few yards of this semi-rural scene and was a frequent habitué of the theatre on the right. Just out of sight to the left was the Sir Hugh Myddelton pub where many of his evenings were spent.

Workmen Being Paid in a Public House: wood engraving from Wight's Sundays in London *1833.*

While the family watch, the publican indicates the workman's drink score to be deducted from his week's wages. One of George's earliest reforming prints.

early-Victorian tastes, and his refusal to commit himself to any established party line may have seemed shallow to those who believe that a man should forge principles for himself and then stick to them regardless. In fact, it is evident that George was a man of firm principle and great purpose. We shall see in the next phase of his life how resolutely he could carry his beliefs into practice, but he was not a man to be *ruled* by principle. He lived pragmatically, a liberal in the old, best sense of the term, ready to let others do as they wished, so long as they let him do as he wished, nobody treading on anybody else's toes. When there were public abuses to be challenged–such as the custom of paying off workers in public houses, or the adulation of dwarfs

The Pursuit of Letters: etching from Scraps and Sketches

"The Pursuit of Letters"

The Knacker's Yard, or the Horse's Last Home: wood engraving from an etching in The Voice of Humanity, *1831.*

George never displayed much interest in animals, and it is characteristic that when he did show any such concern, it was with the way we human beings treat them.

Of this horrifying scene, said to have been sketched on the spot, the critic Francis Turner Palgrave wrote that it was 'scarcely below Rembrandt in force and largeness of style, while it is informed by an earnestness of purpose which the art of Rembrandt never aims at'.

LONDON going out of Town — or — The March of B

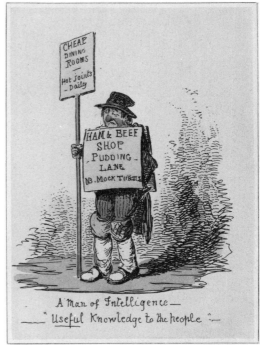

at the expense of true genius–then he felt called upon to speak out, but on behalf of simple justice, not some ideological principle. It was liberal pragmatism of the best English kind, and it made him an artist of the best English kind.

Yet who, when the first number of *The Comic Almanack* appeared in the booksellers' windows, would have guessed that everything George had done so far was simply a prelude, that he was merely on the threshold of his career and that he was about to produce a body of work which would throw all that he had done hitherto into the shade, and establish him for ever as one of the great English artists?

More Scraps

The Almanack gave George a regular assignment–a kind of banker, assuring him of a little stability. But the greater part of his work was still done in the form of one-off commissions. Thanks to his steadily growing reputation, more and more publishers were beating a path to his door, and he seemed ready to take on any job that was offered. The illustrations on these two pages are all minor contributions to minor publications and yet each is a competent piece of drawing which must have enhanced whatever book it appeared in. Together, they demonstrate his fluency and his versatility and although they may not show us George at his most ambitious, they indicate the broad base of professional skill which enabled him to rise to greater heights.

Nelson at Copenhagen: wood engraving from Southey's Life of Nelson *1830*

above right: Stagecoach in Winter: wood engraving from Peter Parley's Tales about Christmas *1838*

The Dead Cart: steel engraving by Davenport from drawing by Cruikshank for Defoe's Journal of the Plague Year *1833. Though this is a perfectly competent illustration, it lacks the individuality which George's wood engravings show even though cut by another hand.*

The First Classics

George in the 1830s was working on three levels: the odd jobs for publishers, his monthly contributions to *The Comic Almanack,* and his illustrations to popular novels which we are about to consider. But though these represent an ascending scale of technical skill and artistic achievement, it is important for us to remember that he was working on all three levels all the time–it wasn't a case of one yielding place to the next. Some of the occasional items on the previous page were produced *later* than the book illustrations we are about to see, and throughout his life he was willing to turn from major projects to knock off some slighter work, whether to oblige a friend or because it was a relief to work on some less demanding job. Nevertheless, the

left: The Magician: etching from Tobias Smollett's Peregrine Pickle *in Roscoe's Novelists' Library 1831*

right: The Battle Royal in the Churchyard: etching from Henry Fielding's Tom Jones *1831*

George Cruikshank

Hobbie Elliott and the Dwarf: etching from Sir Walter Scott's The Black Dwarf *1836*

'One Foot Nearer and I Plunge Myself from the Precipice!'—Rebecca and the Templar: steel engraving by J. Goodyear from George's drawing for Sir Walter Scott's Ivanhoe *1837.*

Joseph Goodyear, incidentally, was one of the quartet who paid that memorable visit to the Pied Bull pub in Islington, twelve years earlier.

decade sees a gradual shift of emphasis as his illustrations to the novels revealed hitherto unsuspected depths in his art.

As early as 1831, George was asked to provide illustrations for a series of reprints of popular works of fiction, Roscoe's Novelists Library. At first the intention had been to use a number of different illustrators, but George's work was so clearly superior that he came to be used on almost all the series. Of the nineteen volumes, seventeen were illustrated by him and they include works by Smollett, Fielding, Defoe, Sterne–in short, all the names you'd expect. George provided two or four etchings for each volume–a total of seventy four–and maintained a very high level of quality. If today we do not rank them too highly as book illustrations, it is only because they are over-shadowed by what came later. In these books he was finding his feet as an illustrator of fiction, learning how to achieve a satisfying artistic com-position without sacrificing fidelity to the author's text. He wasn't always successful. There was still a large element of the whimsical in his drawing which had to be eradicated before he could attain the serious level which some of his subjects demanded. It is this which spoils his illustrations to Sir Walter Scott's novels–34 etchings produced between 1836 and 1838. As drawings they are excellent, as illustrations they are failures. Every character becomes a figure of fun, utterly at odds with Scott's high romantic text, just as his elves and fairies had been too whimsical for the same author's *Letters on Demonology and Witchcraft* a few years previously. The point is effectively made if we compare George's etched work for these novels with one of his drawings engraved on steel by someone else. The scene showing Rebecca on the tower, from *Ivanhoe,* may not be a particularly good effort considered artistically, but it is far more in sympathy with the emotional level of Scott's romance than the plate we illustrate from *The Black Dwarf,* far superior though the latter may be as a work of art.

In the same year as he did his first Scott illustrations, 1836, George did his first illustrations for William Harrison Ainsworth. It was the start of his most fruitful collaboration. Ainsworth, though little read today, was in his day so popular as to rival Dickens. He developed a formula of dressing up history as fiction in a sensational way which nevertheless managed to be respectable and even 'literary'–the best comparison in our times would be with a Hollywood version of history, broadly true to the facts but everything a few sizes larger than life, romantic sub-plots added to counteract any tendency of the central theme to overweigh the book and depress the reader. In novel after novel, Ainsworth took some eventful historical period–the Gunpowder Plot, the Reign of Henry VIII, the Great Plague and Fire of London–and fashioned it into fiction, or he would take the career of some notorious villain, such as the thief Jack Sheppard or the highwayman Richard Turpin, and weave a romantic fiction round his exploits.

It was Ainsworth's book about Turpin, *Rookwood,* which first brought him into contact with George. Three editions of the novel had already appeared without illustrations, and had proved an immense success; now his publisher, Macrone, ventured to see if he could milk the market further by issuing an illustrated edition. George was a natural choice, and the choice proved a wise one, too. Though his illustrations for this Ainsworth novel are far from being his best for this author, they are nevertherless very fine, and proved to the world that George was capable of more serious book illustration than he had hitherto produced. I dare say he surprised even himself.

Rookwood marks the turning point in George's career as an illustrator. That old bedevilling whimsicality is still in evidence, there is still just a shade

too much of the former caricaturist in the faces and the gestures. But there is a new sense of sympathy with his subject, which tells us that the artist has let himself be governed not by his feelings for the particular situation, but by the spirit of the author's overall approach to his theme. There is, for the first time, a sense that illustrations can be more than a visual decoration to the author's text, that they can be a kind of alternative expression, a simultaneous presentation, in visual terms instead of verbal, of the author's vision.

The Cruikshank-Ainsworth collaboration was not resumed until 1839, not because of any misgivings about the success of *Rookwood,* but simply because circumstances didn't favour such a venture immediately. Anyone who has ever tried to get a book published knows what a fortuitous, chance-directed business it is. A hundred years ago, when publishing was a one-man show and market research unheard of, getting out a book was an infinitely chancier affair. So, for the moment, Ainsworth stepped out of the picture: his place was taken by a young man who had already shown the promise which was to make him the greatest of all novelists, and whose career for a few brief years ran side by side with that of the finest illustrator of the day.

Dick Turpin Leaps Hornsey Tollgate: etching from Ainsworth's Rookwood *1836*

Cruikshank and Dickens

In 1833 there started to appear in the magazines occasional pieces over the signature of 'Boz'. They caught the attention of the more established Ainsworth, who introduced their author–a young unknown named Charles Dickens–to his publisher, John Macrone. Between them, they worked out the notion of a series of 'sketches' on various aspects of London life, since this seemed to be Dickens' forté. It was natural that they should think of inviting George Cruikshank to provide accompanying illustrations.

For Dickens at the outset of his career and George at a turning point in his, *Sketches by Boz* was a critical event. The first volume was published on

Charles Dickens: sketches by George made about the time of their collaboration in 1837

George Cruikshank

George Cruikshank

George Cruikshank

George Cruikshank

*The young author and his
artist may be seen on either
side of the children in
'Public Dinners'. The scene
at Greenwich is interesting
because it is wholly light-
hearted. Later, George was
to speak out against the
depravity of the London
fairs, but at this period he
seems to have entered into
the spirit of the occasion
without any reservations. In
1876 he was to claim that the
Mayor and Aldermen had
begun 'to look at the Fair in
the same light as myself, and
at last put an end to that
which was a disgrace to the
city' thus suggesting that he
had somehow brought the
reform about himself.*

February 7th, 1836, and was an immediate success. Today these pieces by
Dickens, overshadowed by the greater works to come, tend to be less read
than they should be. They are, despite their lightness of tone, astonishingly
mature in attitude and sympathy, and leave the reader in no doubt that here
is a writer of far greater potential than the typical 'comic' writer of the day.
Dickens' text is superbly matched by George's etchings; it was the perfect
collaboration. George's whimsical style, so wrong for Scott, is utterly right
for Boz.

It was not only a successful collaboration, it was also a happy one. There
were moments of doubt, inevitably. Professionally, George was a rapid and
punctual worker, but he met his match in the young novelist, who dared to
complain of him to Macrone, 'I think he requires the spur.' Later, when they
were working on the second volume, Dickens heard that George proposed to
make some amendments to his text. He was furious. 'I have long believed
Cruikshank to be mad!' he exclaimed, and wrote to Macrone suggesting that
a different illustrator be found. But he was reconciled, and after a while, as he
got to know George better, he grew accustomed to the artist's peculiarities
and perhaps came to see them as the inevitable accompaniment of genius. The
working collaboration warmed into a friendship which was to be close for the
next dozen years, and even then it was not broken by any quarrel but simply
faded as their paths diverged.

Joseph Grimaldi, the greatest clown of his day, worked frequently at
Sadlers Wells Theatre, just round the corner from George's home, and the
two were well acquainted apart from George's love of anything to do with the
theatre. Dickens, too, was passionately fond of the theatre, and no doubt
accompanied George on evening theatrical visits. Author and artist were
natural choices when Richard Bentley planned to publish the edited
'Memoirs' of Grimaldi. Dickens was editing Bentley's *Miscellany,* a monthly
journal of popular literature, and George was also under contract to supply a
large etching every month.

It was in Bentley's *Miscellany* that Dickens' first real novel appeared–for *Pickwick Papers* was more a thinly disguised series of sketches strung together. With *Oliver Twist* he established himself immediately as one of the leading novelists of the day. It displays a skill, a confidence and a maturity astonishing when we consider how little he had previously published, and how trivial most of that former work had been.

Oliver Twist inspired George to produce some of his most memorable illustrations. The London setting enabled him to use his intimate knowledge of London locations and London characters. He gave Bill Sikes and Fagin and the street arabs a vivid reality which, even today when his caricaturish style is out of fashion, remains the standard by which all other Dickens illustration must be judged. This is well evidenced by this observation by Arthur Waugh, a director of Chapman & Hall, who published the majority of Dickens' works:

> George Cruikshank, then in his forty-fourth year, was established as the most popular illustrator of his day. His work was in constant demand, and its reputation still survives with such vitality that there seem to be many people who have grown up under the belief that Cruikshank was responsible for illustrating all Dickens's novels. The trade department of Chapman and Hall could bear ready witness to the persistence of this illusion. Again and again the inquiry is repeated. 'A bookseller has offered me a complete edition of Dickens,' some provincial enthusiast writes, 'which he claims to contain all the original illustrations. But on examining it, I discover that a large proportion of the pictures are by some artist named "Phiz". What I want are the original pictures by Cruikshank'.

Alas, *Oliver Twist* was to be the last fruit of their collaboration. Why, has been a matter for speculation ever since. On the whole, the working relationship between the two men seems to have been a happy one. Dickens did, it's true, object to George's proposal for the final plate in the novel, and suggest a replacement, but George seems to have provided it cheerfully enough, and there was no suggestion of a quarrel. It appears, in fact, that

far left: Oliver Twist asks for more

below: Fagin in the Condemned Cell

right: Bill Sikes Attempting to Destroy His Dog: etchings from Dickens' Oliver Twist *1837*

there were plans for George to provide the illustrations for the next Dickens novel, *Barnaby Rudge*, in 1839.

But at the same time as *Oliver Twist* was appearing in Bentley's *Miscellany*, his *Pickwick Papers* was coming out in parts. The early chapters had been illustrated by Robert Seymour, but this noted comic artist had shot himself midway through publication, for reasons which remain unknown, and the rest of the illustrations had been provided – after an anguished talent contest in which many contemporary illustrators were tried and considered – by the young Hablot Knight Browne, better known as 'Phiz'. I think it likely that, for all his respect for George, Dickens found the younger and less established artist more malleable, and preferred to work with him than with the less tractable George.

There was another aspect to his work with Dickens, a further instance of extravagant claims on George's part, but these will be best considered together with similar claims in regard to his collaboration with Ainsworth. I doubt if they were a factor in the question of who was henceforth to be Dickens' illustrator. The claims were not made until many years later, and the friendship between author and artist continued long after they had ceased to work together. Whatever its cause, the decision seems to have been motivated by professional rather than personal considerations.

What the world would have seen had it been George, not Phiz, who illustrated the later Dickens novels, is a tantalising conjecture. Splendid as Phiz's contributions certainly were, there is no doubt in my mind that George's would have been very much finer. His illustrations to *Oliver Twist* showed that he had the sympathy and the emotional range necessary to illustrate a writer of Dickens' breadth of vision, and his illustrations for Ainsworth were to show that he was acquiring a new technical virtuosity which vastly extended his powers of expression. We can only guess at what might have been, but we can be sure that it would have been the wonder of the world.

far right: Oliver Restored: water colour from his own etching, for the same book.

This 'fireside' scene, intended to be the final illustration in the book, displeased Dickens, so George agreed to replace it with the no less sentimental but more dramatic picture of Rose Maylie and Oliver at Agnes' tomb. It was obliging of George to accede to his collaborator's wishes, but no less characteristic of him to resurrect the rejected design when, some years later, he was asked to work up water colour designs based on his etchings.

Cruikshank and Ainsworth

Posterity has not been kind to the author whose contemporary popularity rivalled that of Dickens himself; a few lines dismiss him in the biographical dictionaries, and the judgments of scholars are rich in disparaging phrases:

> Even Dickens had his fine gold jewelled by Cruikshank. Ainsworth's tawdry rubbish–now all but forgotten, and soon to sink deep in the mudpool of oblivion–was illuminated with a false splendour by this great humourist.
>
> (Walter Thornbury, *British Artists*)

That this is unfair is proved by the rapidity of the development of George's art during this period. An artist's skill is not improved in a vacuum; George's skill improved as a direct consequence of the challenge presented by Ainsworth's books. We may deplore the fact that it was these second-rate romances which received the full benefit of George's new maturity, but we must not overlook the possibility that it was precisely Ainsworth's high-pitched style, his dramatic scene-setting and eye for telling incident, which drew out George's latent powers to such stunning effect.

If Ainsworth is disparaged today, it is largely because he was an innovator who showed the way along which other and better writers were to follow. He was one of the earliest 'romanticisers'–with the perception to see that, from the flat and pedestrian chronicles of the life of that petty criminal Richard Turpin, the story of the Ride to York (a ride which, if it took place at all, was made long before Turpin's day) had the makings of a legend on a heroic scale. By highlighting the legend of Herne the Hunter in *Windsor Castle,* the ghost stories of *The Tower of London,* the marvellous escapes of *Jack Sheppard,* Ainsworth showed an instinct for the dramatic which struck an answering chord in his illustrator. George, too, had a love of the theatrical and the dramatic; he too liked to romanticise; to give, even to the most trivial incident, a myth-like quality. (For example, on page 108, he captions his scene not 'A gentleman desecrating a bright poker' but '*The* desecration of *the* bright poker', raising the domestic accident to classic level.)

Apart from the earlier *Rookwood,* George's first work for Ainsworth was for *Jack Sheppard,* which appeared in the monthly parts of Bentley's *Miscellany* in 1839. *The Tower of London* followed in 1840, and *Guy Fawkes* in 1841. He was paid £40 a month for his plates, the equivalent of some £100 a week today, so that even if he had been doing no other work, George was assured of a very satisfactory income.

The quality of these illustrations is enhanced by the fact that he was now using steel plates instead of copper, and was discovering the added potential the harder metal gave him. To make any verbal comment on these illustrations would be superfluous to the point of impertinence–they are sufficiently eloquent in themselves. We don't need to be familiar with the text to appreciate the drama in each illustrated situation–every picture tells a self-evident story which even the illiterate can read. There is an object-lesson here for every artist who proposes to illustrate a book. The artist has, in a sense, humbled himself by setting aside his own inspiration and lending his

left: Jack Sheppard visits his Mother in Bedlam: etching from Jack Sheppard *1839*

left: The Name on the Beam

art to that of the author, but he then discovers that what he gives, he gets—the author's text has called out unsuspected depths in the artist. Required to concentrate his imagination on a given situation—the instant where Jack Sheppard is discovered carving his name on the roof-beam, let's say—he is driven, unconsciously I'm sure, to empathise with the scene, transport himself into the situation, feeling, not as tacked-on embellishment but as integral elements in the scene, the hungry cat, the guttered-out candle, the handbills, the tools of the trade and all. What's more, all this humdrum detail serves, not to confuse the central subject of the picture, but to throw it into relief. In realising his author's text, the artist has realised his own art.

And if this is true of each individual picture, how much more impressive it is when we pass from one picture to the next, and see the dazzling breadth of George's new-found skill. From the meticulous detailing of the name-on-the-beam scene to the breathtaking audacity of Jack's confrontation with his mad mother, just two figures in a room, and then we come to the seemingly pedestrian diagramming of Jack's escape which builds up, as the sequence proceeds, to an archetypal comic-strip series—long before the comic-strip was invented! Even without the display of artistry in each individual plate, the virtuosity which could achieve such a diversity of treatment would be sufficient to guarantee George's inclusion among the world's greatest illustrators.

William Harrison Ainsworth: engraving by Daniel Maclise in Fraser's Magazine *circa 1834.*

The novelist about the time he wrote Rookwood. *He was himself a fine horseman.*

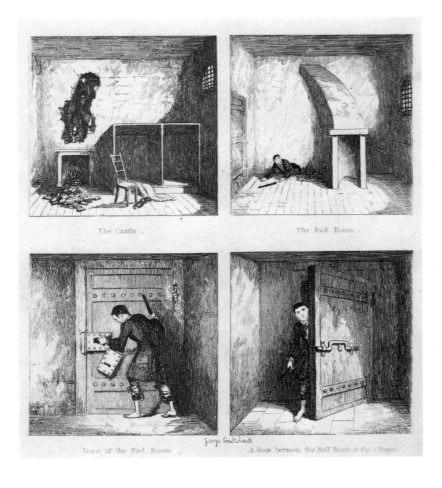

The Castle.

The Red Room.

Door of the Red Room.

A door between the Red Room & the Chapel.

The Escape (ten scenes): etchings for Ainsworth's Jack Sheppard, *first published in* Bentley's Miscellany *1839*

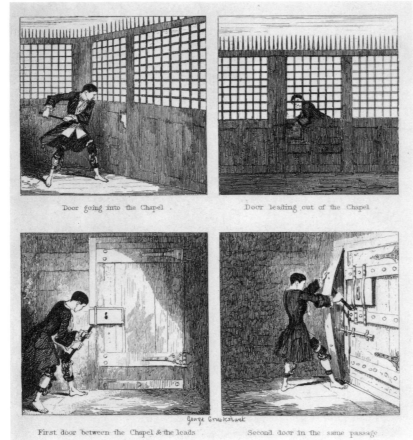

Door going into the Chapel.

Door leading out of the Chapel.

First door between the Chapel & the leads.

Second door in the same passage.

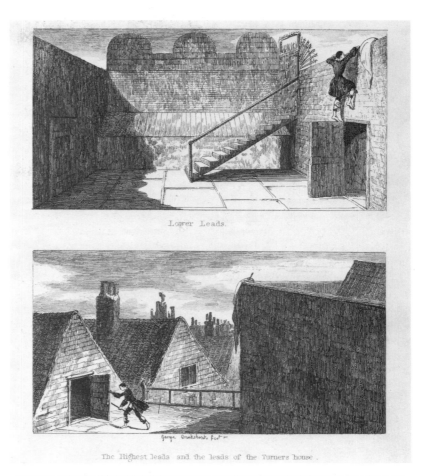

Lower Leads.

The Highest leads and the leads of the Turners house.

Below right: Jack Sheppard in Company with Edgeworth Bess Escaping from Clerkenwell Prison

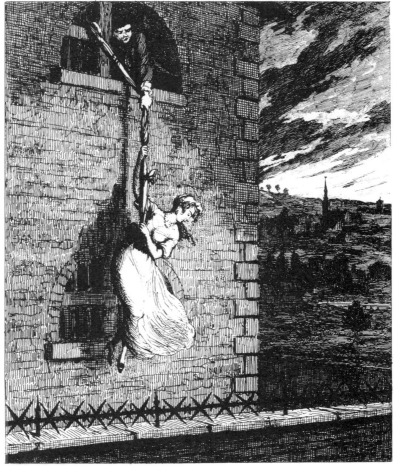

Claims and Counter-claims

The collaboration with Dickens and Ainsworth requires us to take notice of one of the rare regrettable incidents in George's career as man and artist. There is little point in going deeply into the ins and outs of the matter; put simply, it is that George claimed, in respect particularly of Dickens' *Oliver Twist* and Ainsworth's *Tower of London* and other books, that it had been he who had initiated most of the ideas not only for the illustrations but also for the stories – that, in effect, the authors had written up their narrative to fit in with his pictures rather than the other way about. The first public reference to these claims seems to be that made by an American writer, Dr Shelton Mackenzie, in a periodical named *The American Round Table,* but it would seem that the claims he now put into print had been made privately long before:

> In London I was intimate with the brothers Cruikshank, Robert and George, but more particularly with the latter. Having called upon him one day at his house (it was then in Myddelton Terrace, Pentonville), I had to wait while he was finishing an etching, for which a printer's boy was waiting. To while away the time, I gladly complied with his suggestion that I should look over a portfolio crowded with etchings, proofs, and drawings, which lay upon the sofa. Among these, carelessly tied together in a wrap of brown paper, was a series of some twenty-five or thirty drawings, very carefully finished, through most of which were carried the well-known portraits of Fagin, Bill Sikes and his dog, Nancy, the Artful Dodger, and Master Charles Bates – all well known to the readers of *Oliver Twist*. There was no mistake about it; and when Cruikshank turned round, his work finished, I said as much. He told me that it had long been in his mind to show the life of a London thief by a series of drawings engraved by himself, in which, without a single line of letterpress, the story would be strikingly and clearly told. 'Dickens,' he continued, 'dropped in here one day, and, while waiting until I could speak with him, took up that identical portfolio, and ferreted out that bundle of drawings. When he came to that one which represents Fagin in the condemned cell, he studied it for half an hour, and told me that he was tempted to change the whole plot of his story; not to carry Oliver Twist through adventures in the country, but to take him up into the thieves' den in London, show what their life was, and bring Oliver through it without sin or shame. I consented to let him write up to as many of the designs as he thought would suit his purpose; and that was the way in which Fagin, Sikes, and Nancy were created. My drawings suggested them, rather than his strong individuality suggested my drawings.'

The publication of this claim caused an uproar here in England. George, though he had not initiated the publication of his version, was probably not sorry that someone else had advanced it for him. In a letter to *The Times,* while admitting that the American scholar had not got the facts quite straight, he insisted that the circumstances described were substantially correct. Years later, in a pamphlet, he set out his claim with greater precision:

> *Oliver Twist, The Tower of London, The Miser's Daughter,* etc, were produced in an entirely different manner from what would be considered as the usual course; for I,

Jane's First Night in the Tower

the artist, suggested to the authors of these works the original idea, or subject, for them to write out – furnishing, at the same time, the principal characters and the scenes. And then, as the tale had to be produced in monthly parts, the writer, or author, and the artist, had every month to arrange and settle what scenes, or subjects, and characters were to be introduced; and the author had to weave in such scenes as I wished to represent, and sometimes I had to work out his suggestions.

(*The Artist and the Author,* 1872)

Those words were written when George was eighty years old, and we may ascribe them to the vanity of old age and dismiss his claims completely. But could George, so honest in all other departments of life, really be guilty of what Dickens' biographer Forster called 'an incredible and monstrous absurdity'? I think we must accept that to deny George's claims completely would be unjust. The circumstances under which these illustrated books were created lent themselves to collaboration, and in those days, when copyright was not so sacrosanct as today, ideas and even scenes were happily borrowed without acknowledgement even by the most respectable writers. The whole idea of *The Pickwick Papers,* let us not forget, was not Dickens' own, but given him by the publishers who commissioned the book, and it was one of them, Chapman, who insisted that Seymour's thin, wiry Pickwick was all wrong, and that the man should be short and tubby. In short, such books were the product of an interchange of ideas, and everyone concerned could regard himself as being a partial collaborator.

But from partial collaboration to instigation on the scale that George claimed for himself is a long step. Perhaps if the claims were unique, we might have been more willing to credit them, but we have seen already how he had claimed *The Banknote Not To Be Imitated* as his idea rather than Hone's, and he had also hinted that *Life in London* was fundamentally his own creation.

Blanchard Jerrold, George's first biographer and a close personal friend,

The Roof of the Broad Arrow Tower: wood engraving for the same book.

Though less dramatic than the plates which directly illustrate Ainsworth's romance, George's numerous on-the-spot sketches of the Tower are first-rate examples of his art, drawn with great economy yet with a sharp eye for detail.

Overleaf left: The Execution of the Duke of Northumberland

below left: Lady Jane Grey and Bishop Gardiner

right: The Duke of Suffolk's Attack on The Tower

below right: Elizabeth brought Prisoner to The Tower: etchings for Ainsworth's Tower of London *in Bentley's Miscellany 1840*

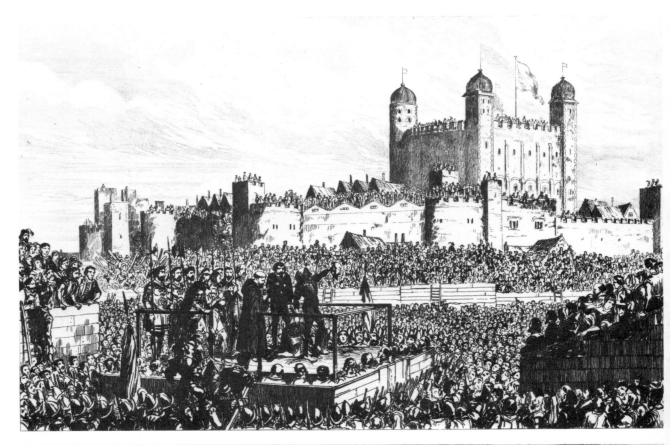

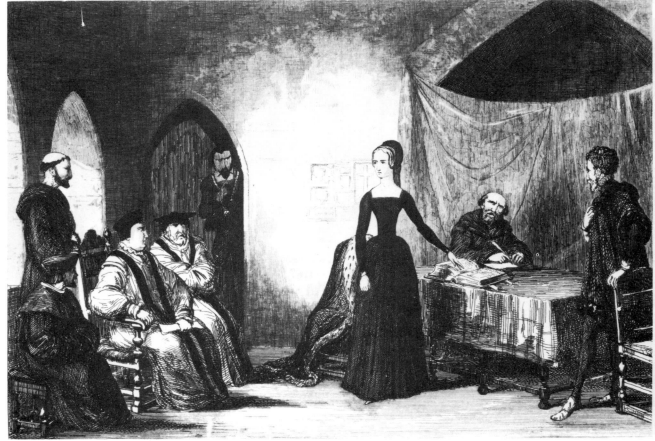

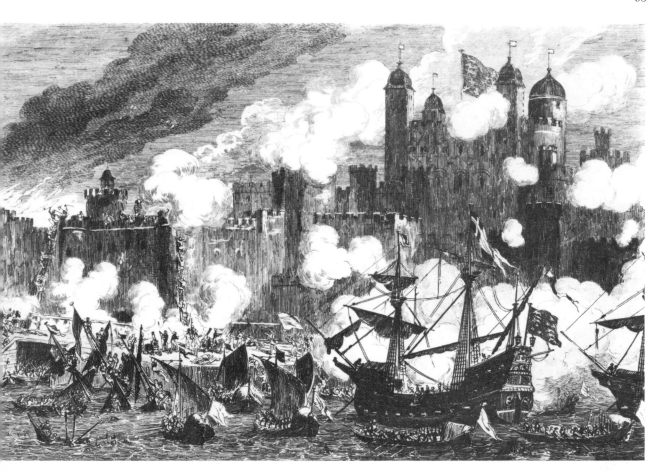

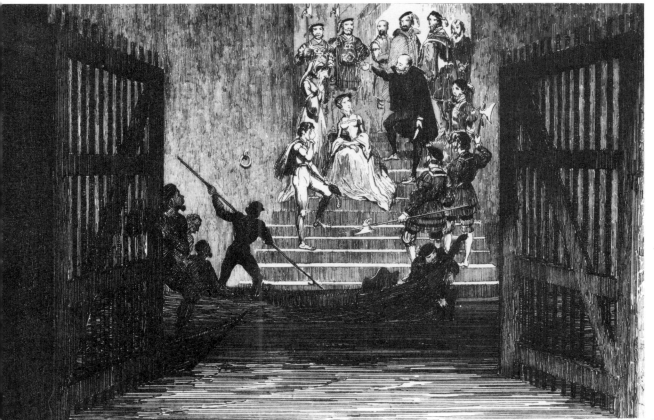

asked an acquaintance who had known George in earlier days, whether he knew anything that could throw light on the matter. His informant recalled an incident which occurred while Laman Blanchard was editing Cruikshank's *Omnibus* (1841), between *The Tower of London* and *The Miser's Daughter:*

> All I remember is something very like a quarrel, one night, when Cruikshank was spending the evening at Blanchard's house. A friend praised a little poem that had appeared in the last number. Whereupon Cruikshank remarked that it was his idea as well as his illustration. I don't call to mind another occasion when I saw Blanchard give way to a violent passion, but on this he did. The idea and the poem were one of his bright and graceful fancies; and he rose and denied that Cruikshank had the least share in it, with a fierceness that confounded him.

George's claims with regard to *Oliver Twist* were not advanced until after Dickens' death, so that first-hand refutation was not possible: but Ainsworth was still alive, and was able to put the record straight as regarded his own books:

> Not a single line – not a word – in any of my novels was written by their illustrator, Cruikshank. In no instance did he even see a proof. The subjects were arranged with him early in the month, and about the fifteenth he used to send me tracings of the plates. That was all.
>
> Overweening vanity formed a strong part of Cruikshank's character. He boasted so much of the assistance he had rendered authors, that at last he believed he had written their works. Had he been connected with Fielding, he would no doubt have asserted that he wrote a great portion of *Tom Jones*. Moreover, he was excessively troublesome and obtrusive in his suggestions. Mr Dickens declared to me that he could not stand it, and should send him printed matter in future.
>
> It would be unjust, however, to deny that there was wonderful cleverness and quickness about Cruikshank, and I am indebted to him for many valuable hints and suggestions. While writing *The Tower of London,* which first appeared in monthly numbers, I used always to spend a day with the artist at the beginning of the month in the Tower itself. To these visits I look back with the greatest pleasure, and feel that I could not have had a more agreeable companion than the genial George Cruikshank.

Well, of course the author in his fine house at Kensal Green was not going to share his credit with the mere artist, living in a little suburban terrace house off the Hamsptead Road, and especially not with one who had been so troublesome and obtrusive with his suggestions. . . . Somewhere between their two opposing statements lies the truth, but so confused by claim and counter-claim that we would hardly recognise it if we saw it. My first inclination was to ignore the matter altogether, not out of any desire to whitewash George, but simply because there seemed no way of arriving at the true facts. But then I reflected that, so long as we do not attach too much importance to it, the episode does tell us a good deal about the relationship between George and his authors, and about the way he saw his role as illustrator. It is evident that he felt himself capable of doing more than playing second fiddle to the performer who received the lion's share both of the monetary profits and the crowd's plaudits. We must concede that, with this motivation, he pushed his claims too far, but we must also recognise that there were good grounds for his resentment. Maybe it is some comfort to him, as he sits up there in the artists' Valhalla, to look down and watch buyers combing antiquarian bookstores for Ainsworth's romances, with no intention of reading Ainsworth's text, but only to admire the Cruikshank illustrations.

Quarrels and Reconciliations

To involve oneself in the publishing world of the early nineteenth century is to enter a labyrinth of private intrigue, cynical calculation, personal feud and professional ruthlessness where motivations are tantalisingly hard to untangle. Was it personal pique or a sense of incompatibility, private boredom or an ambition for other activities, which made, for instance, Dickens resign the editorship of Bentley's *Miscellany* in favour of his friend Ainsworth? And so on, and so on–each new development must have an explanation, and sometimes those concerned offered such explanations, but even then we can't be sure that they are telling the truth, perhaps this too may be a ploy in the game.

George was also involved in these matters, and just because he was by nature open and honest does not mean that everything he said can be taken at its face value–for, as we have just seen, he was quite capable of deceiving himself; indeed, a capacity for self-deception would seem to be a prerequisite for anyone who practises sincerity. So, in the diplomatic shuffling which went on between Dickens, Ainsworth, Bentley and Cruikshank, with a few others also involved in minor parts, it is anybody's guess which of them, if any, is telling the truth at any particular moment, who was being motivated by self-interest and who by spite.

Guy Fawkes in the Cellar right: The Execution of Guy Fawkes: etchings for Ainsworth's Guy Fawkes *in* Bentley's Miscellany *1841*

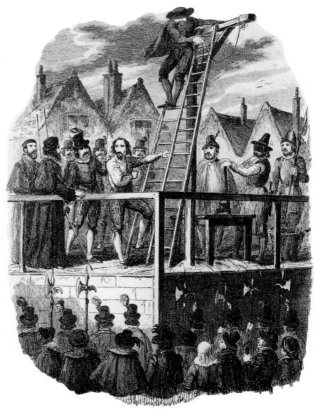

In the last resort, of course, none of it matters very much. This was the normal working climate in the book trade, and the people we have named were all professionals, quite able to look after themselves, and not apt to cherish deep resentments simply because there had been professional disagreements. George continued to be a close friend of Dickens even after they had stopped working together, and produced illustrations for Richard Bentley even after they had quarrelled. So we must not make the mistake of attaching too great an importance to these machinations. And we must also remember that somehow great works emerged from the chaos. We may regret that George didn't end up illustrating *Barnaby Rudge* and *Nicholas Nickleby,* but rather let us be grateful that, at least, he illustrated *Jack Sheppard* and *The Tower of London.*

In 1841 George decided to start a periodical publication of his own, on a more ambitious scale than his still-running *Comic Almanack.* He probably felt that Bentley, to whom he was still contracted, wasn't giving him sufficient scope to express his own ideas, but using him solely as an illustrator of other men's writings. To edit his *Omnibus,* he secured the services of Laman Blanchard, a well-known light author of the day. What he did not do was find an author of real calibre–for a serial story was the backbone of any such publication. *Frank Hartwell; or, Fifty Years Ago* was simply not up to the standard of Dickens or even Ainsworth– and that was the standard the magazine-reader of the day had come to expect. Perhaps George hoped that his etchings would sell the paper but, if so, he was wrong. Though the *Omnibus* ran for nine months, and contained some very fine plates, it never attained the popularity he hoped.

Fortunately events enabled him to get out of the situation without loss of face. For in the same year 1841, Ainsworth also abandoned the *Miscellany,* and immediately set about starting a magazine of his own. He no doubt felt that, since it was evidently his serial stories which were the star attraction of the *Miscellany,* it was wrong that Bentley should get the lion's share of the profit.

Since George was still contracted to Bentley, and was besides producing a magazine of his own, Ainsworth had to look elsewhere for an illustrator. He crossed the Channel to Paris, and secured the services of the celebrated Tony Johannot to provide the plates for his next book, *Windsor Castle.* And so the romance started to appear with Johannot's illustrations.

What happened next can be described in George's vivid words:

> After I had been going on with my *Omnibus* for something less than twelve months, to my utter astonishment my friend Pettigrew called upon me one day with a message from Mr W. Harrison Ainsworth, to this effect, that he (Mr Ainsworth) was extremely sorry that there had been any unpleasantness between us, and that if I would forgive him, and be friends, nothing of the kind should ever happen again; that he was about to start a monthly magazine, and that if I would join him, and drive my *Omnibus* into his magazine, he would take all the risk and responsibility upon himself, and make such arrangements as would compensate me liberally. To this most unexpected proposition at first I would not listen; but as my friend Pettigrew kept on for some time urging me to be friends again with Mr Ainsworth, and as I am (as my friends say) in some cases rather too good-natured and forgiving, I did forgive Mr Ainsworth, and 'shake hands', and agree to work with him again.

The Pettigrew referred to was Thomas Pettigrew, the Cruikshank family doctor, for whom George had provided illustrations for a book on Egyptian mummies (see page 75) and also for a novel entitled *Lucien Greville.* The

Richard Bentley: wood engraving from The Graphic *1871*

right: Regular Habits: etching for Bentley's Miscellany, *Summer 1843.*
The shoddy work that George was deliberately giving Bentley is evident enough in this plate, even without comparing it with the superb illustrations he was producing at the same time for Ainsworth's Windsor Castle. *The drawing of the girl's face in the foreground seems like a calculated insult, designed to see how much Bentley would take. No wonder the print is unsigned, the name being typeset.*

George Cruikshank: self caricature circa 1842 in letter to Laman Blanchard.

The Miser Discovers His Loss: etching from Ainsworth's The Miser's Daughter *1842.*

Though perhaps the least known of the Ainsworth-Cruikshank collaborations, this work deserves to be better known, as this superb illustration shows.

'unpleasantness' may well have been connected with George's claims with regard to *The Tower of London;* though these claims had not at this date been made publicly, George may have advanced them privately and word of this may have got to Ainsworth's ears. An alternative suggestion is that he was piqued because he had not been invited to illustrate Ainsworth's *Windsor Castle.*

Whatever the facts, it was a magnanimous gesture on Ainsworth's part, though we must not forget also that it was very much in his interests to effect a reconciliation. George was the biggest draw, as regards illustration, he could hope to attract for his new venture. No doubt the reconciliation was made still more attractive to George by the fact that an agreed sum of £40 a month was agreed, for two etchings. By the standards of the day that was a very handsome fee.

George also provided some wood engravings for the magazine—we are not told whether he was paid additionally for these or whether he threw them in for good measure. One of them shows author and artist sitting together at a work table, in cheerful collaboration. For a while, at least, everything seemed to go very well. After a few issues had appeared containing chapters from *Windsor Castle,* Ainsworth dropped Johannot, perhaps on the grounds that cross-channel briefing was too inconvenient. It was a wise move. The illustrations which George proceeded to supply are patently superior to Johannot's—indeed, they are among the finest he ever produced. I would not be surprised if the opportunity of competing with the French artist (remember that for the first twenty three years of his life George had lived in a country at war with France) spurred him to give of his best.

In the meantime he was giving Bentley work that was a long way short of his best. Already in 1840–1841, before Ainsworth left the *Miscellany,* George had provided illustrations for *Guy Fawkes* which, though they would have been well enough coming from any other illustrator, were manifestly inferior to those he was doing for *The Tower of London* which was appearing simultaneously. Now that Ainsworth had left and the texts he was called upon to illustrate were worthless rubbish, he evidently felt less obliged than ever to put himself out. It is probable that Bentley kept him on only because of his name—the fact that he broke with both Dickens and Ainsworth showed that the fault was more likely on his side than on George's, and he had a reputation for meanness. Jerrold tells us, referring to George's work for the *Miscellany* in 1843:

> Being bound still to supply him with six more plates, he purposely put bad work in them. This was his revenge—and to the end of his life he never perceived the fault he committed in this act.

We are told that George set his watch on the work table beside him, and allowed himself only an allotted number of minutes for each Bentley plate. The result can be seen on page 99. This tantrum represents one of the few lapses from professionalism which George ever permitted himself. No doubt the provocation was there, but he had after all signed a contract with Bentley, and was being paid well enough for his work. It is pleasant to be able to record that the feud, though long-lasting, was not permanent. One day in 1864 or so, George passed Bentley by chance in St James' Park. Both turned back—and returned to shake hands. 'Twenty years is long enough,'one of them said. They celebrated the reconciliation by bringing out a new edition of Barham's *Ingoldsby Legends,* with a superb frontispiece newly done by George (see page 183).

The collaboration with Ainsworth, too, was not to be of very long duration.

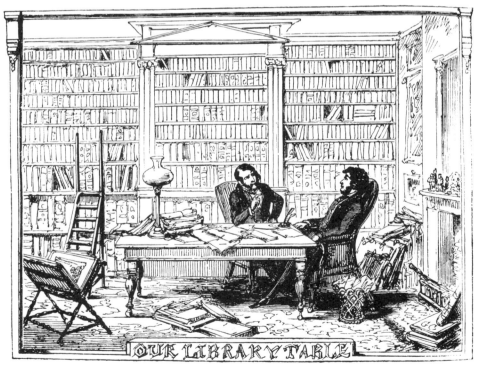

Birdman Fantasy: wood engraving from Ainsworth's Magazine *1842.*
George seemed able to dash off these little flights of fancy on any subject at any moment.

above left: The Dead Drummer: etching for Barham's Ingoldsby Legends *in Bentley's Miscellany 1840*

left: Cruikshank and Ainsworth: wood engraving from Ainsworth's Magazine *1842*

right: 'Alas, Poor Ghost!': etching for George Raymond's Memoirs of Robert William Elliston, Comedian, *in* Ainsworth's Magazine *1843*

After *Windsor Castle* came *The Miser's Daughter,* less well known as a novel, but containing illustrations up to George's highest level. Then came *St James's, or the Court of Queen Anne,* which was less successful. This may be because high society always brought out the worst in George—he was much happier with the lower levels, where his tendency to caricature is less conspicuous. His first-hand knowledge of the world in which, say, Jack Sheppard moved, enabled him to depict it with greater ease than when he came to courts and the corridors of power.

> The last story of mine illustrated by Cruikshank was *St James',* published in 1844. Since that date I saw very little of the artist.

Ainsworth tells us, but he does not tell us why. What had happened to that close and friendly partnership which George had depicted? Did George insist on more credit than he was due? Did Ainsworth quarrel over the illustrations to *St James',* or did he simply wish for a collaborator more tractable, with less of a will of his own? Were there faults on both sides? We shall probably never know, because even if documents should one day come to light, we cannot be sure that they will tell us the truth. But this time we do not hear of any happy reconciliation in St James' Park.

below: The Signal
right: Herne the Hunter:
etchings for Ainsworth's
Windsor Castle *in*
Ainsworth's Magazine *1843*

George Cruikshank

The Signal.

Cakes and Ale

In 1842, while he was still under contract to Bentley, and while he was either publishing his own *Omnibus* or collaborating with Ainsworth, George also supplied the illustrations for Douglas Jerrold's *Cakes and Ale*. For this book he supplied two frontispieces and engraved titles, for which he was paid £84.

Many a man then living made less than that sum in a year. The average income of a man in George's social class—forgetting, for a moment, the reward due to genius—would be in the region of £300 to £400. So he didn't need to pick up very many in the way of occasional commissions to get by comfortably enough, even without the £480 a year he got from Ainsworth, plus what Bentley paid him until their contract finally lapsed, plus what he got for *The Comic Almanack*.

Sala estimated that George's average earnings, taking bad years with good, would have been about £600 a year. When we remember that George was at this time the leading illustrator of his day, the top of his particular tree, such rewards do not seem over-generous. But to put the matter in perspective we must remember that no illustrator was highly regarded at this period; even the fine artist was not yet as generously rewarded as he would be in the late Victorian period, and nobody thought of comparing an illustrator

Sailors Off-Duty: etching from Dibdin's Songs Naval and National *1841*

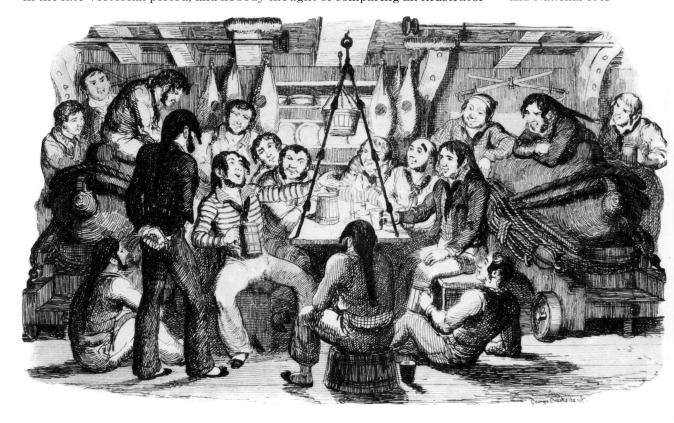

with a 'real' artist. So, by the standards of his day, George had no cause to complain – nor, indeed, did he. He continued to live modestly, to work hard, and to enjoy life in his own way.

To a considerable degree, however, his work was his chief pleasure, and particularly the work which he chose, rather than was commissioned, to do. So it must have been some satisfaction to him to sever his ties with the Bentleys and the Ainsworths and go it alone, trusting that the flow of occasional work would be sufficient for his needs.

Besides *Cakes and Ale* there were many other things that he did simultaneously with his Bentley and Ainsworth illustrations. His illustrations for Charles Dibdin's *Songs Naval and National* in 1841 are notable, and not only because his more personal illustrations of the sea show all concerned being sea-sick! The continuing friendship with Dickens produced not only the *Memoirs of Grimaldi* but also a delightful edition of *The Loving Ballad of Lord Bateman,* 1839, for which Dickens wrote some characteristic tongue-in-cheek notes. That which accompanies the plate we reproduce runs as follows:

> She hears from an aged and garrulous attendant, her only female adviser (for her mother died when she was yet an infant), of the sorrows and sufferings of the Christian captive. Urged by pity and womanly sympathy, she repairs to his prison to succour and console him. She supports his feeble and tottering steps to her father's cellar, recruits his exhausted frame with copious draughts of sparkling wine, and when his dim eye brightens, she gives vent to the feelings which now thrill her maiden heart for the first time, in the rich gush of unspeakable love, tenderness, and devotion – 'I vish Lord Bateman as you vos mine!'

The Turk's Daughter Expresses a Wish as Lord Bateman was Hers: etching from The Loving Ballad of Lord Bateman *1839.*

Of these illustrations, Dickens – who wrote the anonymous accompanying text – declared 'You never did anything like those etchings – never!'

Designed Etched & Published by George Cruikshank 1839

The Turk's daughter expresses a wish
as Lord. Bateman was hers. —

The Comic Almanack

Alongside all these fluctuations in his working life, George's *Comic Almanack* continued to appear month after month, rich with characteristic comments. In 1844 the role of publisher was passed from Charles Tilt to David Bogue, but the contents continued to be very much the mixture as before.

left: The Fall of the Leaf
below left: The Desecration of the Bright Poker
right: The Scholastic Hen and her Chickens
below right: Born a Genius and Born a Dwarf: etchings from The Comic Almanack *1845–7.*

The two scenes from domestic life may surely be taken as comments on George's own domesticity; the self-portrait in The Bright Poker is evident enough, and the lady remonstrating with him could, as we have already suggested, be Mary. We may further suppose that the social milieu depicted here was pretty much George's own–suburban, bourgeois, comfortable without ostentation. Though I can't picture George with a knee-breeched manservant and buttoned page–that scene must commemorate a visit to posh friends!

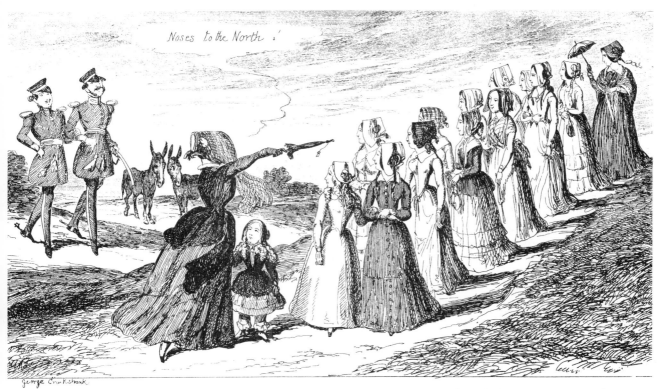

Noses to the North!

THE SCHOLASTIC HEN AND HER CHICKENS.

Mifs Thimblebee loquitur._"Turn your heads the other way my dears, for here are two horridly handsome Officers coming."

'One of the Best of Men': Cruikshank at Fifty

Desite all his quirks and idiosyncrasies–perhaps even partly on account of them–George was a favourite with nearly all who knew him. Even those who found him impossible to work with, had to respect his simple-minded integrity and his spontaneity. If he was vain, it was less a personal vanity than the self-respect he owed himself as an artist; if he was obstinate, that was because he owed it to his art to stand up for what he believed to be the right course. His few quarrels were all concerned with his work as an illustrator and his desire to see that work justly respected.

On the purely personal level, all his acquaintance delighted in him. One of them, Samuel Phillips, observed:

> George is popular among his associates. His face is an index of his mind. There is nothing anomalous about him and his doings. His appearance, his illustrations, his speeches, are all alike–all picturesque, artistic, full of fun, feeling, geniality, and quaintness. His seriousness is grotesque, and his drollery is profound. He is the prince of caricaturists, and one of the best of men.

His future biographer, Blanchard Jerrold, was only a boy when he met George in 1845, but draws a characteristic picture:

> The ingeniously arranged chevelure was within artful elastic bands drawn over the skull . . . I was one of many youngsters who would creep round his chair and endeavour to unravel the mysteries of the extraordinary coiffure. Old-fashioned, tumbled, eccentric, his dress had a studied look. The strong individuality of the vivacious and active little man (for he was under the middle height) appeared to be preserved by attention to the elaboration of a costume unlike that of any of his neighbours.

A friend from the country, W. L. Sammons, came up to London in 1842 and was invited to Amwell Street:

> A friend or two dropped in–Douglas Jerrold and, I think, Laman Blanchard, the editor of Cruikshank's *Omnibus*–and the former Mrs Cruikshank was present and presided, and threw a charm over the tea and supper tables. . . . George Cruikshank was particularly busy on this day, because of *The Miser's Daughter,* by Ainsworth, that he was illustrating for Bentley's *Miscellany* (*), and he assured me if not finished by such an hour and such a day he should forfeit £50; and yet he risked the uncertainty to show hospitality to his friends.
>
> During this visit to London, dear George took me the round of several of the theatres and gardens. He was petted and respected by all, lessees, managers, and actors, and readily ushered into any quarter that caprice, pleasure, or professional duties required, whether pit, boxes, or gallery; but the 'dress circle' was less to his taste than others, because there life was fossilised, artificial, and restrained, and dress mere tinsel.
>
> One morning he led me to the burial ground of St James' Chapel, Pentonville, near his house, and pointed out the graves of Thomas Dibdin, son of the great sea-songster, and of his old and 'mutual friend' Joey Grimaldi, whose mortal coils are laid near each other; and I wish I could remember so as to record the tender and sympathetic little oration he then delivered.

(*) In fact it was for Ainsworth's Magazine.

Blanchard Jerrold: engraving in Illustrated London News *1884*

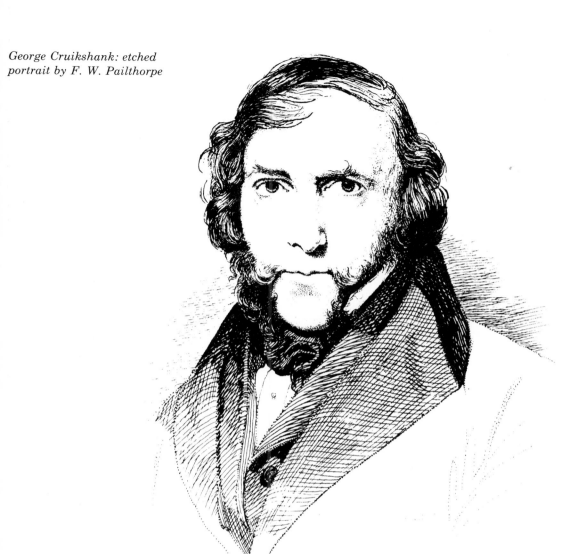

George Cruikshank: etched portrait by F. W. Pailthorpe

Percival Leigh, in a letter to Blanchard Jerrold, gives another glimpse of George at this period of his life. The occasion was a convivial visit to the Cheshire Cheese tavern in Fleet Street:

> This was in George Cruikshank's pre-teetotal period. After dinner came drink and smoke, of course: and George Cruikshank was induced to sing 'Billy Taylor', which he did with grotesque expression and action, varied to suit the words. He likewise sang 'Lord Bateman' in his shirt-sleeves, with his coat flung cloak-wise over his left arm, while he paced up and down, disporting himself with a walking-stick, after the manner of the noble lord, as represented in his illustration to the ballad.

The Cheshire Cheese, Fleet Street: process engraving from a drawing by Herbert Railton in The English Illustrated Magazine

The singing of this particular song seems to have been George's standard party piece. Another friend, W. H. Wills, testified to the splendour of the performance:

> In his first wife's life time he sacrificed to the jolly god rather oftener than occasionally; and surely no man drank with more fervour and enjoyment, nor carried his liquor so kindly, so merrily. Then was the time to hear him sing 'Lord Bateman' in character . . .

The same writer testifies to George's good nature and generosity – even though it might be with other people's money:

Even when dependent upon his pencil and etching-needle for means of existence, if any good was to be done for a decayed brother artist or literary friend, George was only too ready to throw down his tools, and stroll about the country with a theatrical company, or go anywhere to solicit subscriptions and make speeches, or to settle to his work-table again to make gratuitous sketches for bazaars and charities. When acting in Edinburgh for Leigh Hunt's benefit, with Charles Dickens and his brilliant dramatis personae, news came to him that a country editor, with a large family, whom he had often previously helped, was on the edge of ruin for want of £50. 'I *must* send it to the poor fellow,' he said to Dickens, 'immediately.' 'That would be very kind to him,' answered Dickens, 'but very unkind to yourself. By the bye, have you got £50 in your pocket?' 'Oh dear no,' was Cruikshank's reply, 'but I want you to lend me the money to send to him – now – at once.'

Jerrold describes the kind of incident which George's closer friends had to expect:

Dickens was living in Devonshire Place, and was just settling to work one morning in his library, when Cruikshank, unwashed and 'smelling of tobacco, beer and sawdust', burst into the room. He said he had been up all night; was afraid to go home, and begged for some breakfast. While he was breakfasting, Dickens did his utmost to persuade him to go to bed. But George resolutely set his face against it. He said he dared not even think of Islington. Seeing the state of affairs, Dickens closed his desk, and proposed to accompany his friend to face the domestic storm with him. But Cruikshank would only consent to a walk – the farther from Islington the better. And so they walked about the streets for hours, strolling in the course of the day into the famous aviary of the Pantheon in Oxford Street. Here Cruikshank came suddenly face to face with one of Mrs Cruikshank's intimate friends. . .

In a letter, Dickens described how George attended a reunion dinner at Greenwich to celebrate the novelist's return from America:

Cruikshank came home in my phaeton on his head, to the great delight of the loose midnight loungers in Regent Street. He was last seen taking gin with a waterman.

In another letter, dated 2 March 1843, he describes how he and George attended William Hone's funeral:

Cruikshank and I went as mourners; and as he lived, poor fellow, five miles out of town, I drove Cruikshank down. . . . Now, Cruikshank has enormous whiskers, which straggle all down his throat in such weather, and stick out in front of him, like a partially unravelled bird's nest; so that he looks queer enough at the best, but when he is very wet, and in a state between jollity (he is always very jolly with me) and the deepest gravity (going to a funeral, you know) it is utterly impossible to resist him, especially as he makes the strangest remarks the mind of man can conceive, without any intention of being funny, but rather meaning to be philosophical. I really cried with an irresistible sense of his comicality all the way; but when he was dressed out in a black cloak and a very long black hat band by an undertaker (who, as he whispered me with tears in his eyes – for he had known Hone many years – was 'a character, and he would like to sketch him') I thought I should have been obliged to go away.

Even Ainsworth, despite the estrangement between them, did not allow it to cloud his memories of their former friendship:

When I knew him, he was extremely convivial, and used to sing a capital comic song, and dance the sailor's hornpipe, almost as well as the great T. P. Cooke. Perhaps he may have rather exceeded the bounds of discretion, but if he took a little too much, he was hearty and good-humoured, and would never have boasted as he afterwards did of writing portions of *Oliver Twist* and *The Miser's Daughter*.

The Progress of Mr
Lambkin: Four etchings
from The Bachelor's Own
Book, being the Progress of
Mr Lambkin (Gent.) in the
Pursuit of Pleasure and
Amusement, and also in
Search of Health and
Happiness, *1844.*

*The two dozen plates
which tell the story of Mr
Lambkin show George
thoroughly enjoying himself.*

*1—Mr Lambkin having
come into his property,
enters the world upon the
very best possible terms with
himself, and makes his toilet
to admiration.*

*9—Mr Lambkin is so
fortunate as to be introduced
to some highly talented
members of the Corps de
Ballet.*

22—Mr Lambkin determines to reform his habits, but contemplating an old bachelor member of the Grand Mausoleum Club who sits poring over the newspapers all day, he feels horrorstruck at the probability of such a fate becoming his own, and determines to seek a reconciliation with the Lady of his Affections.

23—Mr Lambkin is forgiven! He skips for joy! Pa and Ma give their consent.

Hooligans and Housemaids

Soon after his break with Bentley and Ainsworth, George tried his hand at another periodical on the same lines as the *Omnibus*. He called it *Cruikshank's Table Book,* no doubt remembering his old friend Hone's publication of twenty years earlier. The *Table Book* appeared in monthly parts from January to December 1845, and contains some of his finest social commentary. (From one of the plates, 'Sic Transit' (page 118) we can I think deduce that this is a souvenir of his one and only foreign excursion, a day trip to Boulogne. His drawing helps us to understand why the exploit was never repeated!)

The *Table Book* didn't sell well enough to be continued after the first year; nevertheless in April 1846 George found a publisher for yet another periodical, *Our Own Times*. This time only four numbers appeared, of thirty-two pages each, but again it failed to attract a sufficiently large public. Yet it, too, contains some of his very best work, including the astonishing tour de force, *An Outline of Society in Our Own Times,* which we reproduce as our frontispiece. Here is the entire Cruikshank philosophy of life condensed and distilled to a single comprehensible statement, intricate in detail yet devastatingly simple in its total grasp. Here, had his contemporaries had eyes to see, was proof of how far George had transcended the role of 'illustrator' in which they had cast him, and from which they would not allow him to depart.

The term 'tour de force' could be applied with some justification to this as to many others of George's contributions to the *Table Book* and *Our Own Times*. Like that other phrase, 'a virtuoso performance', it bears a somewhat pejorative coloration in our self-deprecating age, as though we blame the artist who seeks to show off his talent. Certainly there was a large element of the showman in Cruikshank, and many of his plates for these periodicals are show-pieces of the etcher's art, but there is amply sufficient content in 'An Outline of Society' or 'A young Lady's Vision of the London Season' to quash any accusations of shallow exhibitionism. Each etching is a profound piece of social commentary–and none the worse for being, at the same time, a spectacular specimen of George's ability to organise his private vision into an artistic unity.

His illustrations for other people's books during this same period suggest a deliberate return from the world of romantic fiction to that of real people and real life–except that no change of direction in George's artistic career seems ever to have been the consequence of conscious planning. His twenty-one etchings for W. H. Maxwell's *History of the Irish Rebellion in 1798,* published in 1845, are unique in their controlled bitterness. Here is none of the crude savagery of the earlier Napoleonic cartoons or the *Political House that Jack Built,* yet each meticulously-placed detail is a testimony to the artist's passionate involvement with his subject and the strength of his response to the scenes he has been asked to depict.

Comparing his illustrations with Maxwell's text, we find that he evidently didn't feel obliged to limit what he drew to what was prescribed by his author. But I doubt if he thought he was being dishonest in so doing; his role was to

A Young Lady's Vision of the London Season: etching from The Table Book *1845*

A Young Lady's VISION of "THE LONDON SEASON"

Return from a delightful Trip, on the Continent ——

"Sic transit" ——

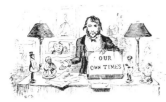

above: Self Portrait: wood engraving from Our own Times *1846*

left: Sic Transit: It is tempting to guess that 'Sic Transit' is a souvenir of George's one and only recorded overseas journey, a day trip to Boulogne

right: The Triumph of Cupid (detail): etchings from The Table Book *1845*

below: Rebels Destroying a House and Furniture: etchings from Maxwell's History of the Irish Rebellion

express in visual terms what the historian described in words. If his rebels are depicted as monsters, it is because George could not conceive that anyone but a monster could have murdered the drummer boy who refused to beat his drum for the rebels. Here is the historical account:

> A drummer named Hunter, of the Antrim regiment, only some twelve years old, fell into the hands of the rebels in the unfortunate affair in which Colonel Walpole lost his life. He carried his drum with him—and being ordered to beat it, actuated by a spirit of enthusiastic loyalty, he exclaimed, 'That the king's drum should never be beaten for rebels;' and at the same instant leaped on the head and broke through the parchment. The inhuman villains, callous to admiration of an heroic act even in an enemy, instantly perforated his body with pikes.

If the text saw fit to describe the rebels as 'inhuman', why should the artist show them as anything more? Perhaps it was the high imaginative content of these illustrations which explains why he was never again invited to illustrate a history—or was it simply that at this period it was only works of fiction which the public was ready to buy in sufficient numbers to justify the addition of costly plates? Whatever the cause, George's illustrations to Maxwell remain an isolated testimony to his ability to portray true history as opposed to Ainsworth's souped-up version, and a rare example of what can happen when historical events are depicted by an artist who is emotionally concerned with his subject.

right: Rebels Executing Prisoners on Wexford Bridge

below right: The Rebel Camp on Vinegar Hill

below: The Loyal Little Drummer: etching from W. H. Maxwell's History of the Irish Rebellion in 1798, *issued in parts 1845*

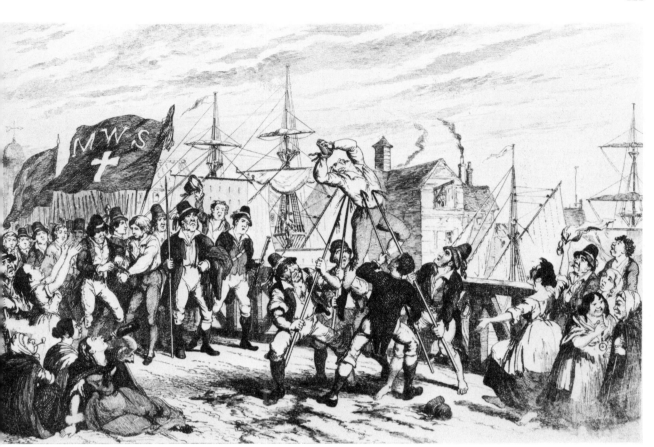

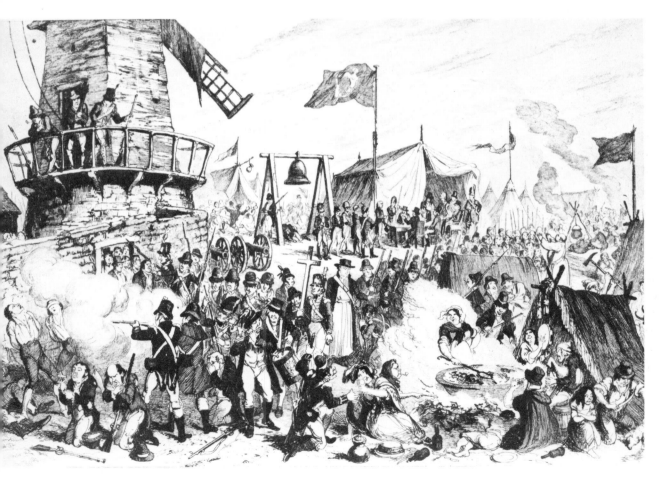

It must have been a relief for him to turn from the cruelties of the Irish rebels to the vagaries of the domestic servant. In 1847 he was invited to provide a set of illustrations for *The Greatest Plague in Life,* a light-hearted treatise on the servant problem by Horace Mayhew and his brother Henry, who was soon to win lasting fame as the author of the vastly more serious *London Labour and the London Poor* (for which George could have provided incomparable illustrations if only it had occurred to anyone to ask him!). *The Greatest Plague* shows us George at his most affable, making his comments devastatingly, but with as much affection as reproach, unable despite himself not to share in the fun, smiling indulgently at the servant girls' mischief and the housewife's dismay.

Servant girls were, of course, a staple commodity of the magazine *Punch* which had been launched in 1841–for a hundred years, 'the servant problem' was a line it could fall back on when any other subject for humour failed. It is regrettable that George didn't join the *Punch* team–but it wasn't for want of asking. The editor, Mark Lemon, invited George to contribute, naming his own terms, but George had taken exception to what he termed 'inexcusable personalities' in some of the earlier issues. 'We shall have you yet!' insisted Lemon. 'Never!' George replied and–unfortunately for *Punch,* for posterity and for himself–he kept his word. But he was on good terms with many of those associated with the paper. When, some years later, *Punch* good-naturedly mocked him for his enthusiasm in the cause of temperance, George declared that 'he had a great mind to go down to Fleet Street and knock the old rascal's wooden head about'.

left: The Morning Gossip

above right: Out for an Airing

above far right: It's my Cousin, Ma'am!

below right: The Sentimental-Novel Reader

below far right: Going out for a Holiday: etchings from the brothers Mayhew's The Greatest Plague of Life, or the Adventures of a Lady in Search of a Good Servant *1847*

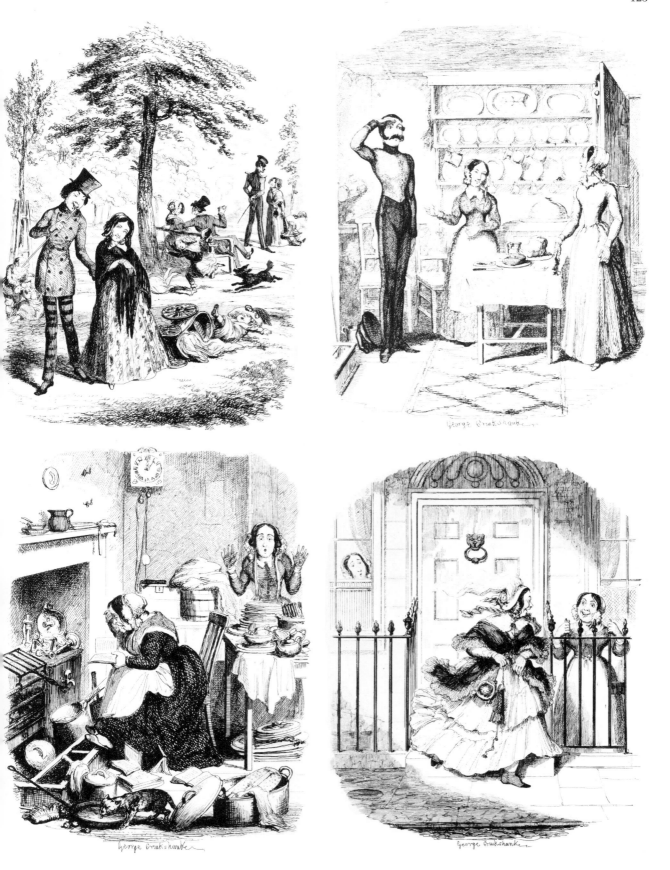

The Bottle

In 1847, at the age of fifty-five, George Cruikshank became a total abstainer from alcoholic drink.

As a young man, he had indulged at least as much as most young men of his day. Though he had never done so to dangerous excess, or incurred any disaster or accident or ailment as a consequence, he had acquired, as we have seen, a reputation for letting himself go—and he had seen many who had let themselves go too far. At a meeting held in Manchester in 1876, George recollected gentlemen coming to dine occasionally at his father's house, and he was often surprised on coming downstairs of a morning, to find some of them 'rolled up in the carpet in an extraordinary manner'. His own father had taken too much drink, and had shortened his life by it. There is indeed a legend that Isaac, before he died, had made a wager with a friend as to which could drink more whisky before falling beneath the table. He had won his wager, but George reckoned that this had helped to bring on his fatal illness. Is there anything more than coincidence in the fact that Isaac, when he died, had been the same age that George was now in 1847? The examples of his father, of the caricaturist Gillray, and others he had known, must have had some effect on him. We also know that he was suffering from gout in 1840. But there seems no definite link between these personal associations and his own decision.

Drink was a fact of life in nineteenth century England in a way it no longer is today, for all our concern with juvenile alcoholics and meths-drinking pensioners. Gentlemen drank wine with their meals as a matter of course, following it with port or brandy. Working people drank their ale or porter with the same casualness. Nursing mothers were encouraged to drink stout. Servants expected beer to be provided along with their other victuals. The gin-palace was the only cheerful place of resort for the overworked underpaid working man and woman, after their long days in the mill and with nowhere to go but a shabby, overcrowded, slum lodging.

But drink was also the destroyer of families and the blaster of promising careers. Though the strong could control it, the weak were conquered by it. Perceptive reformers could see that it was not so much drink itself that was the problem, as the economic factors which drove people to seek solace in drink, but there were many who believed that if drink itself were controlled, benefits would surely follow. The temperance movement grew apace throughout the early nineteenth century, with strong support from the lower middle classes which have always been the backbone of latter-day puritanism.

This was George's social milieu, and he was exposed as much to the preaching as to the practice. Drinking and drunkenness crop up as themes in his work from very early on in his career; they were part of the fabric of life, and inasmuch as his art reflected life, so it inevitably took note of those who drank, whether convivially or pathologically, festively or fatally. As early as 1829 he was depicting the gin shop as a man-trap into which its patrons unwittingly step, while elves dance round the still and death waits, with

patient satisfaction, saying, I shall have them all dead drunk presently – they have nearly had their last glass. In his *Sketch Book* of 1835 he drew the Gin-Juggarnath, the Great Spirit of the Age drawn along by a crowd of devotees; another little sketch for the same book shows a wretched man and woman as 'the Pillars of a Gin Shop'. In 1842 he provided the illustrations for John O'Neill's poem *The Drunkard* which told the archetypal story of a man destroyed by alcohol.

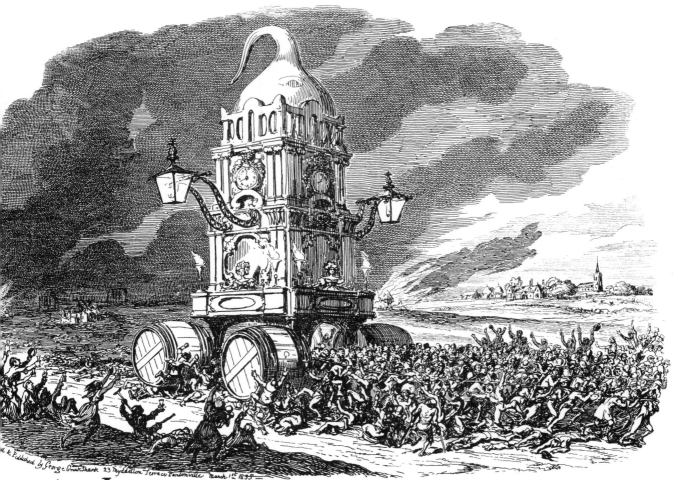

The GIN-JUGGARNATH. Or, The Worship of the GREAT SPIRIT of the age
— It's Devotees destroy themselves — It's progress is marked with desolation. Misery, and Crime —

But drink was not always seen by him as the destroyer. In the *Comic Almanack* for 1838 he depicted 'The Battle of A-Gin-Court', in which drink has led to a free fight outside a gin palace: a sordid scene, yet the effect is genial rather than bitter. And his picture of a Gin Shop for Dickens' *Sketches by Boz* in 1836 is positively affectionate. Though the clientele are caricatured, and the inclusion of a small boy fetching drink for his father could be taken as an implied comment, there is no drunken behaviour, everyone looks cheerful and well-dressed – it could have been used by the drink interests as an advertisement! Another plate from *The Comic Almanack*, dated 1844, makes gentle fun of the noted Irish temperance advocate Father Matthew who, in the form of a water pump, is shown as

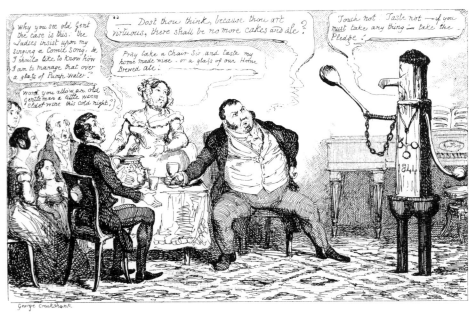

FATHER MATHEW-An-ice man for a small party '

having a decidedly chilling effect on an evening party with his words 'Touch not–Taste not–If you must take anything, take the Pledge!' to which each of the guests makes an appropriate reply. A visitor with a strong resemblance to George himself replies 'Why you see, old gent, the case is this: the ladies insist upon my singing a Comic Song, and I should like to know how I am to manage that over a glass of Pump water?' and the head of the household expostulates in Shakespearean tones, 'Dost thou think, because thou art virtuous, there shall be no more cakes and ale?'

A friend, W. H. Wills, recalled George in the days when he was still of two minds in the matter:

> I remember him about 1846. He was then flirting with Temperance. I wanted him to dine at my house; but he excused himself, saying he should be led into temptation, and he had resolved to be a water-drinker thenceforth.

However, though George refused the dinner invitation, he turned up at Wills' house later in the evening 'much excited', and when his host pushed the water bottle towards him, he gently added brandy.

> The other guests departed, leaving the hilarious George, with two others, to finish the evening; and when the trio got into the street, they found the old difficulty in restraining Cruikshank's boisterous spirits. After trying in vain for something more than an hour to lead him home, they left him–climbing up a lamp post!

It was not–how could it be?–an easy struggle. George had the habits of a lifetime to overcome. Moreover, he had to go against the daily habits of all his acquaintance. We do not know precisely what it was that finally made him fix his will, but Jerrold is surely right in associating the decision closely with his series of plates entitled 'The Bottle'. Having completed the set of eight, George took them to William Cash, chairman of the National Temperance Society, for his approval and perhaps for his support as well:

> Having attentively examined the series, he turned upon the artist, and asked him how he himself could ever have anything to do with using 'The Bottle' which, by his own showing, was the means of such dreadful evil? Cruikshank, in his own forcible

way, described how he was 'completely staggered' by this point-blank question. He said, when he had left Mr Cash, he could not rid himself of the impression that had been made upon him. After a struggle, he did not get rid of it, but acted upon it, by resolving to give his example as well as his art to the total abstainers.

<div align="right">(Jerrold)</div>

'The Bottle' was printed by a new process called glyphography (see page 29) in order to produce the enormous run anticipated by David Bogue, the publisher who was also doing *The Comic Almanack* at this time. A poem by Charles Mackay accompanied the series, which were sold at one shilling for a folded sheet, or half a crown stitched in a wrapper. 'I put them out at that low price,' George explained, 'in order that it might be within the reach of the working classes.' Bogue and he were justified, vast numbers were sold and it remains one of the most famous, as well as one of the most effective pieces of propaganda ever created.

Dickens was one of the thousands who purchased it. Writing to his friend Forster on September 2nd 1847, he said:

> At Canterbury yesterday, I bought George Cruikshank's The Bottle. I think it very powerful indeed: the last two plates most admirable, except that the boy and girl in the very last are too young, and the girl more like a circus-phenomenon than that no-phenomenon she is intended to represent. I question, however, whether anybody else living could have done it so well.... The philosophy of the thing, as a great lesson, I think all wrong; because, to be striking, and original too, the drinking should have begun in sorrow, or poverty, or ignorance—the three things in which, in its awful aspect, it *does* begin.

Today, more removed from the problem with which it dealt and better able to relate the series to George's other work, we can see that 'The Bottle' succeeds as propaganda because it succeeds as art. The story, which could so easily have been overplayed, has not been, or at any rate not to a degree which destroys its credibility. Each downward step is shown as so inevitable that we are deluded into thinking that the entire process must be so. Even if we shake ourselves free of this compulsive acquiescence, we still find ourselves agreeing that, well, yes, it *could* happen like this . . . I am sure Dickens was right in seeing that the philosophy behind it is all wrong; but at the level at which it was designed to work, philosophy was a luxury commodity which few could afford. A hard-hitting body blow, with not too many questions asked, was more to the point—and that is what George gave them.

We shall consider the artistic merits or shortcomings of 'The Bottle' further, when we consider his work in the temperance cause as a whole. Before that, let us see what effect his conversion had on George's personal life.

Throughout his career he had been a reformer. His targets had been many and varied—political harassment; the adulteration of food; bureaucratic pretension; humbug in all its manifestations. Now at last he had found a cause to which he could devote himself and his art whole-heartedly:

> Having been converted to total abstinence from fermented liquors, he could be nothing less than an earnest and a vehement worker in the cause. He threw himself heart and soul into it; and during the thirty remaining years of his life his zeal never slackened, and he had never made sacrifices enough for it. His impulsive advocacy often took ludicrous forms. He sometimes offended people by his denunciations of even the most moderate drinkers, but he never made an enemy by his gaucherie or his downright phrases imported into quiet circles, because the purity of his motive and the well-known impetuosity of his nature excused him.

<div align="right">(Jerrold)</div>

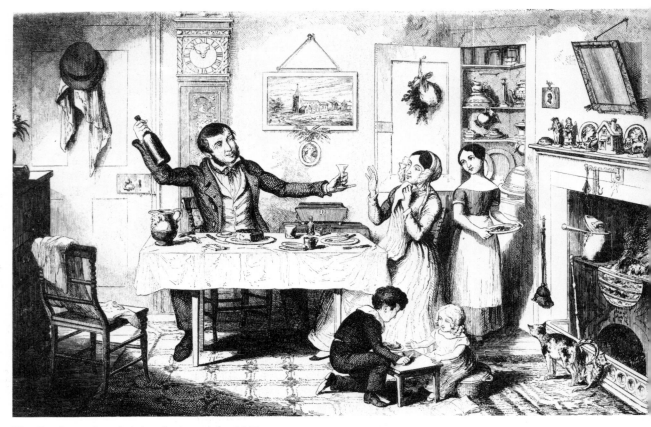

The Bottle: series of eight glyphographs 1847
1—The bottle is brought out for the first time. The husband induces his wife 'just to take a drop'.

2—He is discharged from his employment for drunkenness. They pawn their clothes to supply the bottle.

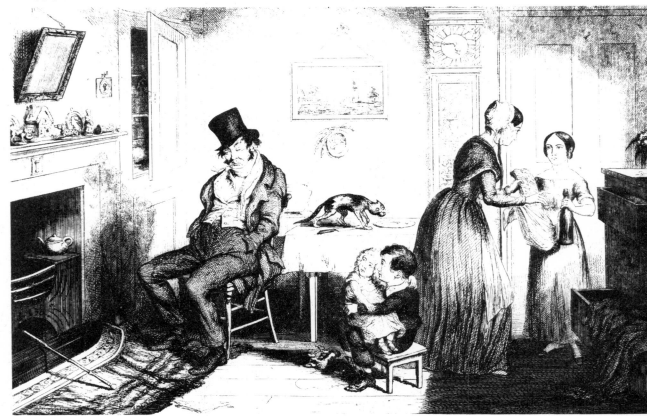

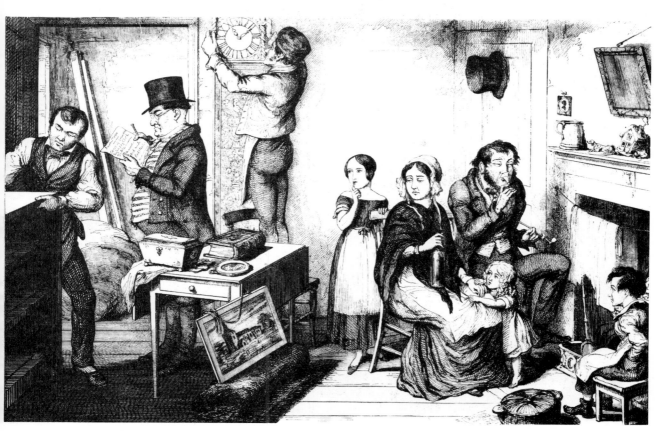

3—An execution sweeps off the greater part of their furniture. They comfort themselves with the bottle.

4—Unable to obtain employment they are drawn by hunger into the streets to beg.

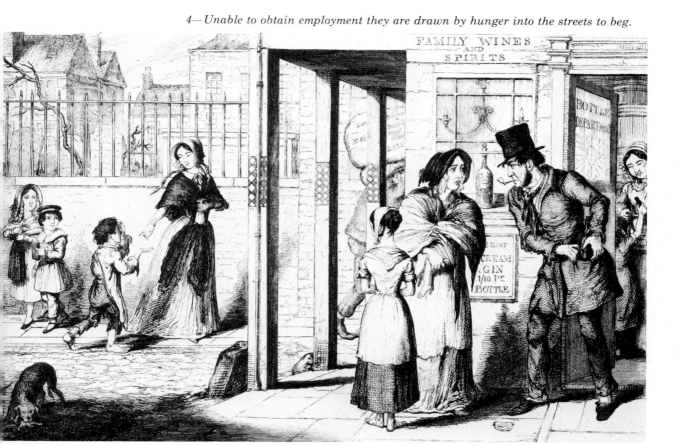

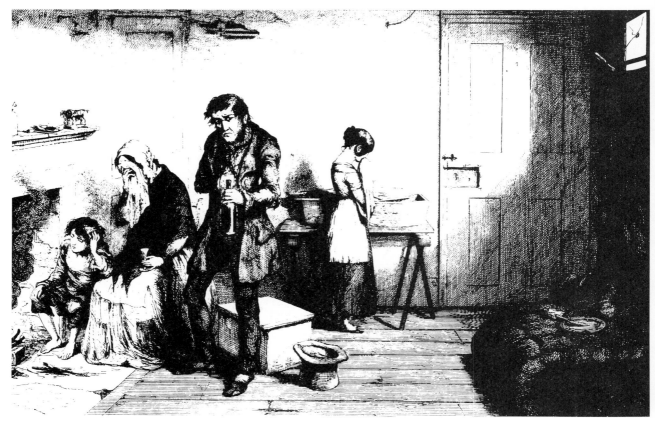

5—*Cold, misery and want destroy their youngest child.*

6—*Fearful quarrels and brutal violence are the natural consequences of the frequent use of the bottle.*

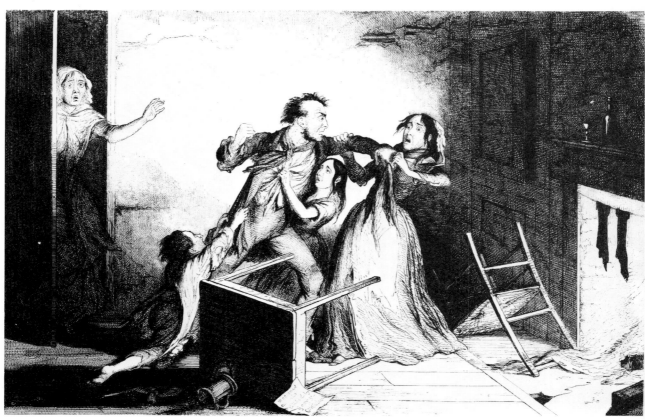

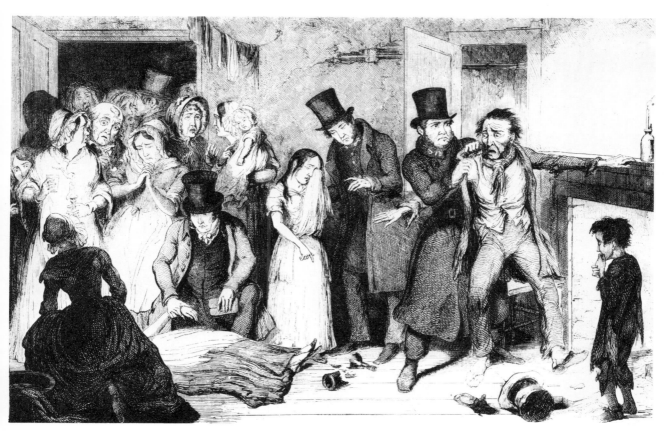

7—The husband kills the wife with the instrument of all their misery.

8—The bottle has done its work—it has destroyed the infant and the mother, it has brought the son and daughter to vice and to the streets, and has left the father a hopeless maniac.

At the time of his death, his obituary in *The Temperance Record* for 7 February 1878 said:

> In his time he must have attended thousands of temperance meetings, and at these few men were more welcome. The style of his advocacy was peculiar. He passed from grave to gay with facility, but he never lost sight of the great object he had in view. He seemed, for years, to be deeply impressed by the numerous murders that were taking place, all of them, or nearly so, being in the last instance, if not in the first, attributable to drink. He used to exclaim, with deep fervour, Can nothing be done to stop these dreadful murders?

A good many of his drawings appeared in *The British Workman,* a periodical devoted to the improvement of the working man's situation largely by

The Loaf Lecture: wood engraving from The British Workman *1855.*

In this picture which appeared on the first page of the first issue of this important journal devoted to the improvement of the working classes, George depicts the healthy father of a well-fed household demonstrating how little nourishment there is in beer compared with bread.

exhorting him to start by improving himself. But his efforts in the new cause were not confined to what he could do as an artist; his talents as an amateur actor–and, no doubt, his gift for comic songs and recitations–made him an effective public speaker. In 1854 when he chaired a Total Abstainers' meeting at the Sadlers Wells Theatre–so often the scene of more frivolous evening excursions–the *Illustrated London News* published his drawing of the scene, in which he depicted himself inviting members of the audience onto the stage to sign the pledge.

> This popular place of amusement was appropriated to a somewhat novel character–for a meeting of 'Total Abstainers'. There was, doubtless, some attraction for our thorough-going friends in the name of 'Wells' and in the convenient contiguity of the New River. . . . The Abstainers met in full force–Mr George Cruikshank in the chair; and by the very efficient aid of his humorous pencil, we are enabled to present our readers with the 'extraordinary' scenes which the theatre presented on this occasion.

After the Chairman had addressed the meeting, with much piquant and incontrovertible truth, an oration was delivered by the great Temperance advocate, J. B. Gough. At the close occurred the incident which Mr Cruikshank has described with his graphic pencil. It is well known that our Artist is a total abstainer, and naturally he was unwilling to lose so good an opportunity as then offered itself for swelling the stream to which he belonged. Accordingly he appealed to the audience to come forward and take the pledge. Nor was the appeal made in vain. A rush from box and pit and gallery was the result. A plank bridge was laid across from the pit to the stage, along which poured the living tide. A young lady was the first to lead the way: her devotion was rewarded with cheers, such as seldom resound in any theatre. Upwards of three hundred followed her example. The number would have been greater had not the evening been far advanced, and the weary scene-shifters anxious to get home to bed.

'Total Abstainers' Meeting in Sadlers Wells Theatre: wood engraving from the Illustrated London News *1854.*

George, who was chairman of the meeting, has drawn himself helping the first volunteer onto the stage.

George's missionary zeal was less cordially appreciated in the private circle. His friends might look upon these public exhibitions as a quaint eccentricity quite in character with George's former behaviour, but it was not so amusing when his reproaches intruded on normal socialising:

I remember, in the first year of his total abstinence, meeting him at a ball given in Fitzroy Square by Mr Joshua Mayhew, the father of Horace and the Brothers Mayhew. He danced and was light-hearted with the youngest; but when at supper the wine began to circulate, he stole round to the head of the table, and laying his hand upon the shoulder of the venerable host (who was a very haughty and quick-tempered old gentleman), said, in a deep, warning voice, 'Sir, you are a dangerous man.' Mr Mayhew had a glass of wine in his hand, and was about to drink a toast to the health of one of his sons, when Cruikshank's hand fell upon his shoulder. 'I look upon every wine-drinker,' Cruikshank added firmly, 'as a dangerous man, sir'. . . . Horace Mayhew burst into a hearty laugh, and told his father to go on, for it was only dear old George.

(Jerrold)

His own mother was furious when she read in a report of one of his meetings that he had declared, 'My mother first lifted the poisoned chalice to my lips!' for had she not always tried to restrain him from excess? He now did his best to convert her, but she, who had always been temperate, saw no reason to give up her pleasures entirely. So to the end of her days she took a glass of beer with her supper, and a little toddy at bedtime.

Though in the years immediately following his conversion, George undoubtedly made something of a nuisance of himself with the zeal of the newly converted, he soon came to terms with it, and his friends came to accept it as just one aspect of his behaviour which had, after all, never quite conformed with that of other people. So far as is known, there was never any backsliding – now that his mind was made up, he never looked back. But nor did he allow it to distort the pattern of his life; he continued to delight in parties and other social occasions, to enjoy life and to be the cause for enjoyment in others.

Not everyone thought so. Ruskin, in *Time and Tide,* declared that the effects of temperance on George had been such that it had 'warped the entire currents of his thoughts and life'. But Ruskin was an erratic judge at best, and we have already noted his preference for those early fairy etchings of the 1820s over any of George's subsequent work – a judgement to which he has of course every right, but which must strike the impartial observer as somewhat blinkered. My own personal opinion is that George's conversion to temperance had no adverse effect on his work at all, except insofar as it used up energy which might have been used for other ends. It is true that there is a falling-off in quantity from this point on in his life, but there are at least two other reasons for that. One is that his popularity was starting to diminish: he had been around for so long, the public was looking for new artists and new styles, as we shall soon be noting. We shall also be looking at the way, about this time, he started to look for other ways of expressing himself artistically, as though he, too, had had enough of the sort of work he had been doing hitherto. Such an aim, whether we approve or not, is certainly admirable – and equally certainly, cannot be blamed on his temperance! Over and above these particular causes, there is the simple fact that George was no longer a young man and we should not look for the same flow of work as before, nor for the diversity which is the result of youthful experiment.

But these explanations why he no longer produced the same *quantity* of work as formerly are not needed when we come to consider *quality* – for in this respect there is no discernible alteration for the worse. True, his propaganda work in the temperance cause is, for the most part, undistinguished, but 'The Bottle', at least, must be placed among his most important work so long as it is not judged – as we may suppose Ruskin was judging it – by inappropriate standards. It must be seen, first and foremost, as a piece of story-telling and, as such, it does a first rate job. Every detail tells, yet all combine to tell a unified story whose broad lines can be taken in at a glance. Without making any concessions to art, he produced a work of art; aiming only at putting across his message, he achieved a masterpiece of narrative compression.

Not all his other temperance work is so successful, but some of the plates from 'The Drunkard's Children', the less well known series which provides a sequel to 'The Bottle', are very fine. I would rank the plate in which the daughter flings herself into the river as one of his greatest concepts. Even a later series entitled 'The Gin Shop', done for the *Band of Hope Review* in 1868 when he was 76 years old, though not to be compared with 'The Bottle', is far from being negligible. As for the greatest of all his propaganda pieces, the

tremendous 'Worship of Bacchus', we shall discuss this at the appropriate moment in his career.

Many commentators on Cruikshank have followed Ruskin in suggesting that his conversion marked a complete break in his career—that Cruikshank after 'The Bottle' was not the same artist as before. As we shall see, this is nonsense. He continued to issue a flow of excellent work, entirely worthy to rank with his best from before his conversion. The 'Crystal Palace' series, the Fairy Books, 'Falstaff' and 'The Giant Bolster'—these and many others amply refute Ruskin and show that George's art, no more than his thoughts and life, had been warped by giving up drink.

The Drunkard's Home: etching for O'Neill's The Drunkard *1842*

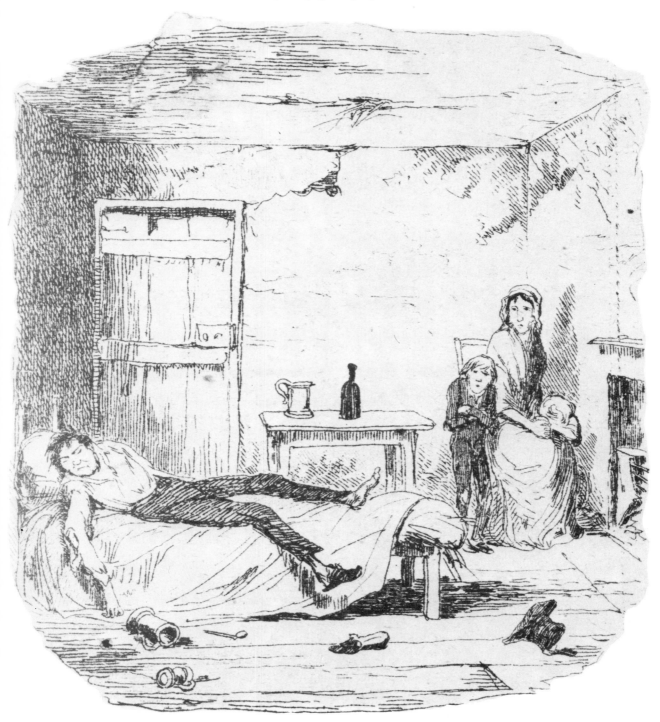

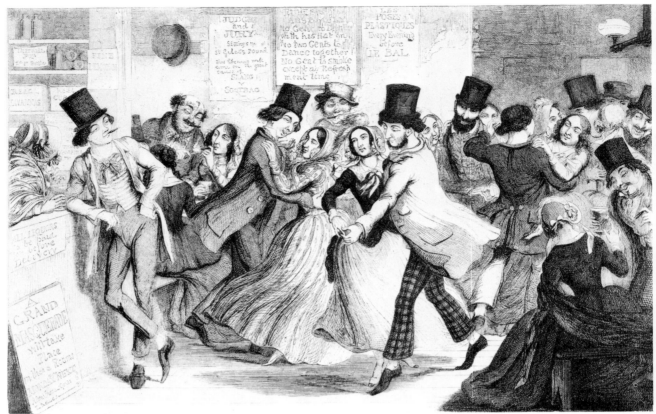

The Drunkard's Children: series of eight glyphographs, of which four are repro-
duced here. They continue the story of The Bottle, showing the fates that overtook
the drunkard's son and daughter. Though as a series the sequel lacks the intensity
of the earlier set, each individual scene is a superb combination of observation with
narration, showing how far the artist had progressed since Life in London.

3—From the Gin Shop to the Dancing Rooms, from the Dancing Rooms to the Gin
Shop, the poor girl is driven on in that course which ends in misery and woe.

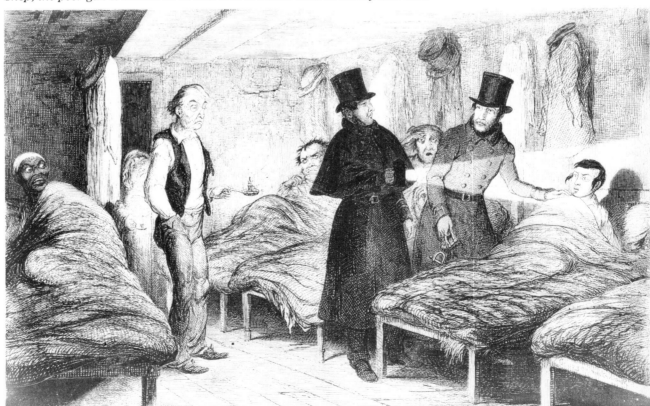

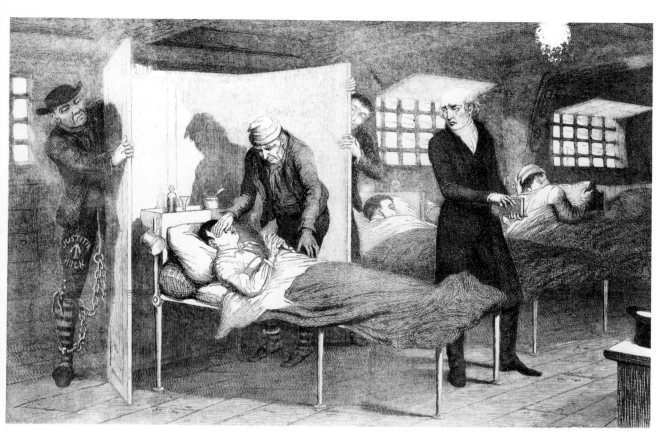

4—Urged on by his ruffian companions, and excited by drink, the boy commits a desperate robbery. He is taken by the police at a three-penny lodging house.
7—Early dissipation has destroyed the neglected boy. On a prison hulk, the wretched convict droops and dies.
8—The Maniac Father and the Convict Brother are gone. The poor girl, homeless, friendless, deserted, destitute, and gin mad, commits self-murder.

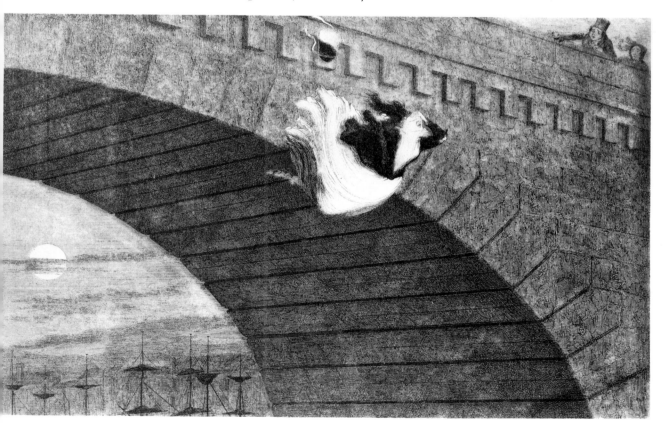

'Mr. Cruikshank
was irresistibly droll'

If the gin shop had been a frequent subject of George's for many decades, so
had the theatre, and as chance would have it, the year after he espoused the
temperance cause he was given his greatest opportunities as an actor.
Besides his known love of the theatre, we know from the many references to
his renderings of 'Lord Bateman' and other ballads that he displayed
considerable histrionic ability in these performances. So it is not altogether a
surprise to find that the *Illustrated London News,* commenting on an amateur
performance of *Plot and Counterplot* at the St James' Theatre on April 27th
1848 in aid of the Artists' General Benevolent Institution, noted 'the farce
was equally as successful, Mr Cruikshank in Pedrillo being irresistibly droll'.

Most of George's theatrical appearances were in the company formed by
his old friend Dickens, who shared in even greater measure his love of the
theatre. He had gathered round him a company of amateurs, who staged a
variety of plays on behalf of different good causes. On behalf of the
endowment fund for Shakespeare's birthplace at Stratford on Avon, Dickens'

*Pit, Boxes and Gallery:
etching from* The Sketch
Book *1836*

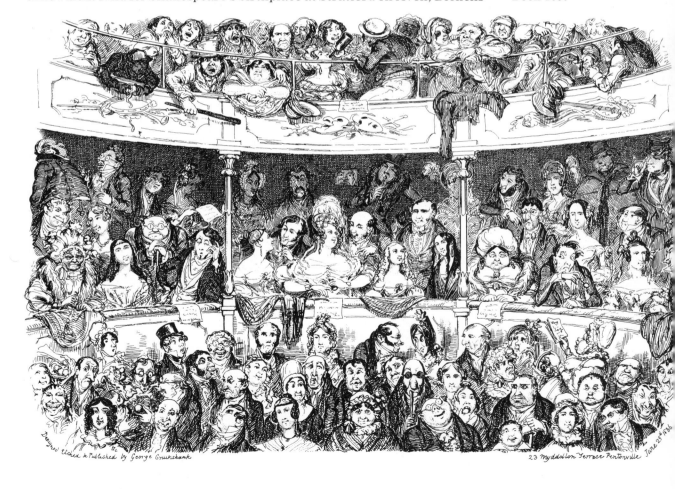

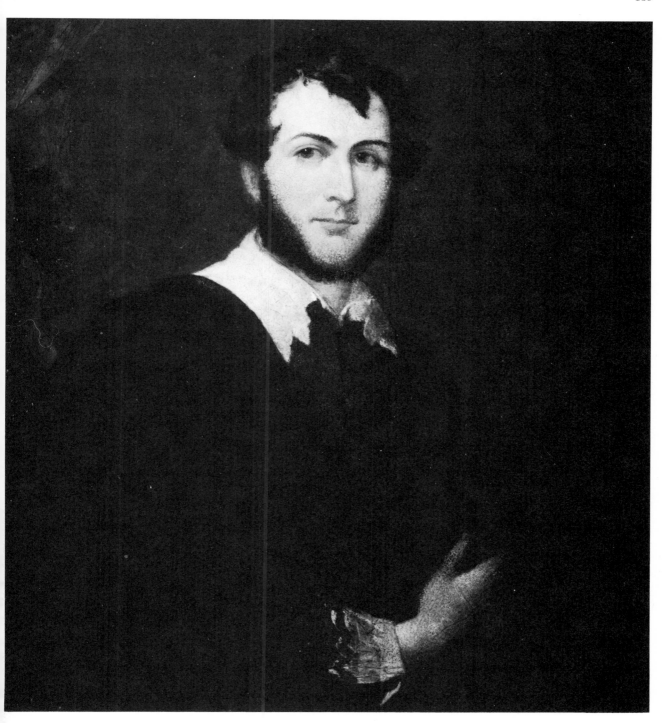

George Cruikshank in Costume of the Restoration Period: painting by an unknown artist, circa 1836.

Reproduced by permission of the National Portrait Gallery.

Was this the costume he wore for one of his stage performances?

company appeared at the Theatre Royal, Haymarket, on May 17th of the same year–doors open at 7.30, costumes by Nathan, evening dress to be worn in all parts of the house. In the first play, Jonson's *Everyman in his Humour*, George took the part of Oliver Cobb. After an interval during which the orchestra played Jullien's Prince of Wales Quadrilles, George appeared as Doctor Camphor in Kenney's farce *Love, Law and Physic*.

By all accounts it was a resounding success. The amateurs had been coached by no less than the great Shakespearean actor Macready. When he

had overcome his initial reluctance, the great man had to admit that, all things considered, they had done very well. Mrs Cowden Clarke, one of the many literary figures whose services Dickens had enlisted, reminisced fervently:

> What enthusiastic hurrahs at the rise of the curtain, and as each character in succession made his appearance on the stage! What times those were! What rapturous audiences a-tiptoe with expectation!

So popular was the production that Dickens was persuaded to carry his company to a number of provincial theatres, and so George found himself travelling to Manchester, Liverpool and Edinburgh, and twice each to Birmingham and Glasgow. The railways co-operated with the good cause by allowing the actors free passes. It may well have been the only occasion on which George visited these distant places. He must have enjoyed himself tremendously.

One cloud marred the period. In July 1848 his wife Mary became ill, while the company were rehearsing a new production, and George had to go home to attend her. After she had recovered, he hurried back to the company and embarrassed Dickens by asking if he could have his part again—that of a blacksmith in *Used Up*.

In the following year Mary died. For a while her death threw George into a state of depression—so much so, that his doctors begged him to fortify his spirits with wine. But even in his grief George remained true to his new principles. A year later he married again. Beyond the fact that we know her maiden name, we know scarcely more about Eliza Widdison than we do of her predecessor. Both remain shadowy figures, who perhaps appear in some of his pictures, but rarely in any written memorials. Eliza was, however, a daughter of the publisher C. Baldwyn, who had on occasion employed George: it would seem, therefore, that her marriage to George was not her first. We assume, since there are no facts to the contrary, that neither wife bore him any children. His second marriage took place on March 7th, 1850, and we may suppose that it was on the occasion of his marriage to Eliza that he moved his home a mile or two westwards to 48 Mornington Place, now No. 263 Hampstead Road, a neighbourhood in which he was to spend the rest of his life.

The Crystal Palace

On May 1st the doors opened on one of the most significant manifestations of Victorian England. The Great Exhibition was a symbolic recognition of Britain as a mercantile and manufacturing nation; an announcement that she wished the world to judge her by her economic and commercial achievements as well as by her military triumphs and political record. It was also a spectacular tribute to the middle classes of society.

The entire nation became, if only for a while, mightily pleased with itself, and though it provided the comic writers and artists with an irresistible occasion for their talents, pride in the occasion bursts through the humorous observations. George's contribution to the event splendidly reflects this. It took the form of a portfolio of etchings intended to accompany Henry Mayhew's *The World's Show, or the Adventures of Mr & Mrs Sandboys and Family*. His view of the opening ceremony, 'taken on the spot' from a vantage-point in the south-west gallery, is almost a straight representation of the event, but the rest of the etchings range from the gently humorous to the out-and-out fantastic. 'All the World going to the Great Exhibition' is a tour de force in his most imaginative vein; it is also a measure of George's superiority as an artist. While John Leech was giving *Punch* readers, week after week throughout the summer of the exhibition, his quaint and often delightful comments on the margin, as it were, of the exhibition catalogue, George in this plate has grasped the greater significance of Prince Albert's concept.

The Opening of the Great Exhibition, from a drawing made by George on the spot

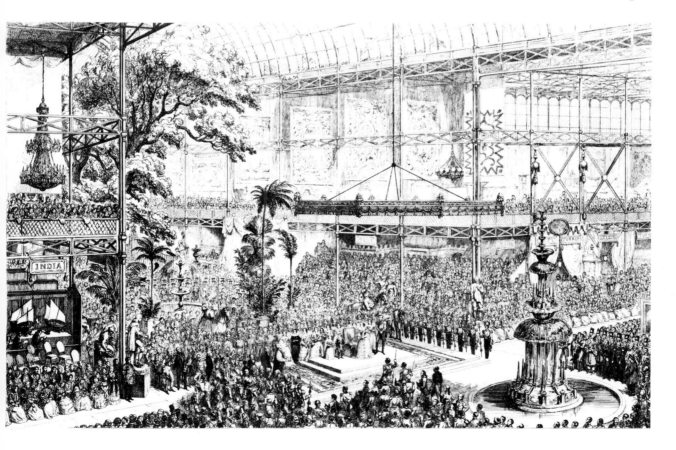

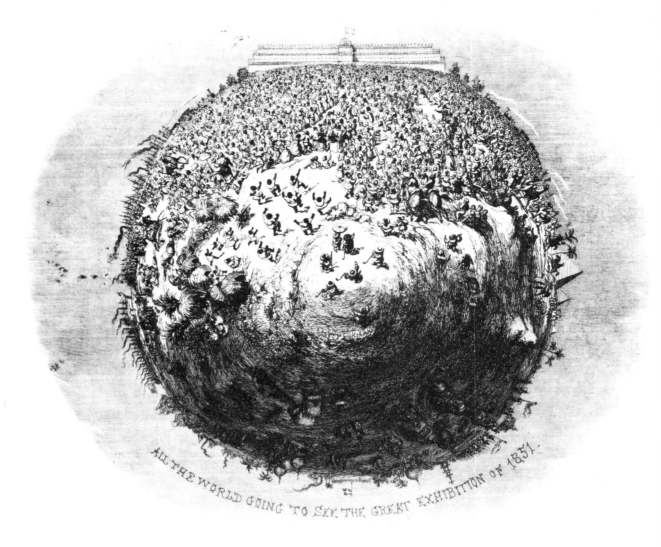

ALL THE WORLD GOING TO SEE THE GREAT EXHIBITION OF 1851.

All the World Going to See the Great Exhibition

above right: Piccadilly Circus in 1851

right: Manchester in 1851: etchings for Henry Mayhew's The World's Show, or the Adventures of Mr & Mrs Sandboys & Family *1851*

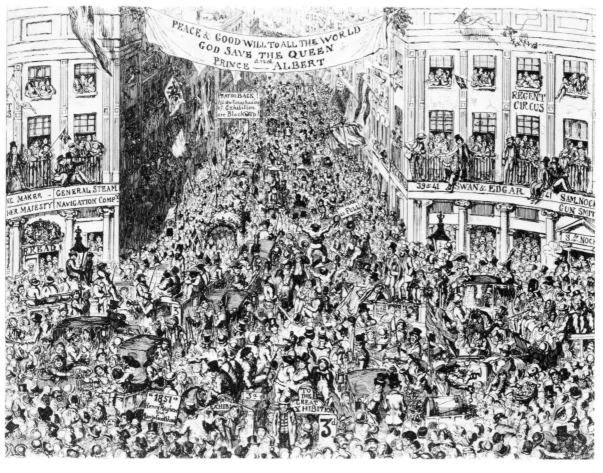

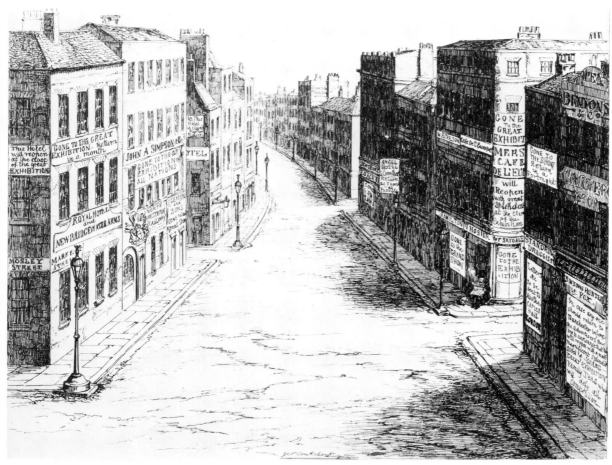

Contemporaries

The Great Exhibition was a turning point in English social history. It is not altogether inappropriate to see it as a turning-point in George's career. The England of the 1850s was a vastly different place from that in which he had grown up. The rowdy, reckless, cynical, outspoken England of his young manhood – the London of Tom and Jerry – had vanished almost entirely. Victorian England was just as capable of enjoying itself, but in a soberer, more measured, more discriminating, more considerate way, just as the hard-drinking artist-about-town of the 1820s had become the non-drinking non-smoking but still immensely genial George of 1851.

As an artist, George was now almost a national institution. He was nearly sixty years old, and he had been entertaining the world with his art for most of those sixty years. Some commentators have suggested that his work was going out of fashion, that whether or not he felt he still had plenty to say, the public was no longer so keen to listen. We shall see that there is perhaps a little truth in this, but we shall see also that he maintained a steady flow of work – and this work was produced, as it always had been, in response to the requests of publishers. If his output flows more thinly from this time on, the explanation, as has already been suggested, is partly that he was looking for new ways of expressing himself, and partly, quite simply, that he was now approaching his sixties.

right: Outdoor Relief: etching by Phiz (Hablot K. Browne) for James Grant's Sketches in London *1838*

A Children's Party: wood engraving by Richard Doyle for the Cornhill Magazine *1850s*

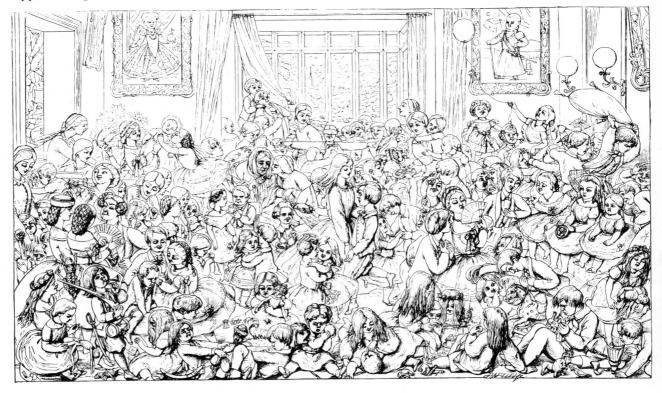

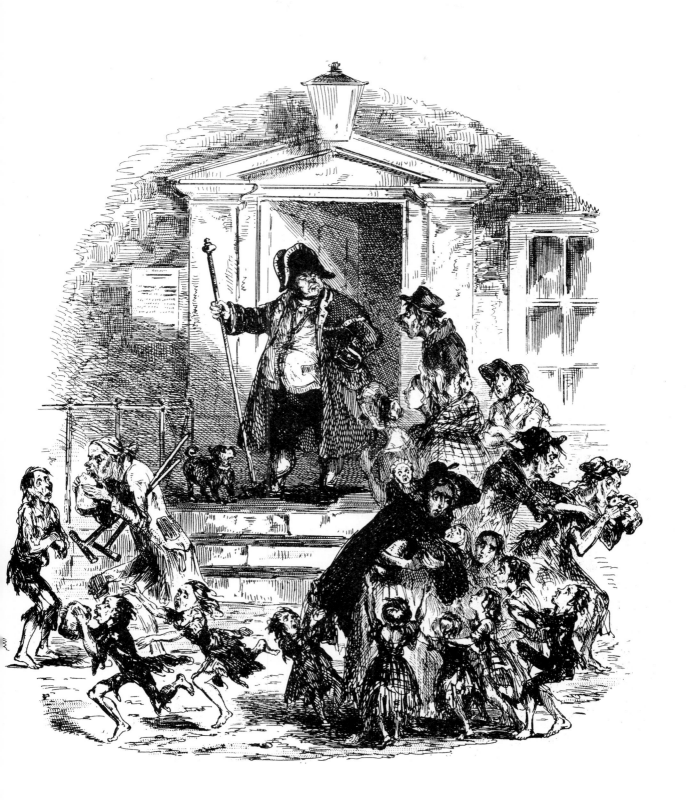

Nevertheless it is worth asking what truth, if any, there is in the proposition that George had become old-fashioned, his work no longer to the public taste, his attitudes out of key in late Victorian society? There is a whole book to be written on the way changing social attitudes in Victorian England were reflected in contemporary artistic taste, but I think the comparison just made with regard to the Crystal Palace pictures reveals at least one facet of the matter. Just as George shows us all the world coming to the Great Exhibition while Leech documents the difficulties encountered by visitors to the Fair, so late Victorian England, while conscious enough of the nation's role in world affairs, looked increasingly inward and concerned itself with domestic issues and social niceties. *Punch*, in particular, was to become by the end of the era little more than a looking glass for the upper middle classes, nor was it by any means alone in this; middle class England was still sufficiently new and unsure of itself to keep glancing in the mirror for reassurance.

The selection on these pages of illustrations by some of George's leading contemporaries has been chosen with no aim but to show characteristic specimens of these artists' work. They reveal the growing sentimentalism, a narrowing of outlook from broad social issues to the particular and personal. It wasn't so much that George's art was out of fashion, as the books which that art was designed to illustrate. The novel reader of the 1850s wanted Trollope, not Ainsworth; Barchester Close, not the Tower of London. And so, inevitably, she wanted Millais, not Cruikshank.

When George died in 1878, Russell Sturgis wrote a lengthy tribute for *Scribners Magazine,* New York. A young lady objected, 'But none of his fairies are pretty!' 'Alas,' Sturgis replied, 'fairies never were pretty, except in very modern books for children.'

Times were changing. Sixty-year-old George had to decide whether he, too, would change with them.

right: Was it Not a Lie?: wood engraving by Millais for Trollope's Framley Parsonage *1860.*

A Son and Heir: wood engraving by John Leech for Punch *1853*

A SON AND HEIR.

Son and Heir. "HOW MANY OF US ARE THERE? WHY, IF YOU COUNT THE GIRLS, THERE ARE SIX—BUT SOME PEOPLE DON'T COUNT THE GIRLS.—I'M ONE!"

Oils

In 1850 George exhibited an oil painting, *The Disturbed Congregation,* at the Royal Academy; it was purchased by Prince Albert, and is still in the Queen's possession. George had been encouraged to try his hand at oils by his old friend Clarkson Stanfield, the marine artist. For a professional as skilled as George, it was simply a matter of learning to master a new technique.

Though well received at the time—his *The Fairy Ring,* exhibited in 1855, was bought by a Mr Henry Miller of Preston for the very handsome sum of £800!—Cruikshank's oil paintings have never been highly regarded by posterity. The reason is clear enough: in this field he was matching himself against artists who had been doing oil paintings all their lives, and it was

The Disturbed Congregation

hardly to be expected that George, starting in his late fifties, could surpass them. The astonishing thing is that he did as well as he did. Though his earliest paintings date from before 1830, it was not until after 1850 that oils were anything but an occasional diversion. Then, over a period of nearly two decades, he exhibited regularly at the Royal Academy and the British Institution. The subjects were typical salon themes–Tam o'Shanter (Academy, 1852), A scene from *The Midsummer Night's Dream* (Academy, 1853), Cinderella (Academy, 1854), The Runaway Horse (British Institution, 1855), Cinderella again (Academy, 1859), Shakespeare on the stage of the Globe Theatre, 1564 (Academy, 1867), and so forth.

Coming from any other artist but George Cruikshank, they would have been sufficient to make a small but solid reputation. But it is difficult to evaluate them independently of his graphic work. Though many of his characteristic traits are as apparent in the paintings as in the etchings, we miss the *most* characteristic–which is the 'feel' of George's hand in the way a line is set down on the paper, the way so much is said while appearing to say so little. Just look, by way of example, at 'The Happy Family' from *The Comic Almanack* for 1849 (page 15). Consider the girl reading on the left . . . how

Tam o'Shanter

economically she is drawn, how little care the artist seems to have bestowed
on her – and yet her whole pose tells us so much about her that it is almost as
though she were drawn from life. And yet I don't suppose she was, and I don't
suppose George gave her very much conscious thought. He just put her there,
like that, because 'there' was where she had to be and 'like that' was how she
had to be. She just came naturlly.

And it's that 'naturally' which marks the difference between the etchings
and the oils. For all his considerable facility in the new medium, it didn't
come naturally to him. He must have felt this himself, for on April 22nd 1853,
at the age of sixty-one, George Cruikshank enrolled as a student in the Royal
Academy Schools.

It was a splendid gesture, and wonderfully in character. It is easy to think
of George as a proud man, and he certainly took the pride in his work that
every artist should take. But that it was a legitimate pride is shown by the
fact that when he felt unhappy about his work – when it was work of which he
felt he had no right to be proud, despite Albert's princely purchase – then his
pride became humility and the greatest illustrator of his day was ready to go
back to school.

Except that of course it wasn't a matter of going back. He never had been to
school, not as an artist. His art had been learnt by practice, not from lessons,
and his skill came through the hands, not the head. According to Charles
Landseer, art student George 'made very few drawings in the Antique and
never got into the Life'. An ironic comment on a man who had been in life for
half a century.

*Self Portrait as a student in
the Academy Schools*

The Last of the Comic Almanack

IT NEVER REIGNS BUT IT BORES.

It never reigns (Napoleon III)

The happy family (a quiet hint)

Whatever else happened in George's life, *The Comic Almanack* kept going. To his friends it must have seemed a permanent feature of his life. In the late 1840s, however, there were signs that the public was no longer so enthusiastic. To encourage greater sales, in 1848 he and his publisher David Bogue tried the experiment of reducing the size and cutting the cost from half-a-crown to a shilling. However, this didn't produce the hoped-for effect, so they reverted to the original format. In 1849 Henry Mayhew took over as editor until 1852, then in 1853 Robert Brough, whose *Falstaff* George was later to illustrate so superbly, took over for what was to prove the Almanack's last year. At the end of 1853 it was felt that the nineteen-year-old publication had reached the end of its useful life. Bogue planned to replace it with a more ambitious publication, more on the lines of the *Omnibus; Cruikshank's Magazine* was launched in December 1853 but was abandoned after the second issue.

And yet there was no sign of fall-off either in George's technical skill nor in his imaginative quality. These four plates from the final years of the Almanack are as good as any he ever did for the publication, the detail as well observed, the social comment as perceptive.

The Happy Family.
"A Quiet Hint to the Wives of England"

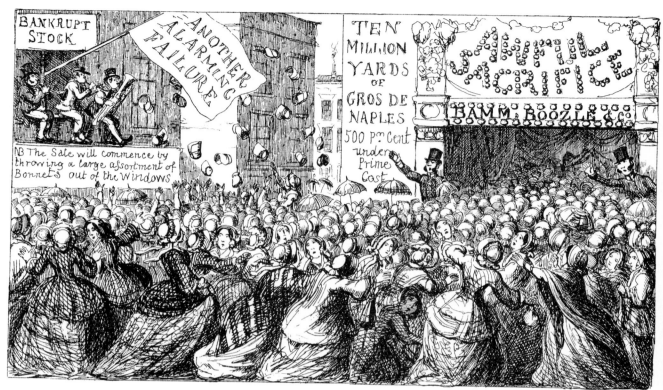

Satire on sales

Fine couple (Will you be our vis a vis?)

Fairies and Farmers

George had always been at his happiest with the odd and the grotesque–drawing menacing ogres and long-nosed dwarfs with the same ease and familiarity as he drew pickpockets and parish beadles. As a boy of seven he had helped his father carry out a series of illustrations to *Baron Munchausen,* one of which is thought to have been the young artist's own design: it would have been one of his very first productions. And his very last etching was to be the frontispiece to a fairy tale.

There are many ways of delineating the supernatural, but they fall into two chief divisions. One school insists on the inhuman and monstrous aspect, emphasising the gulf which separates it from our everyday experience, stressing the other-worldliness of it all. For others, on the other hand, the weird and the wonderful are kept to human proportions if not to human size, so that the supernatural astonishes rather than alarms. George was emphatically of the second persuasion. His apparitions appear in human settings, there is nothing transcendental or ethereal about them and assuredly nothing mystical. They perform mischievous pranks on humans, in human settings, using human apparatus. They are not terribly frightening, they are often not maleficent so much as malicious. His human monsters are far more terrifying than his inhuman ones, Jack the Giant-killer's Giant is not half so awful as Oliver Twist's Fagin.

In 1853, the same year as he took up studies in the Academy Schools, he produced some work which demonstrated how little he needed what the academic teachers had to teach him. His etchings for the series of *Fairy Books* published by the faithful Bogue must be ranked among his finest productions, and among the most effective illustrations ever created for these well-known tales. Perhaps it is a pity that he was also allowed to provide the text, for he took it upon himself to edit the stories so as to make them illustrate the causes he held dear. In a paper entitled *Frauds on the Fairies,* in his magazine *Household Words,* his old friend Dickens gently mocked George for turning the protagonists of the nursery tales into spokespersons for temperance and other hobby-horses. In January 1854, in the second and final issue of *Cruikshank's Magazine,* George defended himself with the same good humour–and managed to score several telling points off his old friend.

But then as now, it was not for the words but for the pictures that readers turned to Cruikshank's *Fairy Books,* and we no more read them for their moral teachings than we do Perrault or La Fontaine. We may be the more inclined to forgive him when we recall that he was still a fresh convert to the temperance cause, and perhaps had not fully learned how to integrate it with the other features of his life. The *Fairy Books* are almost the only instance where his moral fervour is allowed to intrude upon work not specifically intended as propaganda.

He continued to produce a flow of work which, if not so great in quantity as earlier in his life, was still impressive by most artists' standards. It would certainly be irksome to mention all his work even at this stage of his career; mention of a few of the more interesting works must suffice. In 1850 he

overleaf: Jack & Beanstalk (2 plates)

Jack and the Fairy Harp, escaping from the Giant.

The Fairies tie the Giant up in the Bean-Stalk.

Designed & Etched by George Cruikshank.

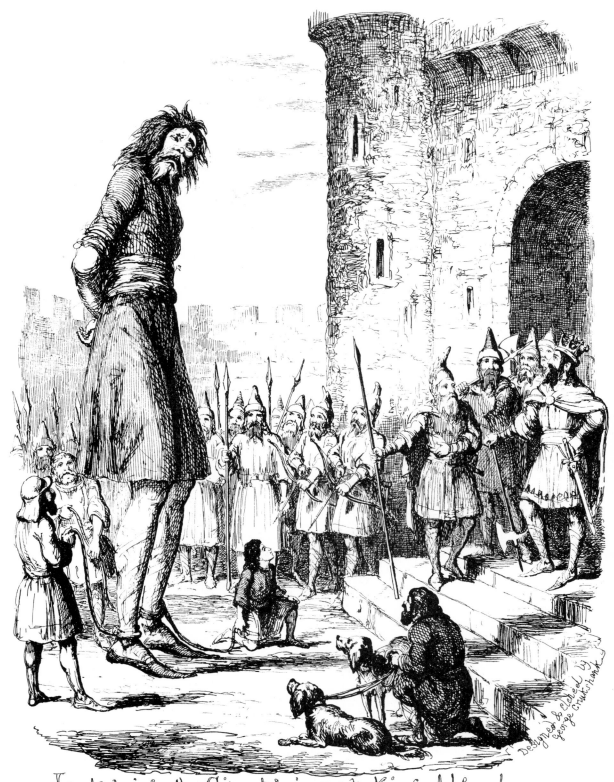

Jack brings the Giant prisoner to King Alfred.

Jack & Beanstalk

Hop o my thumb: etching from the Fairy Books *1853*

The Giant Ogre falls asleep, Hop o my Thumb pulls off the Seven League Boots whilst his Brothers run away

Mad Bess: etching from F. E. Smedley's Frank Fairleigh, *published in parts 1850*

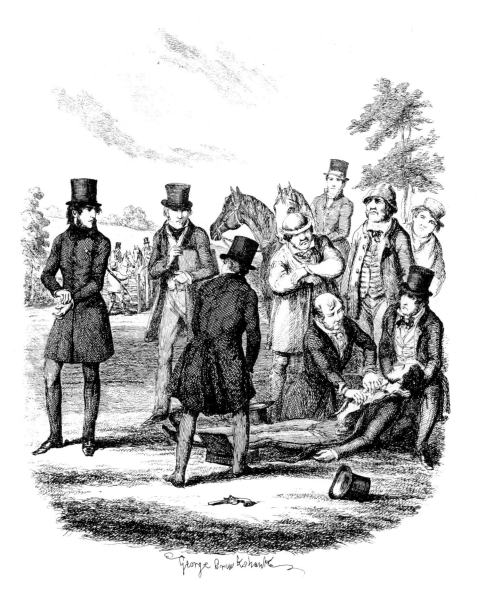

illustrated another picaresque novel, Smedley's *Frank Fairleigh,* with a
series of etchings which show his ability to handle contemporary themes with
the same relaxed mastery as he had brought to Ainsworth's historical
romances ten years earlier. The grouping of the figures in 'The Results of
giving Satisfaction' has a balance which gives the picture tremendous
power—yet the scene is so naturally conceived, so well integrated into the
landscape and set off against the distant action, that the visual balancing of
the successful duellist against his victim and surrounding friends appears the
result of mere chance.

Also from this period is his view of Vanity Fair, for Bunyan's *Pilgrim's
Progress.* George had first done some illustrations for the great noncon-
formist classic in 1816; later in his life he was to produce a series of twenty-
five wood engravings which are of very slight merit. But this single etching,

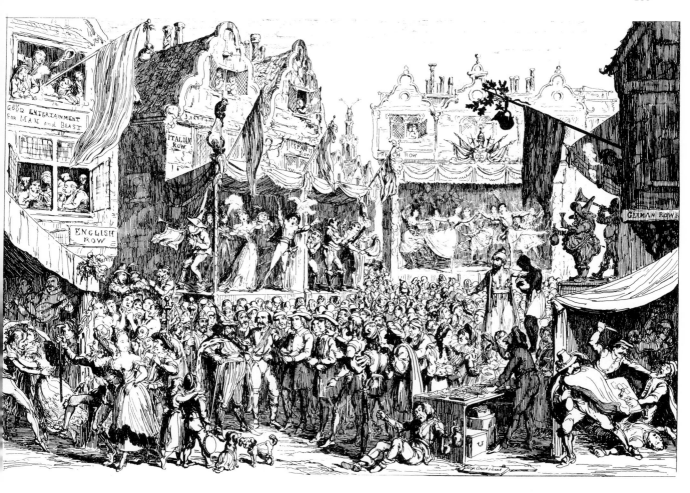

Vanity Fair: etching from Bunyan's Pilgrim's Progress

produced for an undated edition, succeeds better than perhaps most other scenes from the book might have done, because it found George on the familiar territory of the city street which he could people with the characters he knew so well – the actors, the street traders, the ruffians.

In 1852 he provided the illustrations for a work almost as uncharacteristic as Pettigrew's *Egyptian Mummies* – C. W. Hoskyns' *Talpa, or the Chronicles of a Clay Farm.* How George came to be illustrating a book which is described as 'an agricultural fragment', I have no idea, but it drew from him some of the most inventive minor wood engravings of his career. No other artist that I know of ever tried to personify agricultural soil – even Arthur Rackham, who gave human faces to most natural things, never dared as much. And George's figure of Jack Frost, battering fiercely at the farmer's door, is a splendid creation, as is the 'iron horse' which may one day replace the horse-cab. . . . But though the railway rattles past the heron's pool, we have still much to learn from nature – the farmer can learn from the mole. In these *Talpa* engravings George is not, of course, being stretched to his greatest powers: but this only makes his performance the more impressive, bringing to each little sketch an inventiveness that gives each one a touch of his genius. Each illustration reveals the artist taking his subject, giving it thought, and adding an extra dimension which a lesser artist would not have bothered to look for. Here, on a small scale and so the more easily recognised, is 'the Cruikshank method' admirably demonstrated.

"Mingle, mingle, mingle,
Ye that mingle may"

"A sort of jovial rebellion against the long despotism of Jack Frost."

Harrowing

Jack Frost at the Farmer's Door

'The willing giant stands idly panting and smoking.'

The Willing Giant

Heron by the Railway

below: Countryfolk Learning from the Mole: wood engravings for C. W. Hoskyns' Talpa *1852*

'We shall learn of him another and a greater lesson, some day.'

Falstaff: etching for Robert Brough's The Life of Sir John Falstaff, *published in parts 1857*

When we turn to 'Falstaff' we can see the same method operating on a higher level. The illustrations George did for his friend Robert Brough's *The Life of Sir John Falstaff,* in 1857, show the artist at the top of his form despite all his sixty-five years. Whatever he may privately have thought of Falstaff's drinking habits does not appear in this imaginary portrait which presents Shakespeare's character in uncavilling sympathy, no blame, no mockery, only a wholehearted salute from one enjoyer of life to another.

'A Free Man'

When in his seventies, George caught a burglar on his premises. According to an article which appeared in *Mayfair* at the time of his death, 'while keeping a firm grasp of the thief with his left hand, the doughty little painter felt his own pulse with the other, and, finding that the accustomed 75 beats to the minute had not been increased by a single one in spite of exertion and excitement, he gravely began to enlarge upon the benefits of temperance, comparing his own calm with the thief's panting condition. That the rogue was also a drunkard he assumed as a matter of course. In this strange condition the pair were found by the policeman.' When he pointed out that he himself drank nothing but water, 'I wish I'd ha' known that,' replied the unrepentant thief, 'I'd ha' broken your head for you'.

He might not have found it so easy. George in his sixties was a strong and healthy man: a hearty eater, an early riser, a vigorous walker and a hard worker. Much of the work consisted of his efforts in the temperance cause. There had been no reneging on his principles, even though he had learned to be somewhat more discreet in private life about the way he obtruded his sympathies upon his friends. But he was in constant demand at lectures, where he took a characteristic pleasure in demonstrating to audiences how he could hold a glass of water steady on his outstretched hand. Teetotalism was no abstract cause to him, but a real and personal feud. On one occasion, walking with an acquaintance, he happened to pass the shop window of a wine merchant who had received much of his custom in former days. He drew up sharply before the shop, and called out fiercely, 'Give me back my thousand pounds!' And of smoking, which he had given up three years after giving up drink, he observed, 'To that vice I was a slave for many years, but now I am a free man.'

His artistic talents were called for, in 1852, on behalf of a more serious form of slavery; he was asked to illustrate an edition of Harriet Beecher Stowe's *Uncle Tom's Cabin*. But the plight of the American negro, however sincerely

Uncle Tom and Eva: wood engraving from Harriet Beecher Stowe's Uncle Tom's Cabin *1852*

George might sympathise with it in principle, was something too remote from his personal experience. His illustrations suggest a lack of personal familiarity with the situations he has to depict, and for once his imagination fails to provide what his knowledge cannot supply. In consequence, there is none of that sharpness of sympathy which comes from a first-hand acquaintance with the evil. It has been suggested that the disappointing quality of these illustrations is due to poor workmanship in the cutting of the blocks, but the fault lies deeper. The drawings themselves never rise above the level of competence–they lack fire and imagination.

One might have feared that it was George himself who lacked these qualities–that age was sapping his old enthusiasm. But his work on subjects closer to home proves the contrary. In 1859 the first public drinking fountain in London was erected on Snow Hill, thanks to the efforts of the temperance agitators. The event was celebrated by George in a rather too syrupy engraving for *The British Workman,* but he made better use of it in a pair of lithographs, 'Gin' and 'Water'–for all their crudity, they have a vigour to them which is totally lacking in the *Uncle Tom's Cabin* illustrations. Even his

The First Public Drinking Fountain in London: wood engraving from The British Workman *1859*

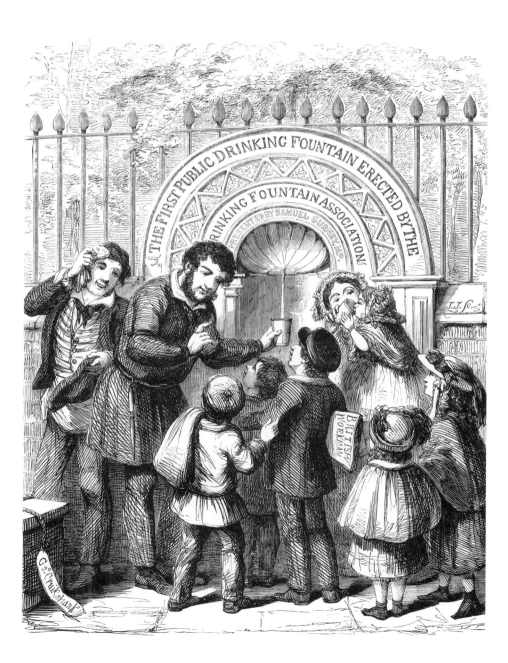

overleaf: Gin and Water: lithographs 1859

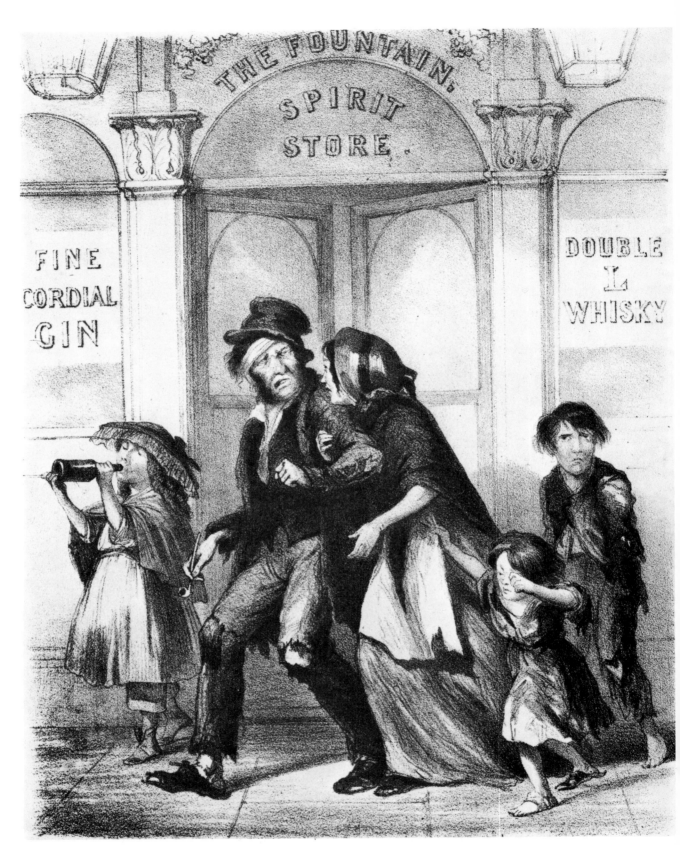

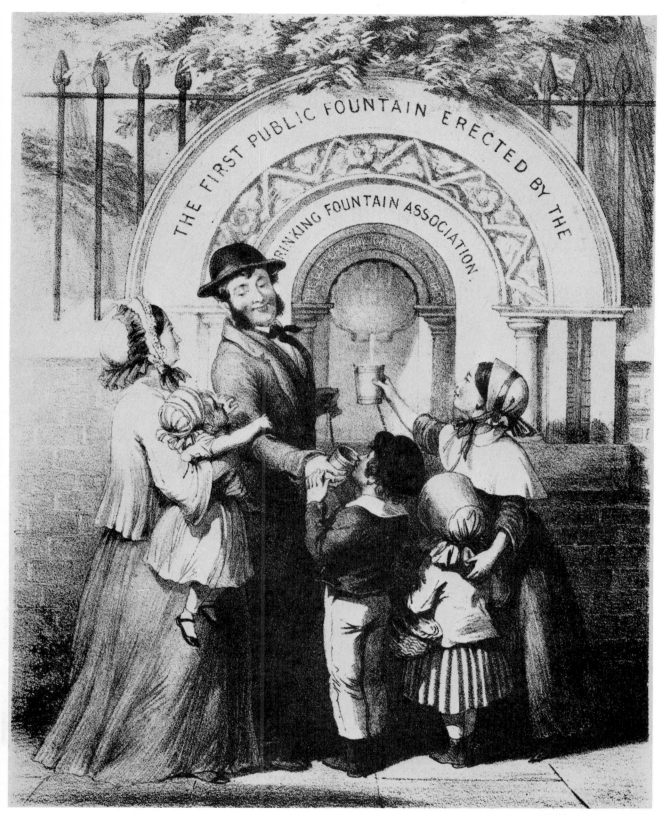

THE FIRST PUBLIC FOUNTAIN ERECTED BY THE RINKING FOUNTAIN ASSOCIATION.

W A T E R .

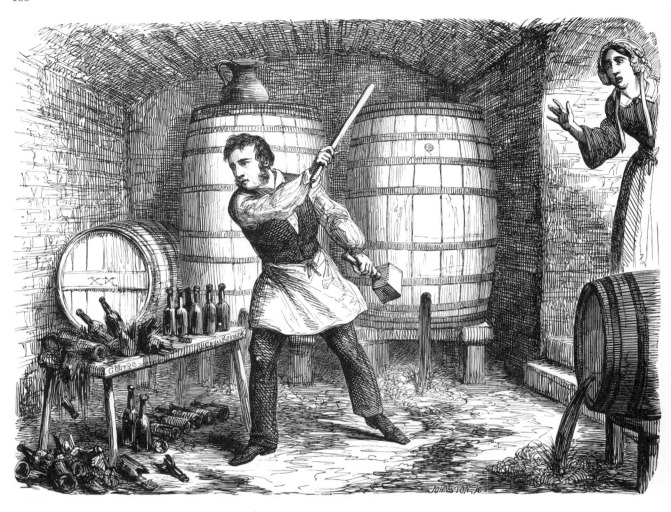

drawing of 'The Landlord of The Grapes emptying the casks and demolishing the bottles in his cellar' possesses a rough boldness which, if it doesn't make for great art, serves to drive the message home with the single-minded drive that propaganda must achieve.

George's energies were also being directed to another good cause. For reasons hard to understand today, there was a genuine fear in 1859 of a French invasion of Britain, despite the fact that a few years previously the two nations had been fighting side by side in the Crimea. Throughout the country, patriotic citizens formed into regiments, drilled and manoeuvred and familiarised themselves with matters military. The Volunteer movement roused all George's latent love of soldiering, thwarted back in 1815. Now he helped to form the Havelock Volunteer Temperance Corps (Havelock, one of the heroes of the recent Indian Mutiny, was a fervent teetotaller) of the 48th Middlesex Rifles Militia, and at the age of 67 became its Colonel, a position he retained for the next ten years despite complaints from his subordinates that he was too old for the job. When some of them made their complaint official, the War Office ordered all fourteen signatories to be cashiered, leaving the regiment with only a handful of officers. Faced with such a crisis, George resigned his command; it must have been a bitter decision. Once again he had had the chance to wear a splendid uniform, and though the trousers he wears in Mayall's photograph are baggy, that was the fashion of the time, and the

The Landlord of the 'Grapes' Emptying the Casks and Demolishing the Bottles in his Cellar: wood engraving from The British Workman *1864*

George Cruikshank as Colonel of the Volunteers: photo by Mayall, reproduced by courtesy of the Greater London Council

George Cruikshank: from a carte-de-visite photo

overleaf: The Worship of Bacchus: etching 610 x 980mm by George Cruikshank and Charles Mottram from George's painting 1864. Reproduced by courtesy of the Victoria & Albert Museum.

rest is all exceedingly splendid, from the plumed helmet to as romantically dashing a sword as any of his Ainsworth heroes ever wore at his thigh!

But his Colonelcy was much more than an excuse for wearing a fancy uniform. Of the small quantity of Cruikshank correspondence which has survived, a very great part is made up of Volunteer business–coping with applications and appeals, dealing with disputes and differences of opinion. He took his military duties as seriously as he took any of his responsibilities, and this no doubt helped him to feel he was serving his country. But the French didn't invade; the threat of war, real or imaginary, evaporated; there was no enemy for him to use that sword on. So he turned his attention again to the enemy he knew to be only too real, only too well entrenched on English soil.

168

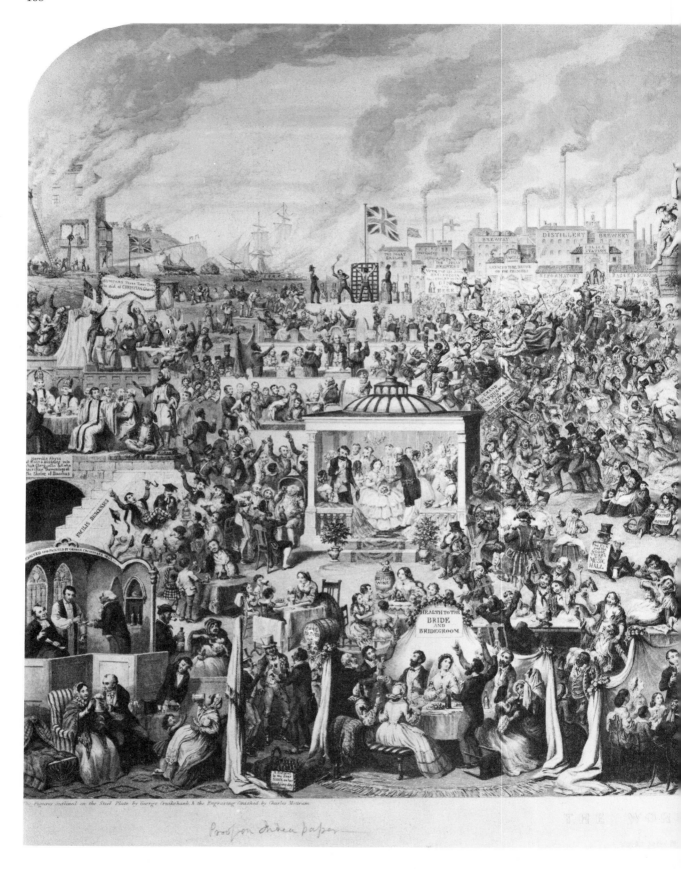

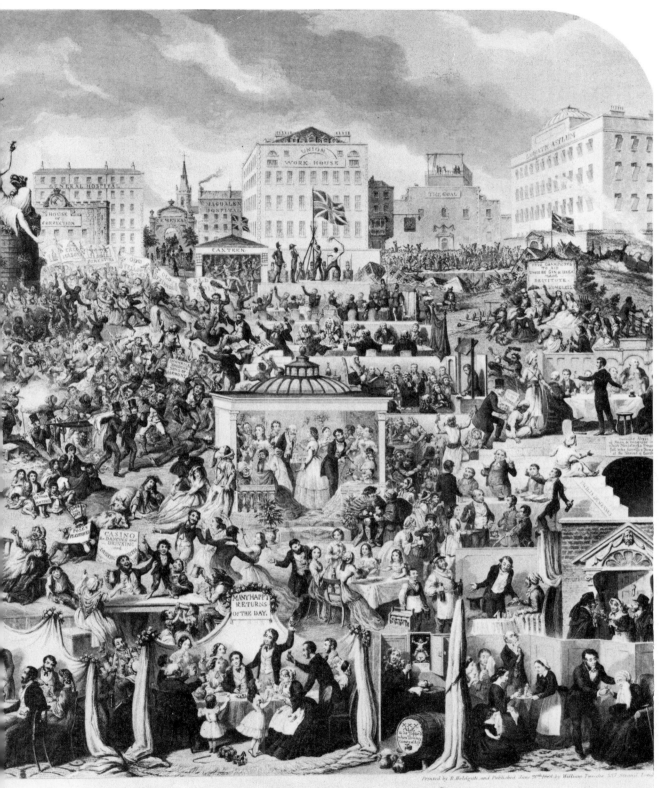

The Worship of Bacchus

In a quiet little room in Exeter Hall a veteran lecturer is holding forth all day upon a subject which moves his heart very strongly. . . He will show you how all ranks and conditions of men are deteriorated and corrupted by the use of that abominable strong liquor: he will have patience with it no longer. For upwards of half a century, he says, he has employed pencil and pen against the vice of drunkenness, and in the vain attempt to shut up drinking shops and to establish moderate drinking as a universal rule; but for seventeen years he has discovered that teetotalism, or the total abstaining from all intoxicating liquors, was the only real remedy. . . His thoughts working in this direction, one day this subject of 'The Worship of Bacchus' flashed across his mind.

<p style="text-align: right">Thackeray, in The Times, 15 May 1863</p>

In the year 1862 George invited a number of friends to his studio in Hampstead Road to consider a new project. He had a rough sketch in oils to show them. It was the sketch for a giant work, more than four metres in width, which would express everything he had to say on the subject of the evil of drink in one vast panorama. It was the biggest, boldest project he had ever proposed in all his seventy years.

His friends were not unnaturally impressed, but how was the thing to be done? Of George's technical ability they had no doubt, nor of his industry; they knew that what his mind could conceive, his hand could accomplish. But such a work as this would occupy even the fast-working George for months, even years. How could he be supported financially until the work had been brought to completion? And even then, could he be sure of getting a just return for so much effort?

Between them, his friends devised a scheme. First, George was to make a complete water colour sketch of the picture. From this, an etching was next to be made, and the sale of these prints would be the first source of income; then George would make an oil painting, whose sale would form the second phase of the operation. A committee of friends agreed to capitalise the undertaking, paying George his expenses while the project was in progress so that he would not need to do any other work. They would get their money back from the sales of the etching, while the sale of the painting would give George his reward. It was all very practical and logical, and seventy subscribers were found, who, between them, put up more than £1000 by way of advance funds.

To begin with, all went well. Then one day one of the committee visited the studio, and found George at work on the oil painting. The canvas had been prepared, the figures sketched in. Since the subscribers were anxious to see the etching completed as soon as possible so as to get a return on their money–after all, with an artist who had already reached his allotted span of four score years and ten, one had to be realistic!–they accused George of failing to honour their agreement. In his defence, George replied that no man could etch all day and every day; painting was his way of relaxing. His explanation was accepted, and he promised to do as much etching as he could each day.

In the event, he continued not to play entirely fair–work on both etching and painting continued side by side. The committee of subscribers had second

thoughts about the way the picture should be promoted, and when, after a year and a half of work, George completed the painting, it was decided to exhibit it, so as to stimulate interest in the etching. In Exeter Hall, close to the Lyceum Theatre in Wellington Street, Strand, the huge painting–thirteen feet four inches wide and seven feet eight inches high–was exhibited along with one hundred and forty seven other pictures or groups of pictures:

> I remember seeing him in his exhibition room. It was empty. There was a wild, anxious look in his face when he greeted me. While we talked, he glanced once or twice at the door, when he heard any sound in that direction. Were they coming at last, the tardy, laggard public for whom he had been bravely toiling so many years? Here was his last mighty labour against the wall, and all the world had been told that it was there. His trusty friend Thackeray had hailed it in *The Times*. A great committee of creditable men had combined to usher it with pomp into the world. All who loved and honoured and admired him had spoken words of encouragement. Yet it was near noon, and only a solitary visitor had wandered into the room.
>
> (Jerrold)

It is not easy to explain such indifference. One would think that the temperance movement alone would have accounted for a steady flow of visitors. For George, not to mention his subscribing friends, it was a bitter disappointment. He offered to take it to Windsor to show it to the Queen. Her

Contemporary comment on 'The Worship of Bacchus': anonymous wood engraving from London Society *1863*

Majesty was graciously pleased to inspect it, so the vast work was trundled all the way to Berkshire and back again. Even that didn't do much to drum up interest. On its return to Exeter Hall, George would stand beside his painting, tirelessly explaining its myriad details and showing how what starts so innocently can have such tragic consequences:

> I have not the vanity to call it a picture, it being merely the mapping out of certain ideas for an especial purpose, and I painted it with a view that a lecturer might use it as so many diagrams, so that the mind might be operated upon through the ear as well as the eye, at the same time.
>
> (Cruikshank's accompanying pamphlet, 1862)

A provincial tour followed, but this barely covered its expenses. In the following year George set to work to complete the etching. The procedure was for him to etch the outline of each figure, and his assistant Charles Mottram would then fill in the details, referring to George's sketches for guidance. The finished print was about a quarter as wide as the painting, but how well it sold is not recorded, and we do not know whether the subscribers ever got their money back. The painting itself went first to the South Kensington Museum (now the Victoria & Albert) in 1869, and then passed to the Tate Gallery.

Getting into the Tate Gallery's storerooms is only slightly easier than entering the Bank of England, but if you do, you can be shown George's painting, safe from robber and rot, damp and damage. But a hundred years of neglect have done their work, it is thick with dust, and even the strongest light gives you only a hint of what lies beneath. But it is evident that we have here, if not a great work of art, certainly a very important Victorian painting–the ultimate expression of a certain aspect of Victorian art, the picture with a moral. Taste changes with the years. In 1891 the critic Frederic G Stephens wrote of:

> . . . that terribly unpicturelike picture and huge unwieldy jumble of discordant elements, the so-called Worship of Bacchus. . . villainously executed as a whole and outrageously ridiculous in parts.
>
> (A Memoir of George Cruikshank)

Of course we see what he meant, but it is equally evident that Stephens, like Ruskin and many other critics before or since, was judging George's work by the wrong set of standards. Where art is evaluated for art's sake, The Worship of Bacchus doesn't stand a chance, but then it isn't a contender in that contest. Success, for George Cruikshank, was not a patronising pat on the back from the art journals, but the response of an actor who, after standing before the painting at South Kensington and taking in all its details, burst into tears, dashed out of the museum, took a cab directly for George's house, and then and there signed the pledge.

I believe that if 'The Worship of Bacchus' were to be cleaned and restored and hung in the Tate today, there would be a crowd continually before it. Despite his own disclaimers to the contrary, the separate scenes add up to an integrated totality of immense power. We can feel that power even while we do not wholly share the belief which inspired it, just as an atheist can be awed by King's College Chapel, and for the same reason. For here is the mind of man reaching out for a solution, hoping to trace a pattern, trying to impose order. Superficially, yes, 'The Worship of Bacchus' is about the harm that drink can do, but it transcends its subject just as King's College Chapel transcends theology. It may be propaganda, but only a great artist could have created such a masterpiece of propaganda.

The Old Reformer

Many of us who did not know him at home have at least met him about; for not only was he a familiar figure of the dreary quarter which he inhabited–where the dingy squalor of St Pancras touches on the shabby respectability of Camden Town–but he travelled much in London, and may well have been beheld handing his card to a stranger with whom he had talked casually in a Metropolitan Railway carriage, or announcing his personality to a privileged few who were invited to see in him the convincing proof of the advantages of a union of genius with water-drinking. He was an entirely honest man; and who is there that would not forgive the little pleasurable vanities that he chose to allow himself at the fag-end of a life not over-prosperous.

(Frank Wedmore)

263 Hampstead Road:
George's home during the
latter part of his life

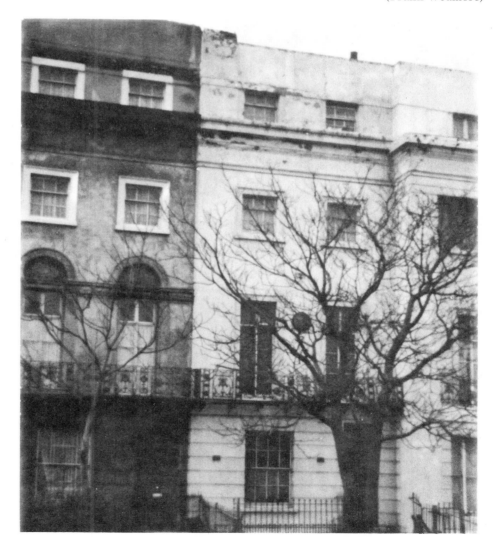

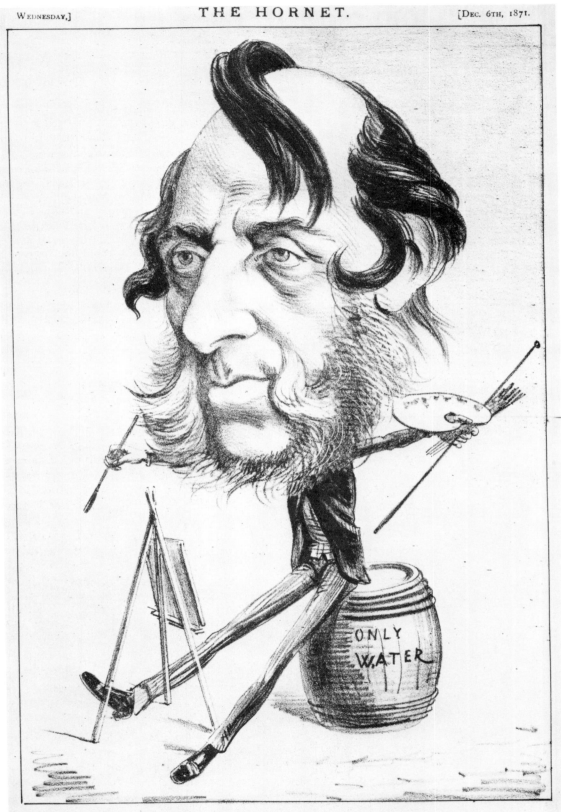

THE VENERABLE GEORGE.

Only Water—The Venerable George: lithograph from The Hornet *1871*

The last years of George's life were no pathetic anti-climax. He kept busy almost to the end: in 1864, regretfully declining an invitation to address a meeting of working men, he declared:

> My present list of engagements appals me when I look at it, for, being myself 'a working man', I find that I have not time to attend properly to my work.

If after 'The Worship of Bacchus' he was to produce no more large or striking masterpieces, we shall see that he produced many fine illustrations worthy to rank with his best. At the same time his talents continued to be at the service of those who might request them in the name of some good cause. Even as an actor he was still in demand, and on July 2nd 1860 he appeared as Prospero in *The Enchanted Isle*—a burlesque version of *The Tempest*—at Drury Lane, a benefit performance for the widow and children of his old friend Robert Brough. During the later years of the decade he was associated with a number of reforming pamphlets concerned with a variety of subjects which for one reason or another roused his partisanship. In *A Slice of Bread and Butter,* for example, he told a story of a boy dying of hunger while well-intentioned persons debated amongst themselves what sort of food they should give him—a characteristic smack at the mechanics of social welfare.

He had never been one to engage in religious controversy. Like most Britons of his day and social class, he was of firmly protestant views—views held no less firmly for being vague. The one article on which all were agreed was resistance to the Pope of Rome. Earlier in his life he had even been known to stand to one side in disdain when a Roman Catholic priest or nun passed, but he had never used his art in a theological cause. In 1868, however, it seemed to many English protestants that the Scarlet Woman was up to her old tricks, and that the Oxford Movement cloaked machinations to rival those of Guy Fawkes and his band. The taste for incense, exotic vestments and genuflexion seems harmless enough today, but the gentlemen of England were as easily alarmed at the prospect of a papal fifth column in their midst as they had been a few years earlier at the thought of a French invasion. So really it was more as a patriot than as a religious partisan that George produced his 'Design for a Ritualist High Church Tower and Steeple'.

On firmer ground the following year, he let fly at the proposal of a certain Miss Rye to export 'gutter children' to America: the year after that he was one of a deputation from the National Education League which called on the Prime Minister, Gladstone, regarding the 1870 Education Act; the League had been founded the year before to advocate compulsory secular education by the state. With a touch of his old vanity, George commented:

> I must say that it afforded me much gratification to hear all the suggestions which I had placed before the public so many years ago, so eloquently advocated upon this occasion.

In 1867 he had given one of the rare signs that he was no longer quite so radical in his views as he had been; it was the year of Disraeli's Reform Bill, and uncharacteristically, George opposed the Bill. He produced a cartoon, 'The British Bee-Hive', which depicted the nation working in harmony like a colony of bees, with the implication that the system was working very well and should not be disturbed. Perhaps he, like so many middle-class citizens of the period, had been alarmed at the demonstrations of the working classes in which angry mobs had torn down the railings of Hyde Park, encouraging many intelligent observers to think that Britain was on the verge of republicanism. If so, we may again suggest that George's apparent reactionariness, like his apparent religious fervour, was merely his

patriotism taking a political cast as in the other instance it had taken a
religious one. His brother Robert had been a republican sympathiser, but
George had always supported the monarchy; even his attacks on the Prince
Regent had been less directed against him as a person, than because by his
actions he diminished the respect due to the throne. When in July 1871 the
Communards seized power in Paris, George produced an etching of 'The
Leader of the Parisian Blood-Red Republic, or the Infernal Fiend–An Awful
Lesson to the World for all Time to Come'. His fears are pardonable even if
they strike us as somewhat hysterical, but we cannot help smiling when we
find him excusing the women of Paris for their part in the bloody proceedings
by suggesting that they had first been misled and then driven mad with drink
by their menfolk–only drink, in George's eyes, could have occasioned such
unladylike conduct.

For drink remained the arch-enemy. No matter what peripheral causes he

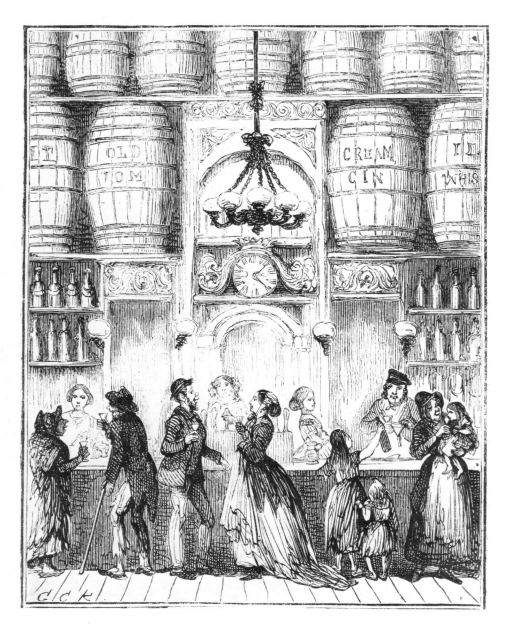

*The Gin-Shop: wood
engravings from* The Band
of Hope Review *1868.*

*They were also issued as
an Illustrated Penny
Reading.*

No. 1.

THIS is the *Gin-shop* all glittering and gay.

No. 2.

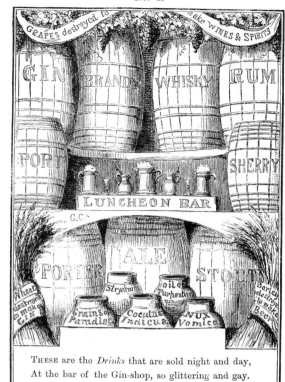

THESE are the *Drinks* that are sold night and day,
At the bar of the Gin-shop, so glittering and gay.

No. 9.

This is the *paper*, the poor drunkard signed,
Which was brought by the pastor, so noble and kind,
Who pitied the woman, with wobegone face,
And her husband, the drunkard, in rags and disgrace;
Who was served by the woman, all jewels and lace,
The wife of the landlord who coins his bright gold,
Out of the ruin of youthful and old,
Who drink the strong liquors he sells night and day,
At the bar of the Gin-shop, so glittering and gay.

No. 10.

This is the *church*, to which, one Sabbath-day,
The once wretched drunkard and wife took their way,
Drawn there by the pastor, so loving and kind,
Who brought him the pledge which he joyfully signed;
The pastor who pitied the woman's sad case,
And her husband, the drunkard, in rags and disgrace;
Who was served by the lady, all jewels and lace,
The wife of the landlord who coins his bright gold,
Out of the ruin of youthful and old,
Who drink the strong liquors he sells night and day,
At the bar of the Gin-shop, so glittering and gay.

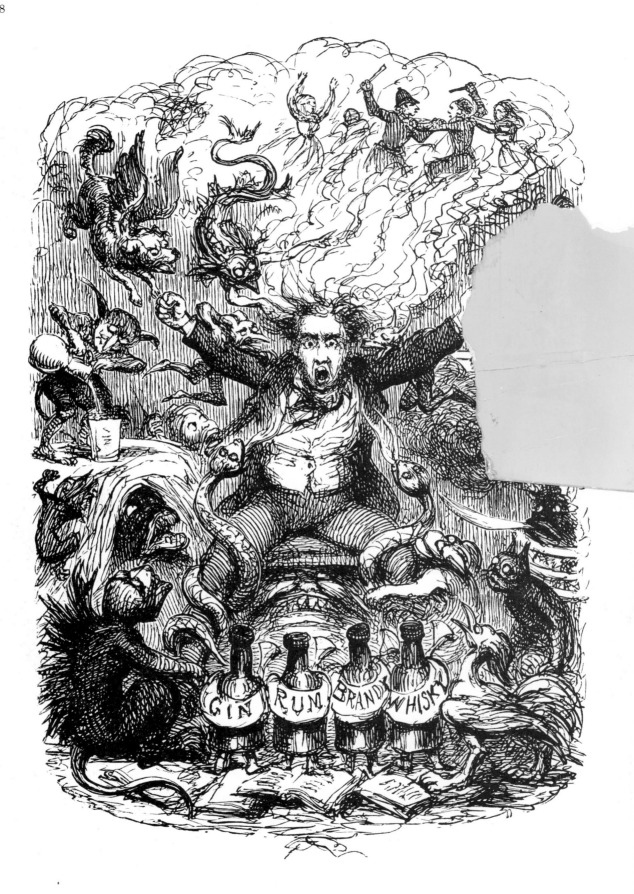

right: Pillars of a Gin Shop

lent his support to, it was temperance which had first and last call on his energy. In a pamphlet entitled 'The Glass and the new Crystal Palace' he protested–vainly–against the proposal to sell alcoholic drinks in the new Crystal Palace at Sydenham. His drawings appeared in journals such as *The British Workman* and *The Band of Hope Review,* for the latter of which he drew in 1868 his famous series 'The Gin-Shop', a kind of Temperance 'House that Jack Built'. Four years later he was one of a group of artists who contributed illustrations to *The Trial of Sir Jasper,* a Temperance Tale in Verse by S C Hall.

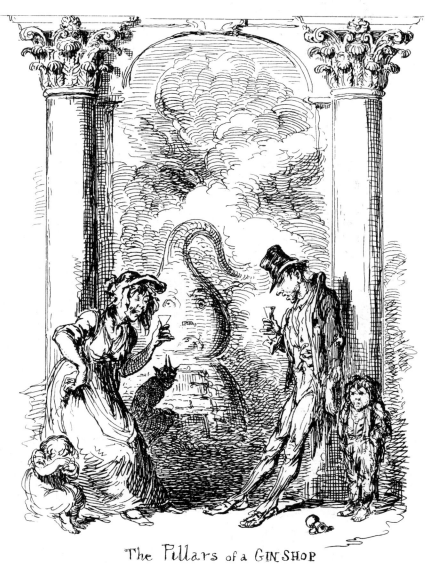

The Pillars of a GIN SHOP

left: Ten thousand devils haunt him: wood engraving for S. C. Hall's The Trial of Sir Jasper *1873*

Apart from these good causes, most of his work at this period was for folk tales and fairy stories. His frontispiece for Robert Hunt's *Popular Romances of the West of England,* 1865, is one of his most striking conceptions. When some critics objected to the foreshortening of the Giant's body, the artist pointed out that since the length of his stride was established at six miles, his head could not be less than three and a half miles above the ground! His ability to relate the creatures of Fairyland to our human world was

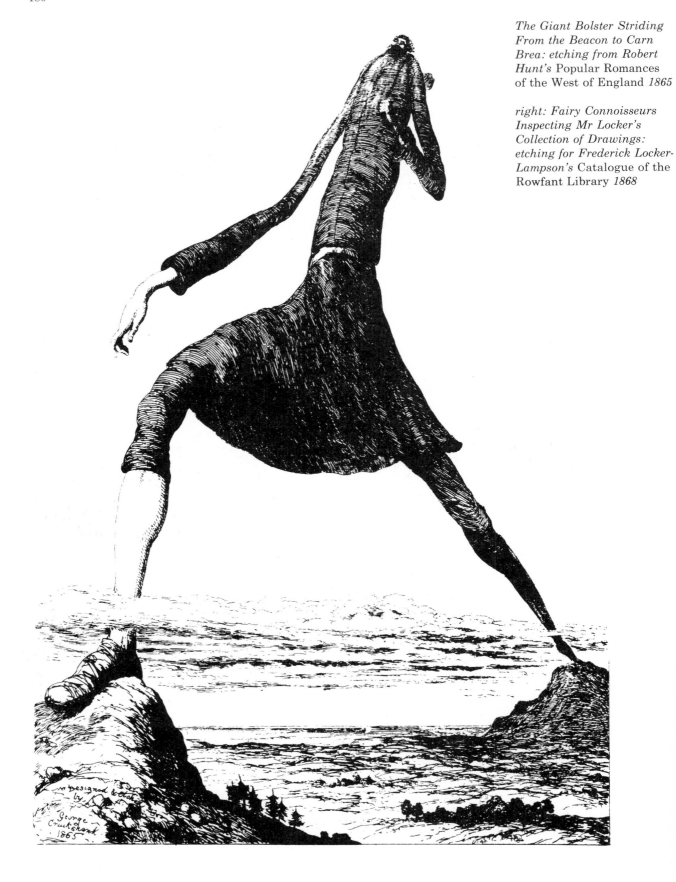

The Giant Bolster Striding From the Beacon to Carn Brea: etching from Robert Hunt's Popular Romances of the West of England *1865*

right: Fairy Connoisseurs Inspecting Mr Locker's Collection of Drawings: etching for Frederick Locker-Lampson's Catalogue of the Rowfant Library *1868*

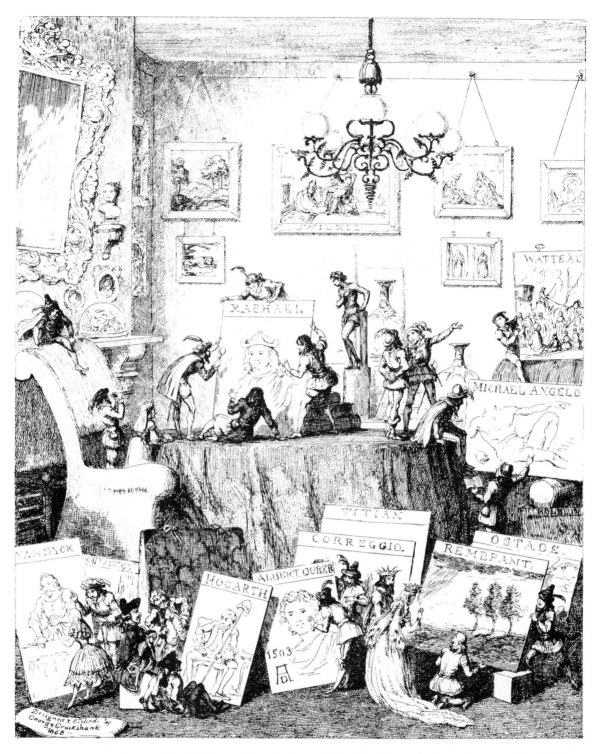

demonstrated in another but equally effective way in a plate entitled 'Fairy Connoisseurs inspecting Mr Frederick Locker's Collection of Drawings', 1868, and in a wood engraving for Mrs Ewing's *The Brownies* of 1871 the two worlds come face to face. His very last etching was for a fairy book, Mrs Blewitt's *The Rose and the Lily* of 1875, executed, as the artist proudly indicates on the plate itself, at the age of 83. It is a worthy finale.

'I'll show you
whether he's alive!'

In 1866, thanks to the efforts of his many friends, George was awarded a state pension of £95 a year from the Civil List. In his thank-you letter to the Prime Minister, the Earl of Derby, he wrote:

> This is a favour which I never should have thought of applying for myself, but some of my dear friends, knowing my heavy pecuniary losses for many years past in working for the public good, without my knowledge made the application which has been so kindly responded to by your Lordship.

In the same year he was granted a pension of £50 a year from the Royal Academy's Turner Fund. Together, these two payments must have given him the equivalent of about £1200 tax free in today's money. It is not easy to estimate his financial circumstances at this time. In 1875 he declared that he had not made a shilling by his art in ten years. This may or may not have been entirely true–George's love of the dramatic statement may have caused him to overlook a casual payment here or there– but it must have contained a large element of fact. We may presume that he asked no payment for the work he did for the temperance cause, and that the illustrations he supplied for the books of his acquaintances were done gratis.

In 1876 he sold his own collection of drawings and etchings to the Westminster Aquarium Company. His nephew, Percy Cruikshank, recalled:

> It was the custom of the artist, before parting with his plates, to have India-paper proofs of the etchings, and this being 'before letters'–that is, before the title was engraved on the plate–made them the more valuable. He also insisted on the engraver's supplying him with a proof of his drawings on wood when completed. This, in time, formed a scarce and choice collection, of which he knew the value full well.

The value, it seems, was a cash payment of £2500 and a life-annuity for himself and Eliza of about £35. The fact that he sold them at all is an indication that he was not living in affluence. He complained that he would be perfectly happy to do whatever work he was asked to do–but that nobody asked him. For this, his very eminence may have been responsible. Whether or not his style was in favour, the fact remains that he was the grand old man of the illustration world, and this may well have deterred potential clients from giving him petty commissions, much as he might have welcomed them.

The few hints we have of his circumstances during these last years of his life suggest that he was living in a modest bourgeois comfort in the semi-suburban neighbourhood of the Hampstead Road. Frederick Locker, whose pictures George had shown the fairies inspecting, recalled a visit at this period:

> One day he asked us to tea, and to hear him sing 'Lord Bateman' in character, which he did to our infinite delight. He posed in the costume of that deeply interesting but somewhat mysterious nobleman. I am often reminded of the circumstances; for I have before me a copy of 'Lord Bateman' and on the false title is written: This evening, July 13 1868, I sang LORD BATEMAN to my dear little friend Eleanor Locker. George Cruikshank.

'Thomas Ingoldsby' (Richard Harris Barham): etched frontispiece for new edition of Barham's Ingoldsby Legends *1870*

In 1873 Lord Shaftesbury recommended him for a knighthood, but evidently it was considered that there were claimants more worthy. It would have been gratifying to the old man to have received some public recognition of the efforts he had made for the public good and, if he knew of the attempt to obtain the honour, he must have been bitterly disappointed. No doubt he laughed it off in his customary way, but it would have been an unkind blow.

On March 8th, 1875, Eliza and George celebrated their silver wedding with a party at Hampstead Road. The writer S C Hall, whose *Trial of Sir Jasper* had been one of George's latest commissions, delivered a speech which brought Eliza to tears so that she fell weeping on her husband's neck–she is described as being 'fairly hedged in on every side with bouquets'. A guard of honour from his old volunteer regiment attended to congratulate their former Colonel. To one guest he observed with characteristic humour, 'You are down on our list of visitors for the Golden Wedding.'

In the following year a gentleman who had been out in India for many years was visiting Dr Richardson, who chanced also to be George's doctor. It happened, in the course of the consultation, that George's card was handed in and, on hearing the name, the visitor exclaimed, 'It must be the grandson, or the son at any rate, of the great artist I remember as a boy. It is impossible the George Cruikshank of Queen Caroline's trial time can be alive!' Upon which the doctor called in his eminent 84-year old patient as proof. 'I'll show you whether he's alive!' George exclaimed, and proceeded to execute a sword dance on the spot, using poker and tongs from the grate.

As it happened, Robert's grandson George was working at this time as an illustrator, a circumstance of which an unscrupulous publisher had taken advantage, issuing some work as being by George Cruikshank in hopes that the great-uncle's name would sell the younger man's work. The older George had protested. During these last years he was also involved in an acrimonious dispute regarding a project for a monument to the Scottish king Robert Bruce, in which misunderstanding and injured vanity led to a complicated and silly squabble which is not worth trying to disentangle. For the most part, George's last years seem to have been quiet and untroubled, in the enjoyment of public admiration and private affection. In January 1878 he became ill from

Boy meets Owl: wood engraving for Julia Horatia Ewing's The Brownies *1871*

right: The Rose and the Lily: etched frontispiece for Mrs O. Blewitt's book 1875

Designed and Etched by
George Cruikshank Age 83 1875

bronchitis, the ailment which had killed his brother, and on February 1st he died at his Hampstead Road home.

It was planned to bury him in St Paul's Cathedral, but because repair work was being carried out in the crypt, he was temporarily interred at Kensal Green. Among the eminent contemporaries who attended the funeral were Charles Landseer, John Tenniel, George du Maurier, Lord Houghton and George Augustus Sala. Of those who might have been there–the colleagues he had worked with and whose writings he had complemented with his illustrations–he had outlived most of them. Hone had died in 1842, Brough in 1860, Thackeray in 1863, Dickens in 1870. Even Ainsworth, who lived here in Kensal Green, was 73, and perhaps not well enough to attend the burial of his old collaborator.

right: George and Eliza Cruikshank: photo reproduced by courtesy of the National Portrait Gallery

George Cruikshank in the Last Year of His Life: wood engraving from The Illustrated London News *1878*

On November 29th of the same year his body was disinterred and taken to St Paul's, where he was buried only a few hundred yards from where his boyhood had been spent, and where he had produced the first examples of his work for which his countrymen now honoured him.

His wife Eliza survived him until 1890. She was well provided for; besides the annuity and pensions, she had the proceeds of the sale of his library and such plates and blocks as remained in his possession. These were sold in May 1878 at Sotheby's for £1133 11s, while a simultaneous sale at Christie's of pictures, drawings and sketches realised an additional £1010 11s 6d. It was not a rich heritage to be left by one of England's most eminent artists, but sufficient to keep his widow in comfort. Curiously, however, the chief legatee in George's will was a lady named Adelaide Archibold, of 31 Augusta Street, Regents Park, where she lived with nine children under 21. Nothing is known of this lady, though it has been suggested that she provides the reason why his financial circumstances were not easier during the last years of his life. While it is possible that he was maintaining a second menage, my personal opinion is that it is more unlikely than otherwise, and I would be reluctant to accept this explanation without more specific evidence.

wood engraving from Talpa
1852

Preferences

Sometime towards the end of his life, George took part in a game of 'Preferences'. His scrawled list of answers survives:

King	Queen Victoria, George III, Alfred the Gt, Arthur
Hero	Nelson, Wellington
Poet	Shakespeare, Burns
Artist	Raphael–or myself. Hogarth
Author	Sir Walter Scott
Virtue	Honesty, Honest charity
Colour	Blue, Green
Air	Marine, Seaside
Dish	No preference, all good food–all alike
Flower	Rose, Lily
Costume	Plain, or Charles the First
Name	Eliza, Mary
Occupation	Drawing and painting to prevent evil and try to do good
Amusement	Drilling, Athletic exercises
Motto	At it again. Nil desperandum. Vis fortibus arma.
Dislike	Humbug, Alcohol
Locality	London or the suburbs
Ambition	To rank with the worthy

George was not the man to think too carefully before replying: these scribbled answers–his drawings are much easier to read than his writing–were probably dashed off quickly and without premeditation. But even if he had considered long and deeply, he could hardly have drawn up a more revealing document. It constitutes virtually a synopsis of his mind; there is scarcely a phrase which does not echo some incident we have noted or some characteristic trait we have seen expressed at one stage or another of his long career, from the preference for Charles 1st costume reflected in the portrait (page 139) to his favourite flowers the rose and lily aptly symbolised in his very last illustration. On a broader scale, we have certainly seen how 'at it again' was an appropriate choice of motto and 'drawing and painting to prevent evil and try to do good' could hardly be bettered as a summing-up of his life's work. It was not only his aim but his achievement, knighthood or no knighthood, and it must be agreed by all that he also achieved his ambition, 'to rank with the worthy'.

He does not seem to have made any enemies–all who speak of him, speak well of him. Yet he managed to be a good man without being a pompous or a priggish man; even his most fervent preaching was done with good humour and a sense of reality. It was evident that his enthusiasm came not from adherence to a doctrine but from a simple, practical desire to help others. I don't doubt that he could be irritating on occasion, and his friends must have sighed as George trotted out his hobby-horses for the umpteenth time, but none could doubt his motives or accuse him of self-indulgence. They could accuse him of vanity–but even that was hardly a blemish so much as a character trait.

When I started to write about him, I had a great admiration for George Cruikshank the artist, but George Cruikshank the man I found a little too self-righteous, a little too vain. It would be absurd to pretend that these things were not present in his make-up. But now that I have got to know him better, I can see how trivial these blemishes were on so fine a man, and how easy to overlook when they are set up alongside his other qualities. He was a good man as well as a good artist. I am inclined to think he was a great man and a great artist. There are not many people from the past I would rather have known.

Other books about George Cruikshank

George's work is continually referred to in any survey of illustration in Britain, but surprisingly little has been written about him. The only full-length biography is Blanchard Jerrold's rambling, wayward and not always reliable *The Life of George Cruikshank* produced four years after the artist's death, in 1882. Frederic Stephens' *A Memoir of George Cruikshank* appeared in 1891, a small book made shorter still by the fact that it reprints in its entirety Thackeray's penetrating *Essay on the genius of George Cruikshank* from the Westminster Review of 1840, written in Thackeray's most flamboyantly irritating style, but, for all that it was written only partway through George's career, wonderfully observant. No more so, though, than the essay in *Blackwood's Magazine* for 1823 in which Wilson (or Lockhart?) with very much less to go on than Thackeray, discerns both George's weakness and his strength. Considering that George's career still had half a century to run, that article is amazingly penetrating.

Of modern studies there are few: Ruari M'clean's perceptive monograph on his book illustration, in 1948, though brief, was the first to get the artist into something like a proper perspective: it paved the way for the 1974 exhibition at the Victoria & Albert which can be said to have given George, for the first time, a balanced recognition. An artist so prolific and so various can be seen in many different lights, and there is room for further study: no doubt someone, somewhere, is at work on a definitive biography which will finally elucidate the mystery of Adelaide Archibold, resolve the question of the numbering of the Amwell Street houses, and establish the ultimate proof as to his contribution to the composition of Ainsworth's *Tower of London*. I have touched on all these matters, but not deeply: they do not seem to be very important. The only thing that really mattered to George Cruikshank was his pictures, and the only way we shall get to know the man is through the pictures.